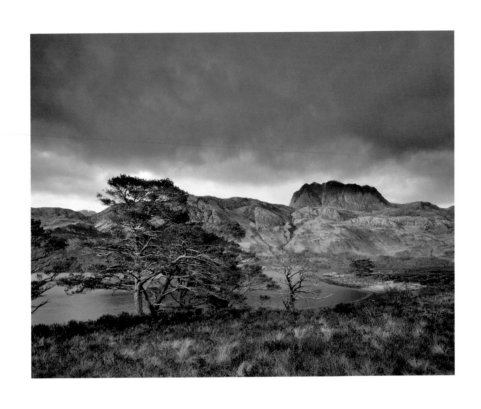

SCOTLAND'S
MOUNTAINS

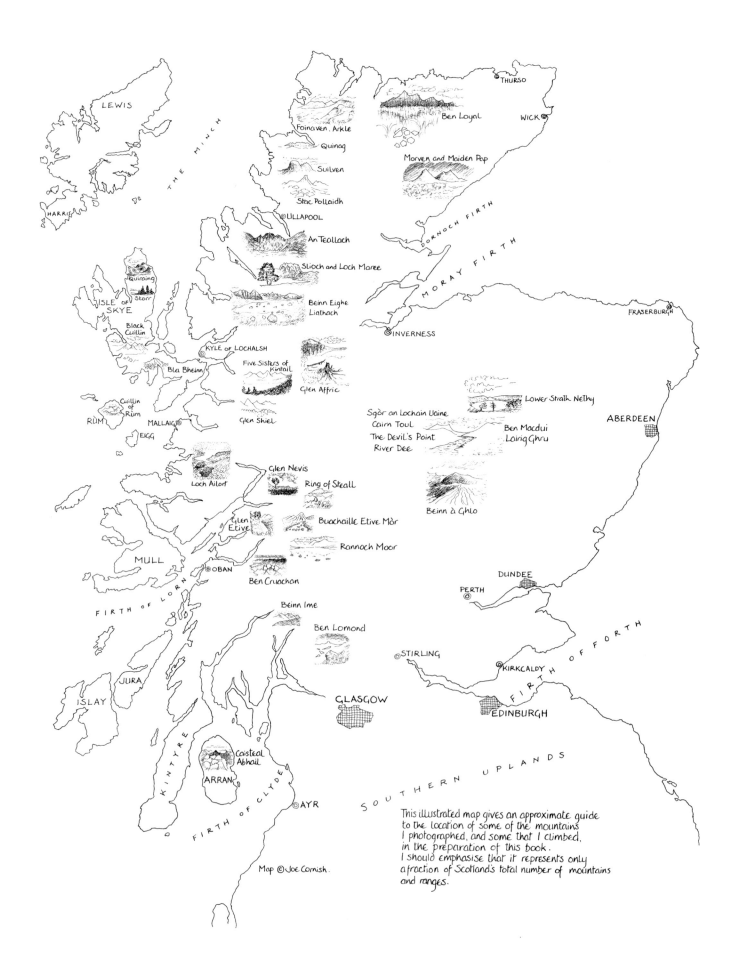

LEWIS

HARRIS

THE MINCH

Foinaven, Arkle

Quinag

Suilven

Stac Pollaidh

ULLAPOOL

An Teallach

Slioch and Loch Maree

Beinn Eighe
Liathach

THURSO

WICK

Ben Loyal

Morven and Maiden Pap

DORNOCH FIRTH

MORAY FIRTH

FRASERBURGH

INVERNESS

Quiraing

Storr

ISLE of
SKYE

Black
Cuillin

Bla Bheinn

Cuillin
of Rùm

RÙM

EIGG

MALLAIG

KYLE of LOCHALSH

Five Sisters of
Kintail

Glen Affric

Glen Shiel

Lower Strath Nethy

Sgòr an Lochain Uaine

Cairn Toul

The Devil's Point

River Dee

ABERDEEN

Ben Macdui
Lairig Ghru

Loch Ailort

Glen Nevis

Ring of Steall

Glen
Etive

Buachaille Etive Mòr

Rannoch Moor

Beinn à Ghlo

MULL

OBAN

Ben Cruachan

FIRTH OF LORN

Beinn Ime

Ben Lomond

DUNDEE

PERTH

STIRLING

KIRKCALDY

FIRTH OF FORTH

JURA

GLASGOW

EDINBURGH

ISLAY

KINTYRE

Caisteal
Abhail

ARRAN

FIRTH OF CLYDE

AYR

SOUTHERN UPLANDS

This illustrated map gives an approximate guide
to the location of some of the mountains
I photographed, and some that I climbed,
in the preparation of this book.
I should emphasise that it represents only
a fraction of Scotland's total number of mountains
and ranges.

Map © Joe Cornish.

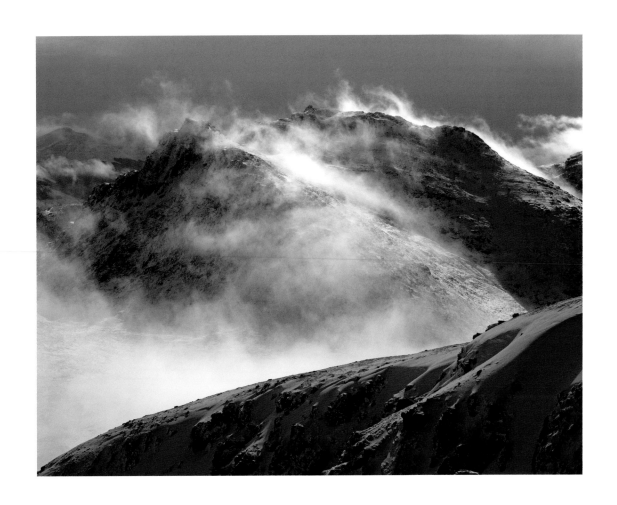

SCOTLAND'S MOUNTAINS

A LANDSCAPE PHOTOGRAPHER'S VIEW

Joe Cornish

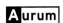

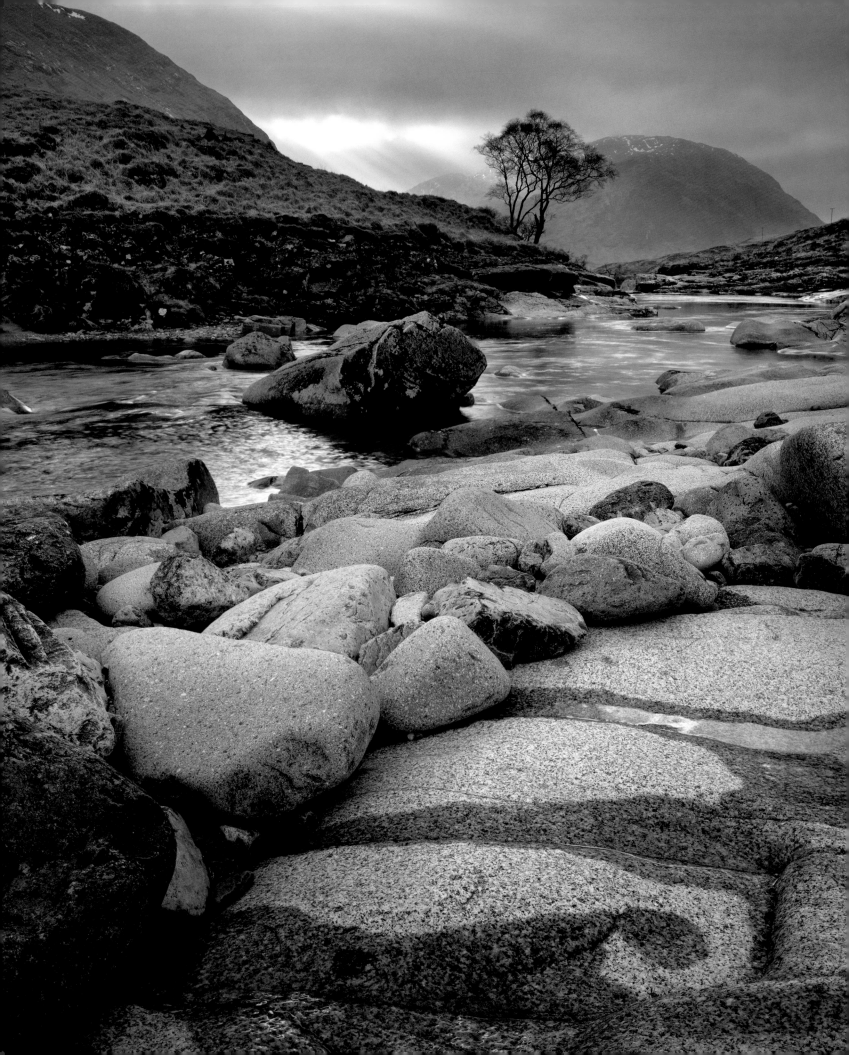

CONTENTS

GLEN ETIVE

River Etive and Sgurr Dubh

A LANDSCAPE PHOTOGRAPHER'S VIEW

"The source of sculptural energy is the mountain."
Henri Gaudier-Brzeska

IN THE POPULAR IMAGINATION – certainly in the eyes of a landscape photographer – nothing symbolises Scotland so powerfully as its mountains. The heart and soul of this proud nation, the wildest place on the Celtic fringe of Atlantic Europe, is its mountainous landscape. Mountains not only define Scotland's appearance; they have shaped the character of its people, and its history. Gaelic, the dominant language of Scottish mountain names, has more than 70 different words for 'mountain'.

6

Anyone with a keen interest in the geography of our planet will know that in global terms, Scotland's mountains are small. Even her highest summit, Ben Nevis, is only a fraction of the height of foothills in the Himalayas or Andes, let alone the summits of these great ranges. And while one might expect great continents to throw up giant mountain ranges, the world also has island archipelagos similar or even smaller in size to Britain whose mountains are very much higher, such as New Zealand, Vanuatu, and Hawaii.

Yet in the distant past Scotland's hills really were among the world's highest. Hundreds of millions of years ago, the Highlands were part of a vast continent straddling the equator. Tectonic pressures built a stupendous range, Himalayan or Alpine in scale. Since then, the irresistible forces of nature have taken a huge toll. Aeons of erosion and weathering, combined with spectacular continental crust migration and a multitude of 'recent' glaciations have left the hills of lesser stature that we see today. Not all Scotland's mountains originated so far in the past; the Cuillin Hills of Skye (regarded by many as the country's most Alpine in character) are the remnants of a great volcano active a 'mere' 65 million years ago. By contrast, the Torridonian hills and their northern cousins are composed of sedimentary rock laid down at least a billion years before now.

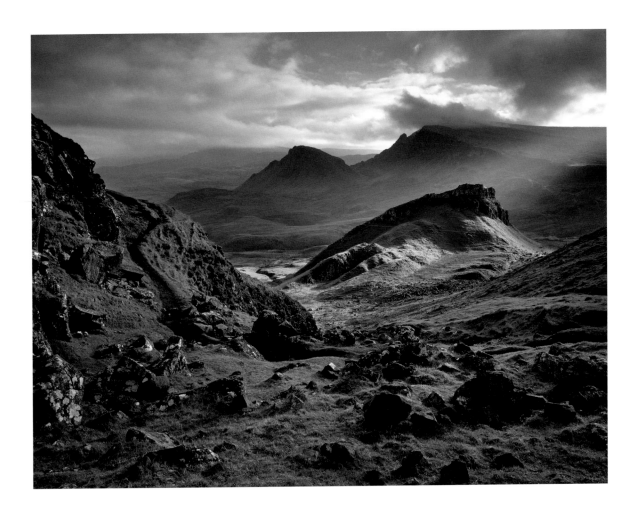

CNOC A MHÈIRLICH
The Quiraing, Skye

Currently, Britain's age of mountain-building is well and truly over. As I write these words the remorseless action of snow, ice, wind and rain continues the erosion process, for in those immortal words, 'geological time includes now'. But lack of altitude has not diminished the character and beauty of these hills. The sculpting processes of geology, and the surprisingly long period of occupation of the mountain hinterland and glens by man has left a unique signature.

While we can rightly regard the Highlands as the wildest landscape in Britain, no purist could ever define this as a wilderness. The influence of humanity – occupation and exploitation – is everywhere. Deforestation, over-grazing, reforestation (with non-

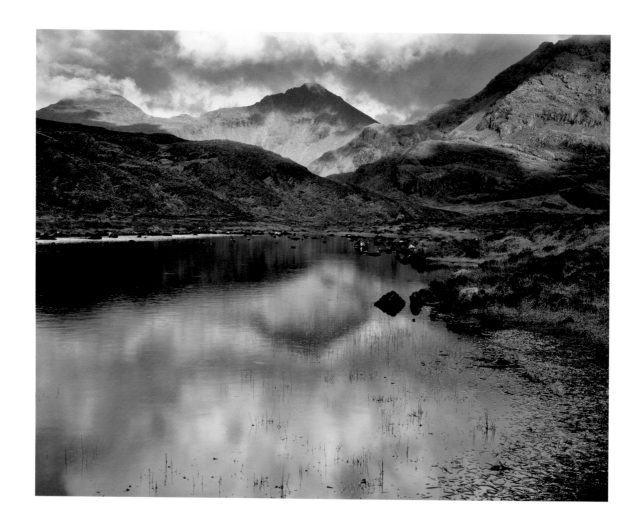

THE RÙM CUILLIN
Un-named lochan

native trees), heavily engineered hydro schemes and their attendant reservoirs, powerlines, stock fences, tracks and roads have all had a degrading effect on the natural beauty of the landscape. And while wind turbines may be a sincere attempt to generate environmentally friendly power their presence close to and encroaching onto the fringes of Scotland's mountain ranges threatens to corrupt the wildness of the natural scenery.

Yet without the roads and services that give such easy access to these hills, how would we appreciate them? Human occupation has not all been negative, and the vast numbers of visitors to Scotland prove this is truly a cherished landscape. Humans have

lived in Scotland for at least six thousand years, and from that perspective it is worth remembering that we are part of its landscape narrative.

For the climber and walker on these hills there are no altitude-related breathing difficulties to contend with, but that does not mean they are without danger. Northerly latitude exaggerates the impact of height; above 4000 feet, especially in the Cairngorms, the habitat in winter is best described as sub-Arctic. And capricious weather makes Scotland's mountains notoriously unpredictable. Serious accidents and deaths occur without fail every year. Tempted onto the hills by the stirring challenge they present, inexperienced individuals may set off with poor weather protection and be caught out when conditions turn from benign to malevolent. Even 'battle-hardened' veterans have accidents too, for meteorologically these hills generate their own malicious microclimate. Once at altitude temperatures can plunge, and hurricane force winds whip the mountaintops when the valleys are simply breezy. Rain down below may be a raging blizzard above.

The epoch-straddling vastness of time has created a landscape both complex and beautiful. There are few Fujiyama-like volcanic cones here. Instead, expansive ridges abound, bristling with rock features, cliffs and outlying buttresseses. An Teallach, Liathach, and Beinn Eighe exemplify mountains whose many summits make a range in their own right. The inverse of a multitude of mountains is its corresponding valleys, and Scotland's deep glens, usually filled by lochs and lochans, burns and turbulent rivers, are as integral to the landscape as the mountains themselves. Secluded lost valleys, sculpted gorges, spectacular waterfalls and cascades, remnants of ancient Caledonian forest, wide vistas that often overlook the sea, and rare birds and animals are powerful attractions for walker, mountaineer and photographer. Often consumed by Atlantic weather, sometimes wreathed in swirling mists and in winter graced by blankets of snow, Scotland's mountains can be elusive and unforgiving, making them especially difficult – and so hugely rewarding – to photograph.

In this book I have made no attempt to pursue summits on the basis of height, or popularity, but rather on the appeal and charisma they hold for me as an artist. Nor did I make any attempt to provide a full catalogue. There are so many wonderful hills in Scotland, and because exploring all of them with a camera would be the enterprise of not one but several lifetimes, the months I have spent making the images here

could never be enough. Connoisseurs of Scotland's mountains may well ask, 'Where is Knoydart?', and 'Why no pictures from the Cuillin Ridge?' But no book of this kind could ever be comprehensive; it is instead a work in progress, one I hope to continue for the rest of my days.

My goal has been a feeling for place, for mood, depth, intimacy, grandeur, beauty. I have tried to learn from the mountains, to make pictures that reflect, even in some small degree, their heart and soul (or perhaps more truthfully, mine). On the way, I have discovered a new level of patience, application and acceptance to fulfil my ideas of what makes a picture. Majestic yet elusive effects of light mocked many of my photographic aspirations, leading to much unfulfilled photographic effort, and a challenge to every philosophical faculty and experience I have. In landscape photography, an old saying, 'if you've seen it, you've missed it', rang true for me frequently. When younger, I might have compromised my standards. No longer. If I can make one good photograph a day, that keeps me going. And if I cannot manage one, well, at least I have had the huge privilege of being in the mountains.

STRUCTURE OF THE BOOK | From the outset I knew it would be difficult to group the images, for Scotland's areas are confused by the complexity of its western coastline, the variety of its geology, and by the baffling (to the outsider) proliferation of historical, political and administrative regions.

However, presenting so many pictures in one huge bite would make quite an indigestible meal. Thus, I have decided that chapters must be used. And since the emphasis in this book is indisputably the photography, with the writing playing a supporting role, the main colour pictures are presented in portfolios.

The regional divisions made will not please everyone, but I make no apology for an arrangement that emphasises my own photographic adventures and experiences. I could have combined Torridon with the Far North for example, but felt that these two zones have so much to offer that one portfolio would have been excessive.

Throughout the course of creating this book, I have come to equate the mountains with the challenges they present both physical and philosophical. On a number of occasions I have wondered why I would put myself through this much fatigue, discomfort, exhaustion, frustration, cold, hunger and occasionally pain and danger. But I genuinely

10

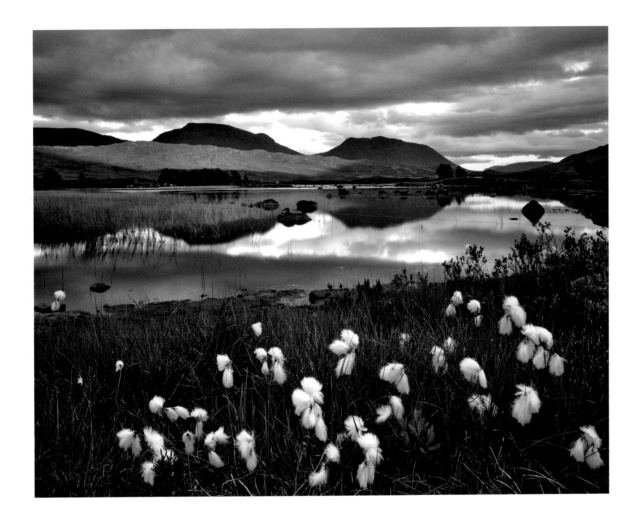

LOCH BÀ

Beinn Achaladair, Beinn an Dothaidh in the distance

do believe that every moment in these hills has been worth it (spiritually, not financially I should emphasise!), and the experiences could be described as 'character-building', 'life-affirming' or just plain 'pretty amazing', depending on your point of view.

In my ruminations about life and about photography I can't help but make the connections that exist between the mountains and the human spirit, aspiration and endeavour. And it is some of these themes that I focus on in my short essays preceding each portfolio. I hope they may resonate back through your own experiences in the mountains. I would not wish the essays to be seen in any way as an explanation for

my photography, nor should it be necessary to read them at all before looking at the photographs. Rather they are a reflection of my own preoccupations, which may illuminate the pictures for you in some way.

Gaelic is a beautiful and poetic language, but it can seem opaque to English speakers; the correct pronunciations often bear almost no resemblance to what we might expect from the printed words. So in an effort to make them a bit more approachable I have included some English translations (bracketed) of the names in the Afterwords. While this is by no means universally applied, there are translations for most of the major peaks in the book. Gaelic mountain names are wonderful and weird; from the poetic and romantic, to the humorous, to the sexually explicit, to the blindingly obvious. It must be mentioned too that on Skye and Rùm, and in some parts of the far North, many names are of Norse origin. I hope this might inspire the reader to research further into the fascinating topic of Scotland's mountain names. Peter Drummond's beautiful and classic book, *Scottish Hill Names* provided me with virtually all the information I sought.

The colour photographs form the main creative effort; I have deliberately kept the titles place specific and minimal. I hope the reader will bring their own feelings and interpretation to their viewing. It is sometimes a challenge to find pictures that work together well on opposite pages, and I must acknowledge the debt I owe to Eddie Ephraums for his inspired sense of what works with what, as well as the overall design.

At the beginning of each chapter are some stories that emerged from the making of the pictures. Sometimes they are associated with walking on a specific mountain or range, or they may relate a more general view of photographing in these hills. I see these stories as a complement to the pictures, and hopefully a helpful background to some of the decisions and thought processes that have to be made 'in the field'.

If there is one word that I would hope defined my photography, it is *distillation*. Photographically-speaking, I aim to distill the essence of the subject. And just as the making of whisky is the enterprise of distilling the spirit of the Highlands with malted barley and spring water, my raw materials are light, time and composition.

I am sure we could all drink a toast to the health and well-being of Scotland's mountains. May their wildness and wonder forever be preserved.

Joe Cornish 2009

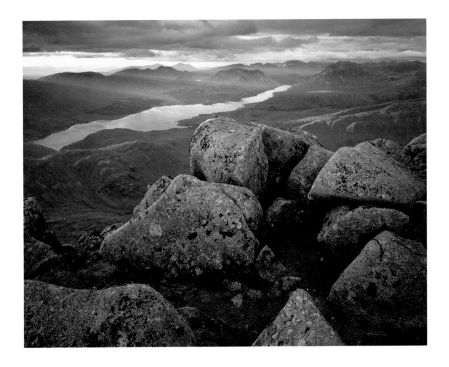

BEN CRUACHAN
Sunset over Loch Etive, summer

13

"*Ultimately and most importantly, mountains quicken our sense of wonder. The true blessing of mountains is not that they provide a challenge or a contest, something to be overcome and dominated (although this is how many people have approached them). It is that they offer something gentler and infinitely more powerful: they make us ready to credit marvels — whether it is the dark swirls which water makes beneath a plate of ice, or the feel of the soft pelts of moss which form on the lee sides of boulders and trees. Being in the mountains reignites our astonishment at the simplest transactions of the physical world: a snowflake a millionth of an ounce in weight falling on to one's outstretched palm, water patiently carving a runnel in a face of granite, the apparently motiveless shift of a stone in a scree-filled gulley. To put a hand down and feel the ridges and scores in a rock where a glacier has passed, to hear how a hillside comes alive with moving water after a rain shower, to see late summer light filling miles of landscape like an inexhaustible liquid — none of these is a trivial experience. Mountains return to us the priceless capacity for wonder which can so insensibly be leached away by modern existence, and they urge us to apply that wonder to our own everyday lives.*"

From *Mountains of the Mind*, by Robert Macfarlane

THE SOUTHERN HIGHLANDS

The Highland Fault lies an hour's drive north from the centre of Glasgow, and it is here that the landscape really soars skyward for the first time. West of Stirling and south of the Great Glen these ranges include Scotland's highest mountain, Ben Nevis, and some of her most challenging and iconic Munros (hills exceeding 3000 feet in height). Given their proximity and convenient position in relation to the country's largest cities it is no surprise that these are by far the most visited (and most photographed) of Scotland's mainland mountains. While mountains such as Ben Lomond, Beinn Dorain, Meall a Bhuiridh, and Buachaille Etive Mòr may hold the focus of the visitor, this is also a land of exceptional valleys. Glen Orchy, Glen Etive, Glen Coe and Glen Nevis are as outstanding in their geological wonders as the mountains that surround them.

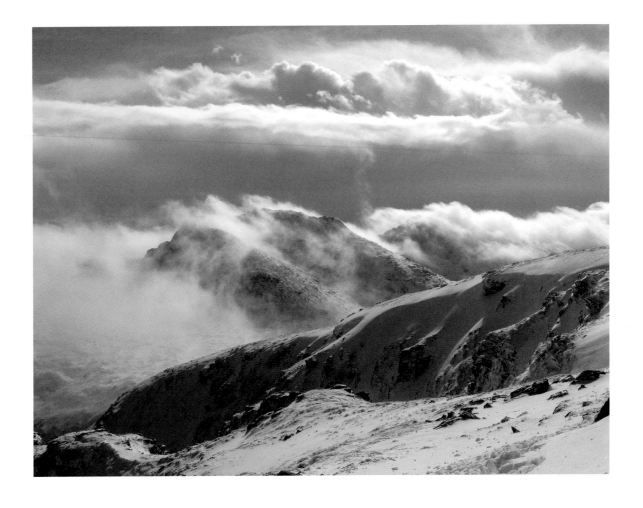

THE COBBLER
from Beinne Ìme, clearing storm

BEINNE ÌME | The day before my 50th birthday I rose before dawn, left my camper van beside the shores of Loch Long in the gloom, and set out on foot from sea level through wet snow into the Arrochar Alps. Route-finding was difficult in the snow, but eventually I found a way through a winter fantasy woodland and began to climb. The sun rose, appearing sporadically through cloud and concealing snow showers. By mid morning I was below the Cobbler with its characteristic rough-horned top, making pictures near to an erratic boulder the size of a small house (opposite).

I had in mind a viewpoint I knew of on Beinn Ìme beyond so kept going, though the weather was restless, the light increasingly sullen and mean. The visibility was deteriorating, and I wondered if I would need a compass to retrace my steps. If so, would I remember how to use it? I felt unnerved. What little I could see of the main shoulder of Beinn Ìme looked straightforward enough, but by now the summit had disappeared into descending cloud. I resolved to climb it anyway. High on the mountain's southern flank I stopped to investigate some icicles suspended from the overhang of a huge boulder. Attaining the position should have been simple enough, but the wind was rising, and the snow slopes dropping steeply away looked distinctly unstable.

By the time I reached the boulder, the blizzard had struck. The wind was ferocious, howling, and even in the shelter of the eastern slope (the wind direction being westerly) snow and ice particles rushed around wildly, covering everything in an instant. I hunkered down and waited. It was necessary to keep brushing away the snow or I would have been entombed within minutes.

Warding off the cold became a matter of necessity, and I began the task of 'building' a shelter, using the snowdrift which had formed below the boulder's overhang as a starting point. I dug down with gloved hands and built up the drift into a makeshift wall. The activity restored my circulation, but after a while the thought occurred that I might eventually need this refuge to keep me alive, as the blizzard continued relentlessly. Attempting a downhill retreat in these conditions seemed impossible. My tripod and camera backpack were still on the plateau above; facing the onrushing wind I ventured up to retrieve them, half expecting the bag to be buried, but the wind had scoured past it leaving a tail of snow to the lea side.

16

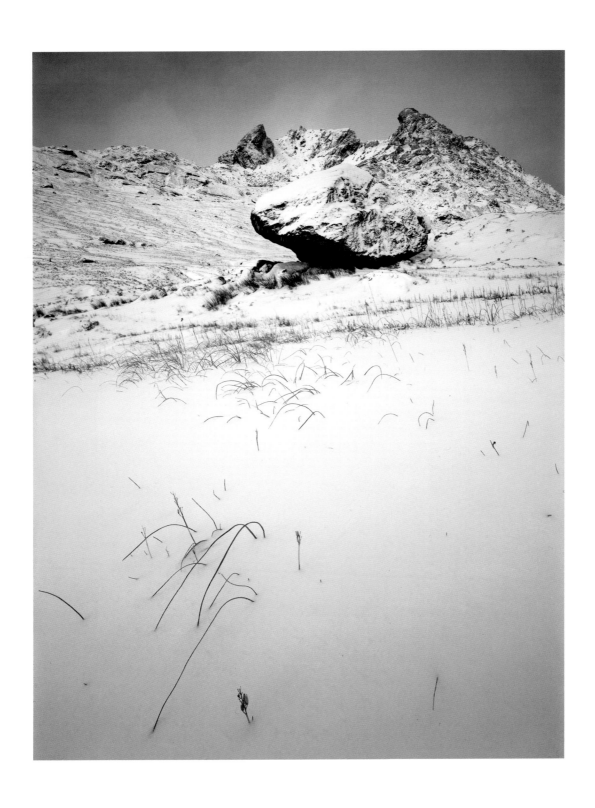

THE COBBLER

Ominous weather

Taking the pack into my walled den I ate lunch in the most civilised fashion I could muster. A dusting of snow was included with every mouthful and I wondered if it was like this high on some Himalayan or Andean peak, though I knew perfectly well how remarkably tame my predicament really was. It was hardly *Touching the Void*. I am rarely ruffled by events in the outdoors, and I have a good personal safety record. But it was the first time I had been caught out alone at this kind of altitude in a blizzard, and I couldn't help wondering whether I would get down the mountain before nightfall.

I felt the light lifting and the wind abating. Within minutes the blizzard blew itself out even more quickly than it had arrived. The sky brightened, and after that interminable lunch hour a brilliantly sunlit, snow-covered world of misty mountains and deep glens was revealed (pages 3, 15). I climbed up to the intended viewpoint as the wind eased. The contrast was astonishing; and the brightness range had become photographically almost impossible.

A couple of hours were spent trudging around near Beinn Ìme's summit, searching out angles in deep snowdrifts, without great success. Hard sunlight and unbroken snow everywhere were starting to hurt my eyes, and exhaustion overwhelmed my creative instincts. It was nowhere near sunset, but I had done enough and descended the mountain. After the baptism by snow and wind I was ready for the comforts of my camper van, sleeping bag and some hot tea.

The following morning I woke well before dawn, and scanned the eastern horizon. The sky was clear, the wind hardly stirring; snow-clad mountains beyond the Black Mount lochans glowed dark blue in the dying of the night. A short drive, followed by a mile or so of walking, took me to the edge of Lochan na Stainge (page 151). The panoramic prospect there would not make the most original landscape photograph, but constituted a gift to receive gratefully after the travails of the day before. I worked carefully with my camera for nearly two hours, watching the luminous predawn glow, the curious 'dead' light that so often occurs just before sunrise, the vivid pink of the sun's first rays on the hills, and the golden hour that follows. The sky even clouded over for a while, and some light flakes of snow fell. This surely was an auspicious way to start the day.

By midday I was back on the hill, ascending the slopes of An Caisteal south of Crianlarich. Wet snow and lumpy terrain made for heavy going, but things improved

with altitude, the snow getting crisper, and numerous icicle cascades invited me to stop, study and rest. By the time the sun was descending towards the western ranges I was on the main ridge but still far from the top. A weather front was approaching from the west; the light would soon deteriorate. I made the near two-hour descent, reaching the van in enveloping darkness. My camera backpack had become a gravity-intensification device, and tearing off the boots, now soaked through, was almost an ecstatic relief. I felt my age. What was that again? Oh yes, 50 today. Almost forgot.

BUACHAILLE ETIVE MÒR | If you were a Martian arriving on earth for the first time at a Scottish motorway service station, and browsed the postcard spinners, you could be forgiven for thinking there was only one mountain in Scotland. And it would be Buachaille Etive Mòr, the Great Herdsman of Etive; it stands imperious, pyramid-like at the convergence of Rannoch Mor and Glen Coe. It is not the highest mountain in Scotland. It is not even the highest mountain locally (Bidean nam Bian and Meall a' Bhùiridh comfortably surpass it), but its commanding position and easy access for photographers have made it the ubiquitous Scottish peak, king of the mountains (and of the postcard industry).

Mid December and mid week seemed a sensible moment to climb a mountain that undoubtedly sees many thousand on its summit ridge through the course of a year. How nice it is to meet and chat to other mountain walkers when one passes them; but surely nobody wants to share their mountain with a crowd! And when there is fresh snow, a pristine untrodden foreground is always better for photography.

From a few thin patches of snow near the main road, I ascended the north-facing Coire na Tulaich gulley into snow so thick I was waist deep at times approaching the top. The light was blue, the down draft chilling, and the physical effort a necessary counter to the freezing air. Occasionally I made use of my ice axe for cutting steps, but mostly it was just a steep slog. I hoped the snow was stable enough and not avalanche-prone. Once on the ridge and back into the sunlight the prospects everywhere were tremendous. The original idea was to climb on Stob Dearg, the highest of the Buachaille's three summits; it is the one that rises above and so wonderfully commands Rannoch Moor. But the moor itself was almost free of snow, and dark in the shadows of a short winter's day. Time (and available energy) did not allow me to nip up Stob Dearg for a quick look. I would have to commit

myself to a course of action, and stick with it. Stob na Doire, the second and middle summit, might be better positioned from a lighting point of view. But that was a longer walk, and would make the retreat more risky. Decisions, decisions.

For photographic reasons, Stob na Doire won the day. There should be more photographic 'sight lines' from there, so a better chance to make use of whatever lighting opportunities might arise. On its peak I met two other walkers. Their route and schedule would see them safely back down the mountain half an hour before sunset. Why did life have to be so difficult for photographers? I tried to persuade myself that the light might *not* improve as the sun went down, but failed. My descent would inevitably be in the gathering darkness.

The weather was beautiful for a walk, but the absence of cloud made a stark lighting environment. The snow itself offered a creative solution. The sun's lowering rays revealed ever more texture and shape in the wind-blown accumulations, and it was a wave of snow that finally became my focus, with the ridges of Buachaille Etive Beag and Aonach Eagach forming a backdrop (page 39). Of the two large format photographs I made that day, I knew this would be 'the one'.

Retracing my steps through the twilight was easy on the Feadan Bàn (ridge), but when I came to the Coire na Tulaich again it was a different story. A tired move led to a missed footing on the steep snow slopes and I suddenly found myself slipping and sliding. Fortunately I made a good self-arrest before I could really start to gain much downhill momentum, and the snow had remained stable, but it was a salutory lesson. My pack was heavy and unbalancing, I was exhausted, and if I had failed to brake at that point there was little prospect of stopping for hundreds of feet before hitting rocks and a very hard landing. The rest of my descent was made with total concentration. By the time I had reached open ground again there were stars in the sky.

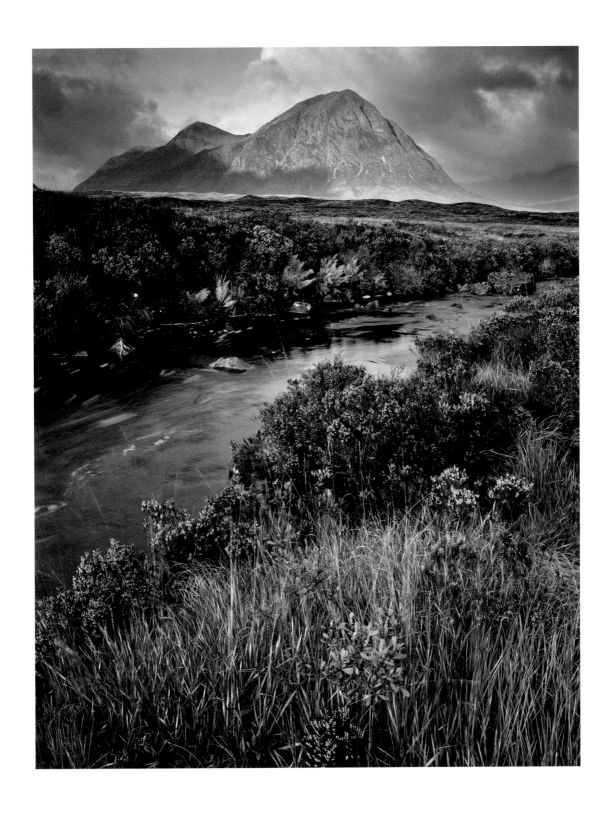

BUACHAILLE ETIVE MÒR
Morning light

The Southern Highlands
Portfolio

INSPIRATION | A prerequisite for any meaningful artistic endeavour is to feel something for the subject matter. More than that, in landscape especially, the artist must feel inspired by it. My earliest photographic efforts in Scotland were on (and around) Rannoch Moor; coming from the south, these hills were my first real Caledonian passion. Combining lochs and lochans, beautiful streams and rivers, charismatic rock, deep glaciated glens, and the sea never far away to the west, it is a landscape both of broad gestures and subtle intimacy. A vital element of my photographic ethos is practice in familiar places, and this is the place I know best and feel closest to. It is therefore the area with which I have the strongest spiritual connection, and remains a limitless source of inspiration. The etymology of 'inspiration' is Latin, *inspirare*, to breathe (or blow into); in this way the word connects us with the most basic act of being alive. I also take the word to mean being stimulated creatively; and, the elevation of the spirit.

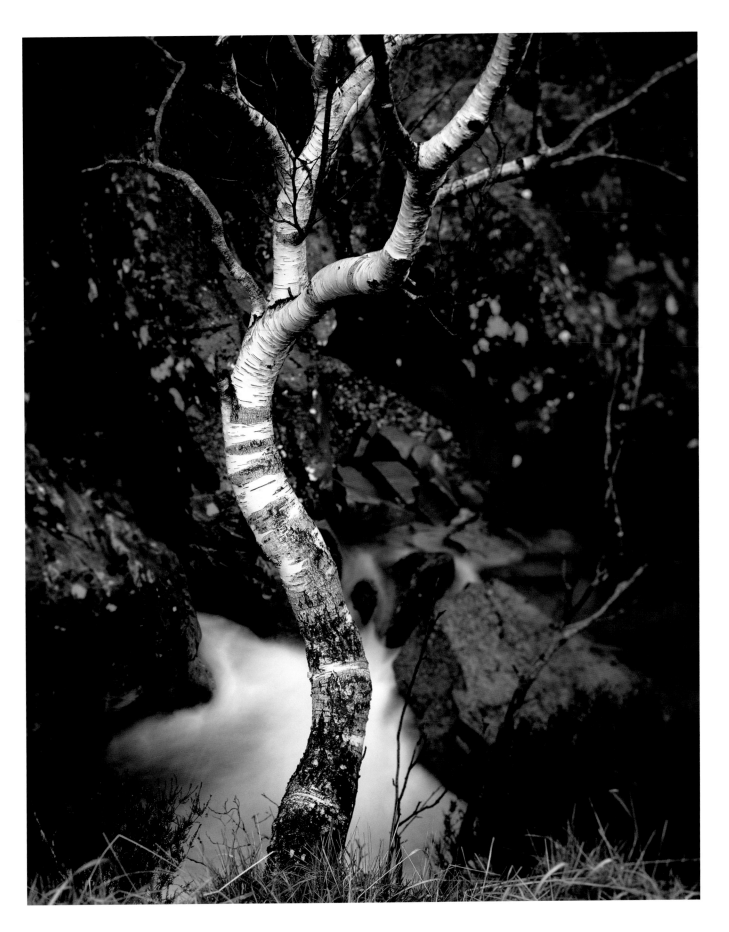

GLEN NEVIS

Birch in winter

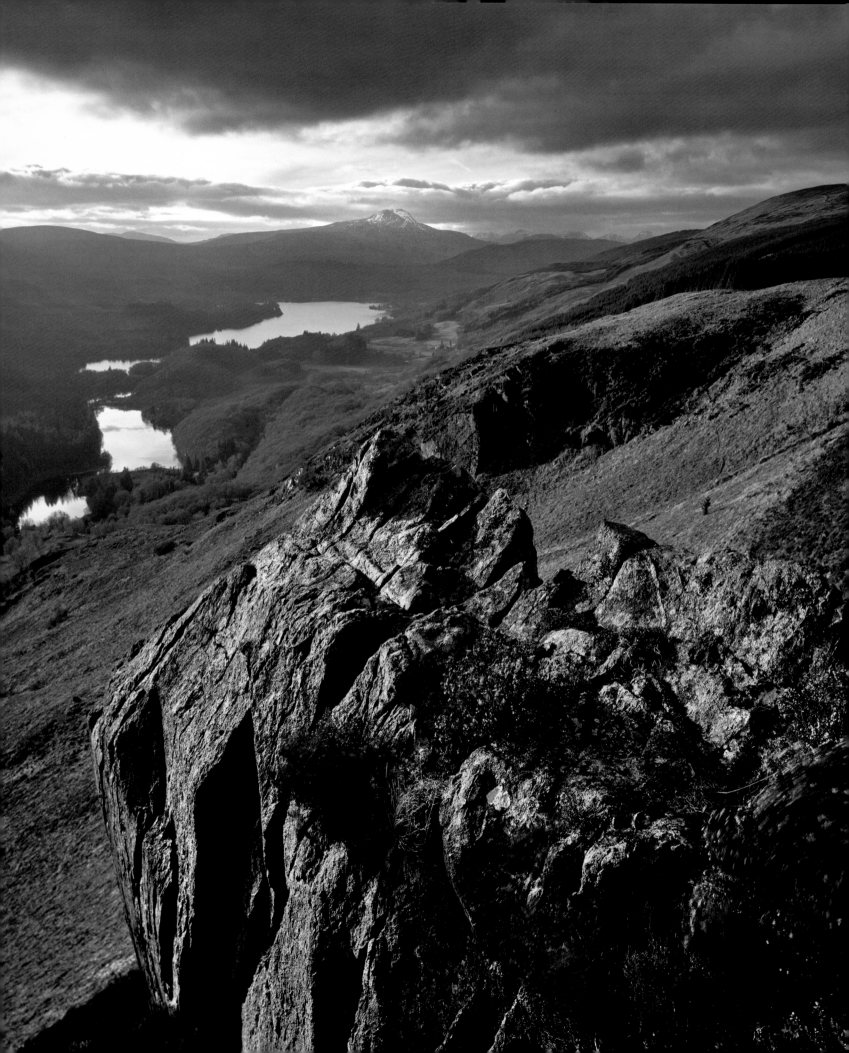

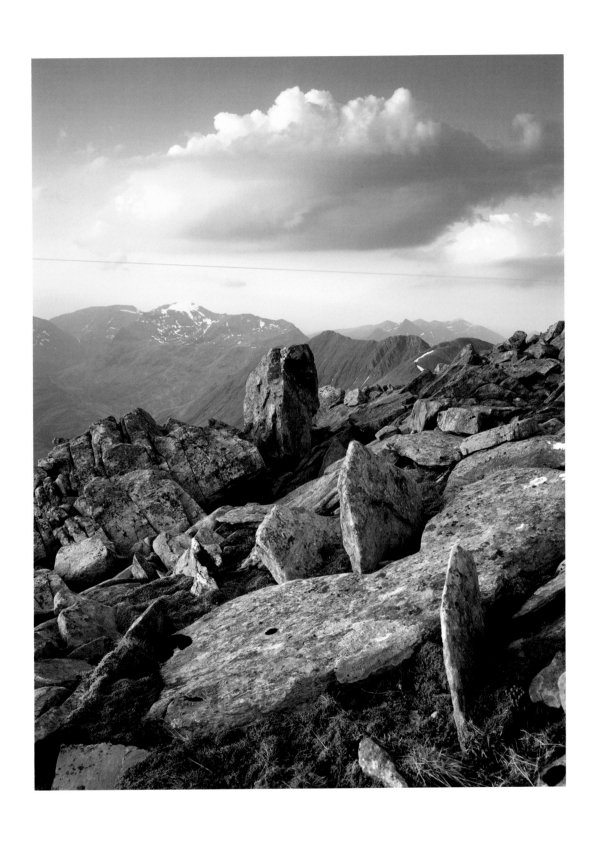

BEN LOMOND

and Highland Fault

AM BODACH

Ring of Steall

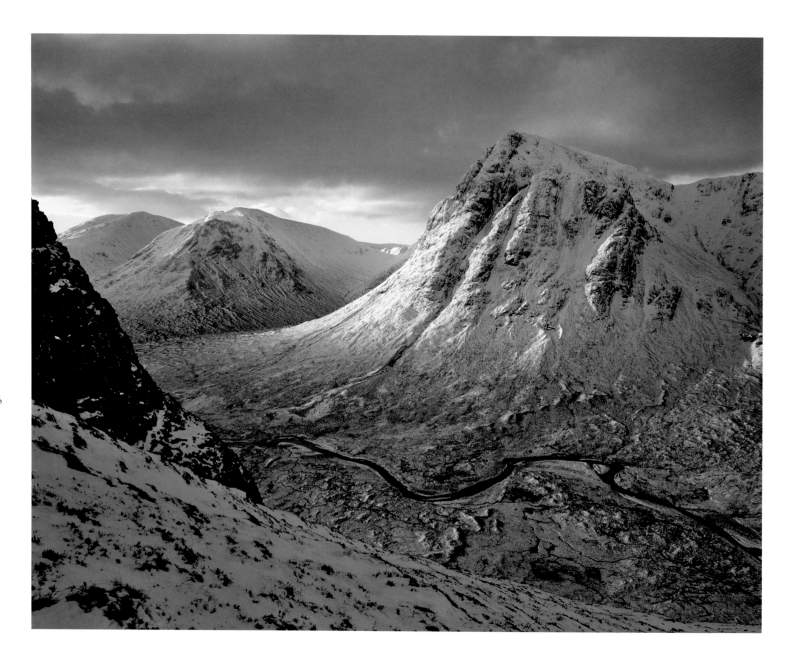

26

STOB DEARG

from Stob Beinn a' Chrùlaiste

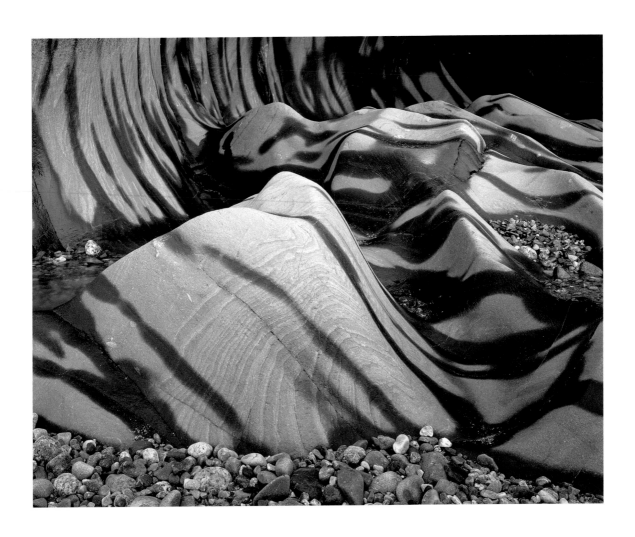

BENDERLOCH

Shore detail

28

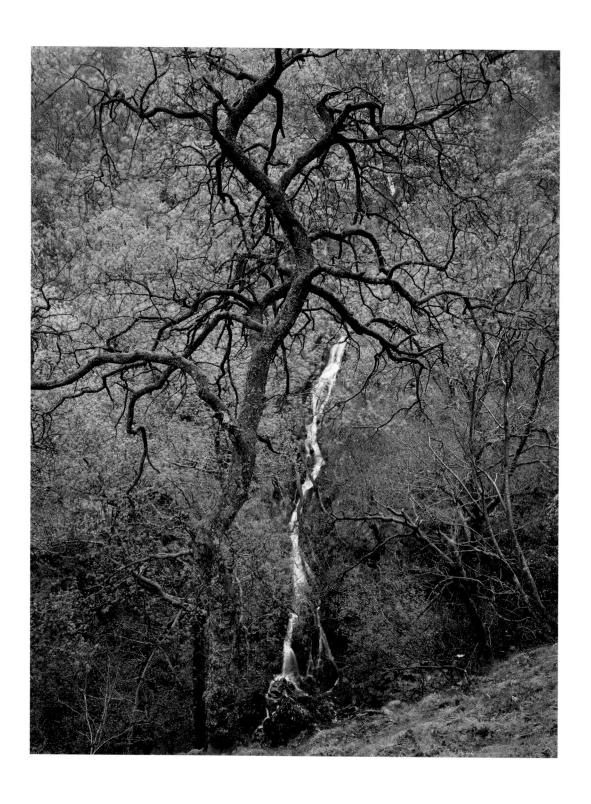

BEN LOMOND

Woodland waterfall

STOB A' GHLAIS CHOIRE

Autumn rain

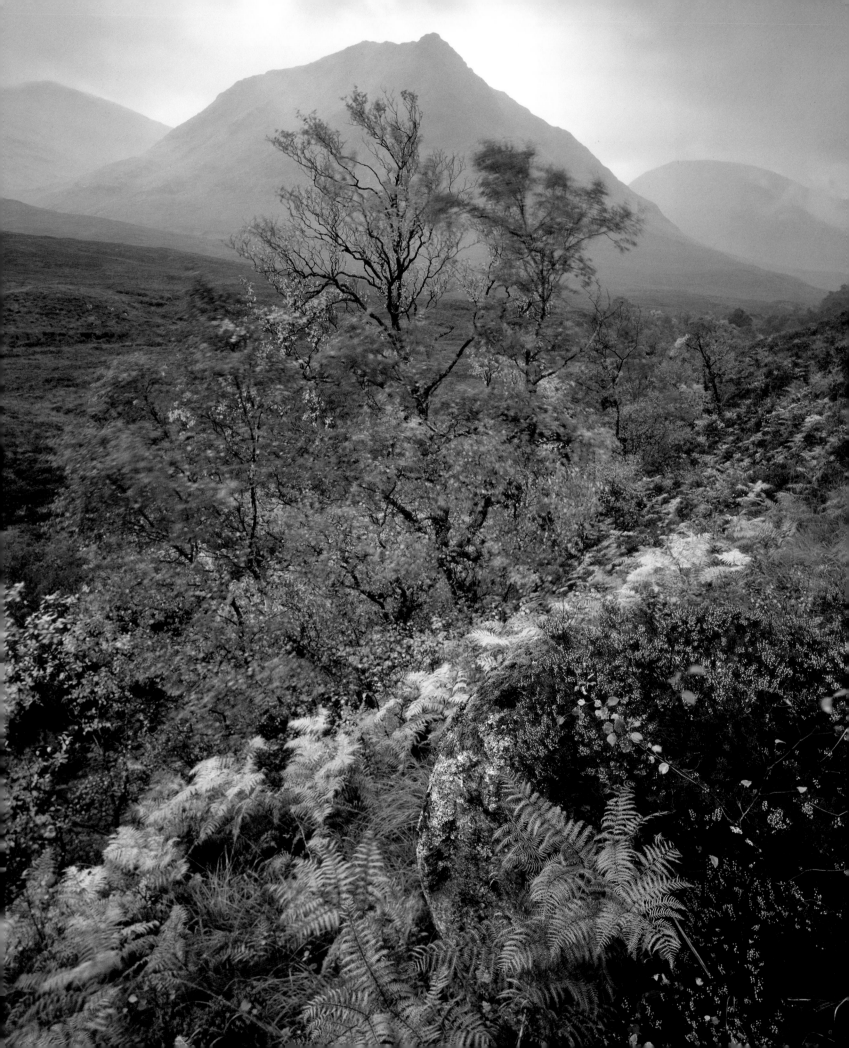

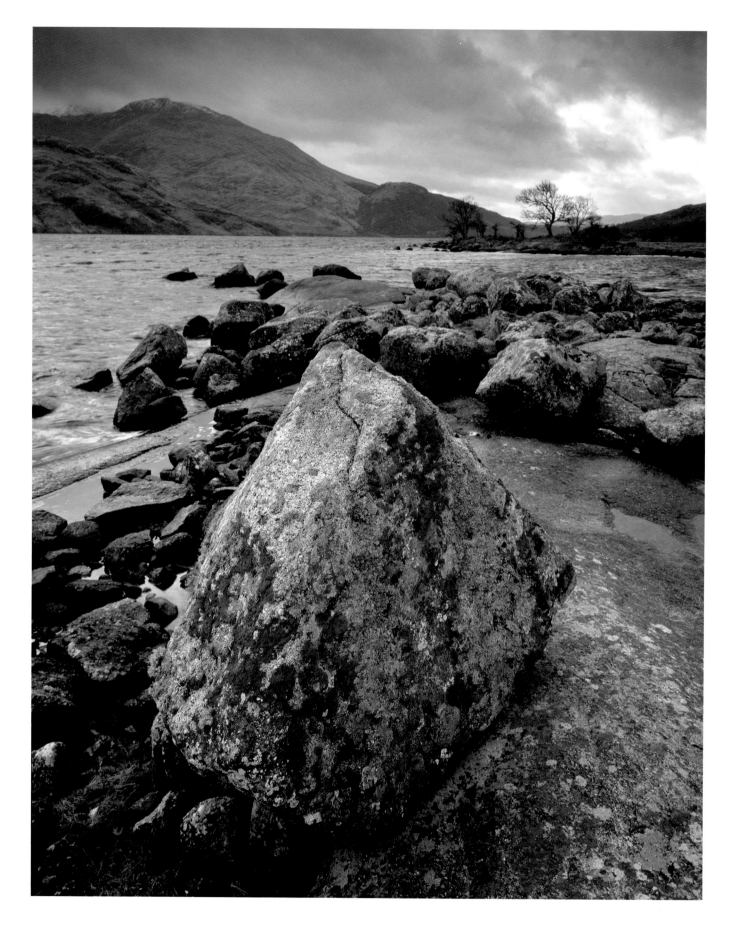

LOCH ETIVE

and Ben Cruachan

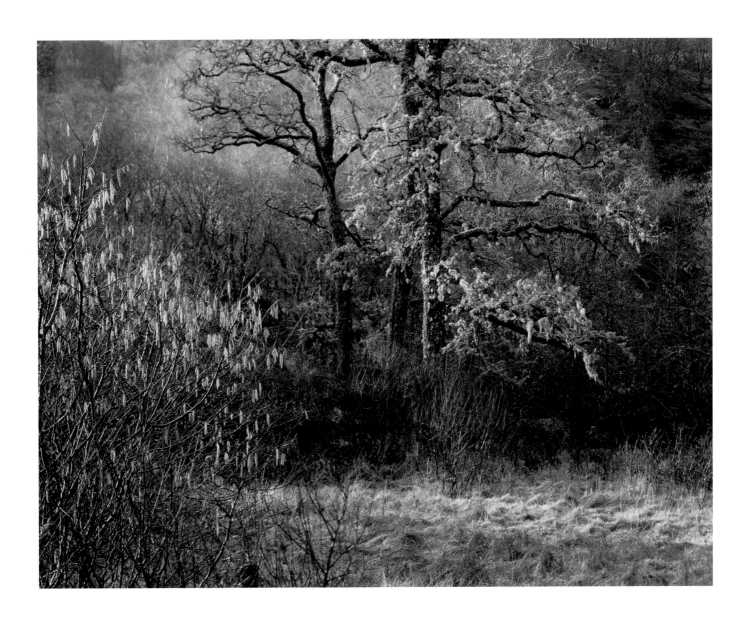

GLEN NANT
Spring

32

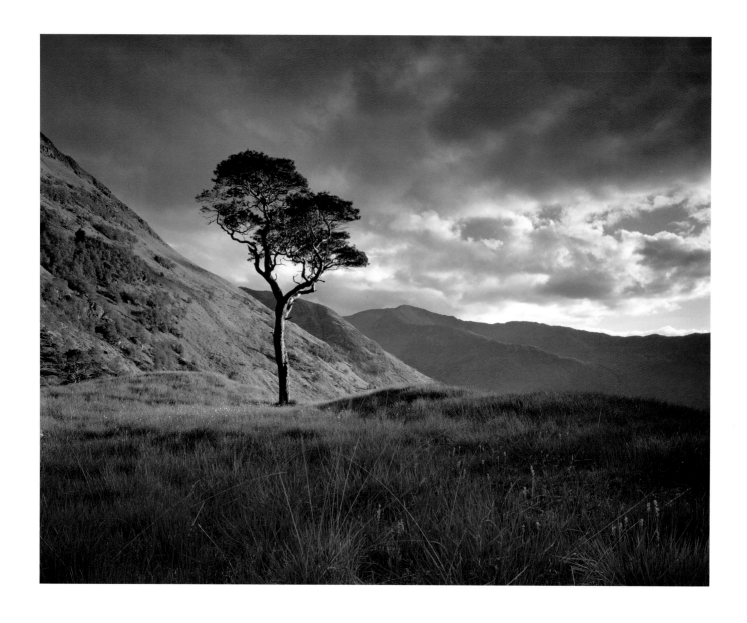

GLEN NEVIS

Caledonian pine and the shadow of Ben Nevis

GLEN ORCHY

River bank

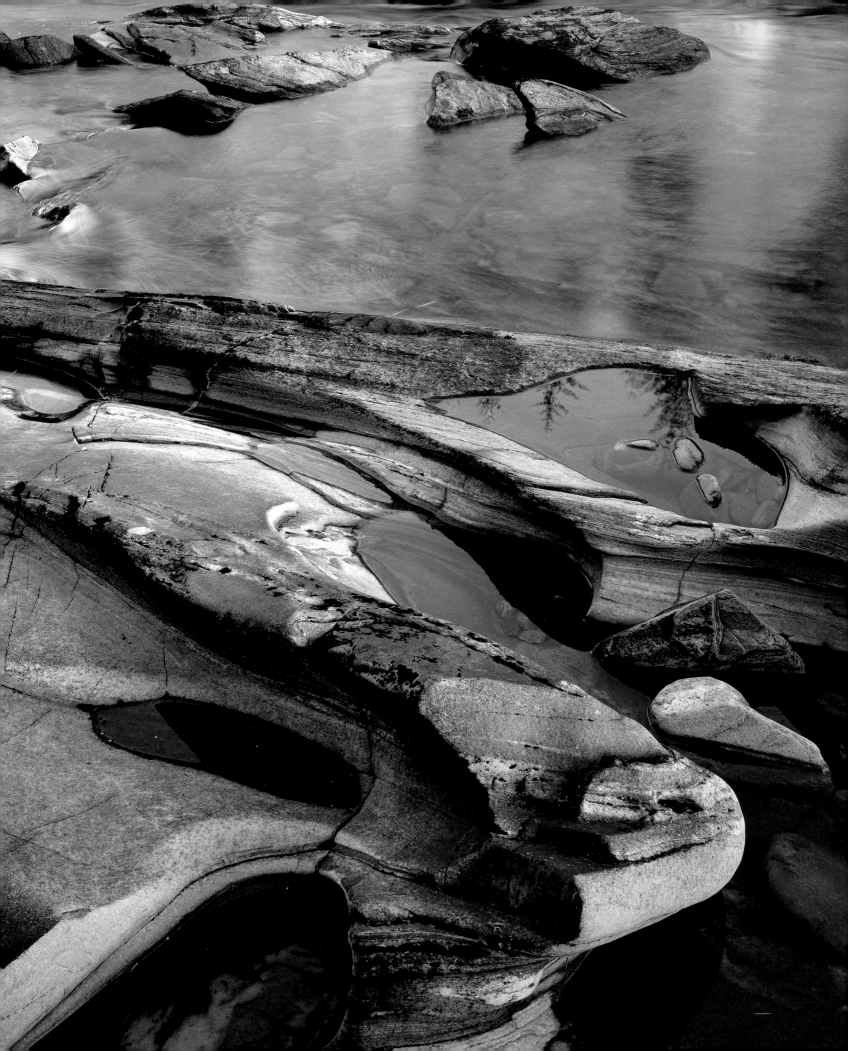

34

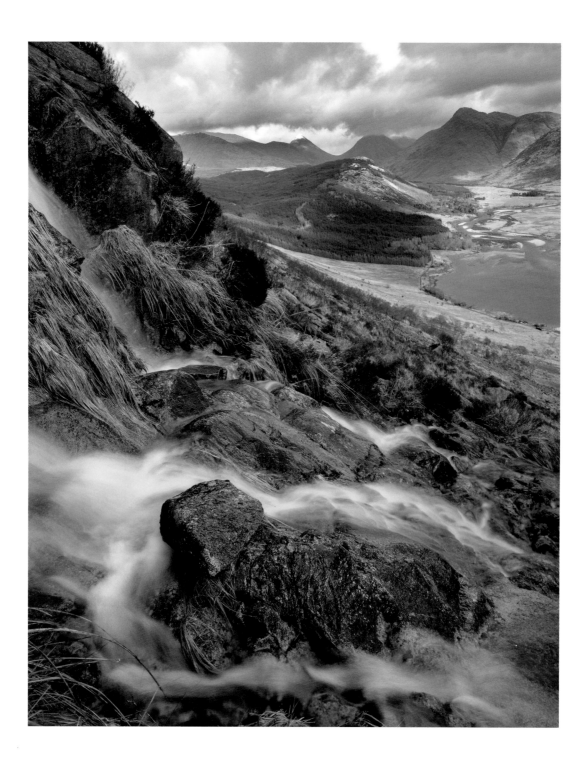

BEINN TRILLEACHAN
View of Glen Etive from the Slabs

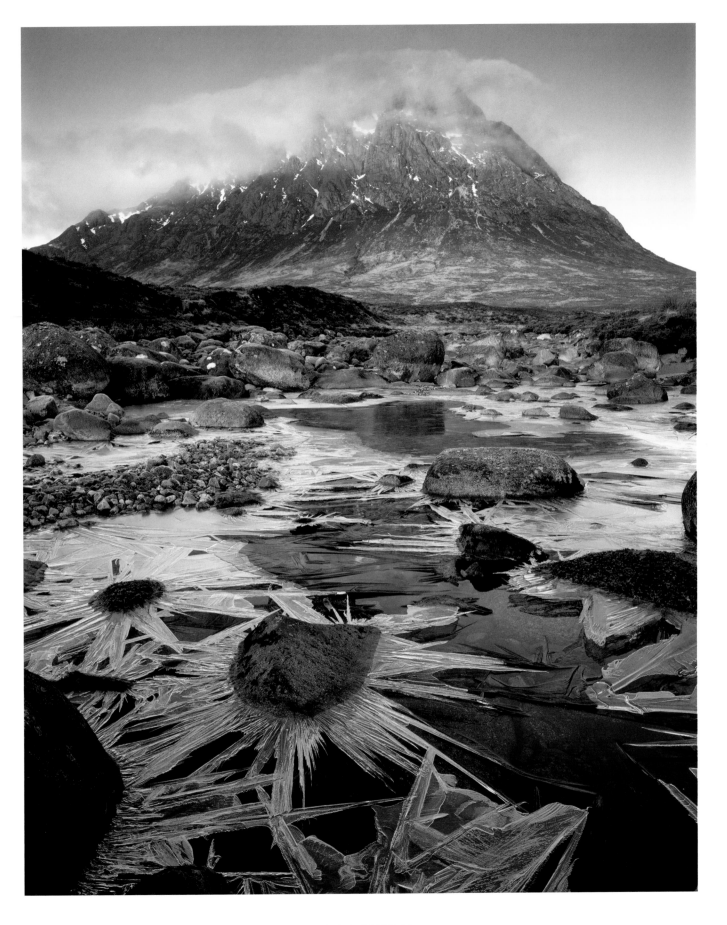

RIVER COUPALL

Buachaille Etive Mòr

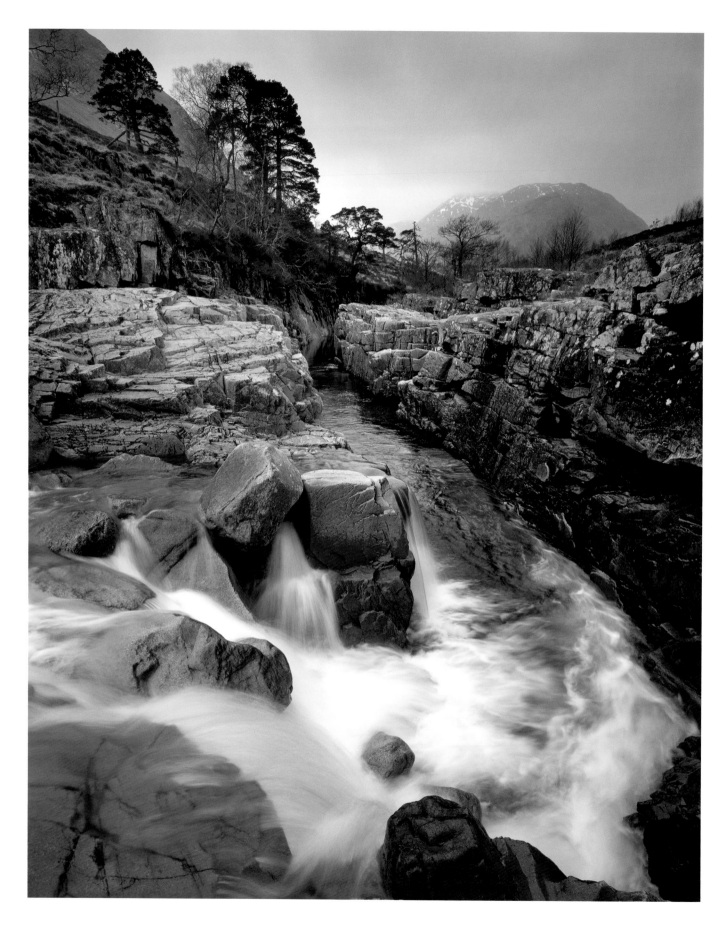

GLEN ETIVE

Gorge

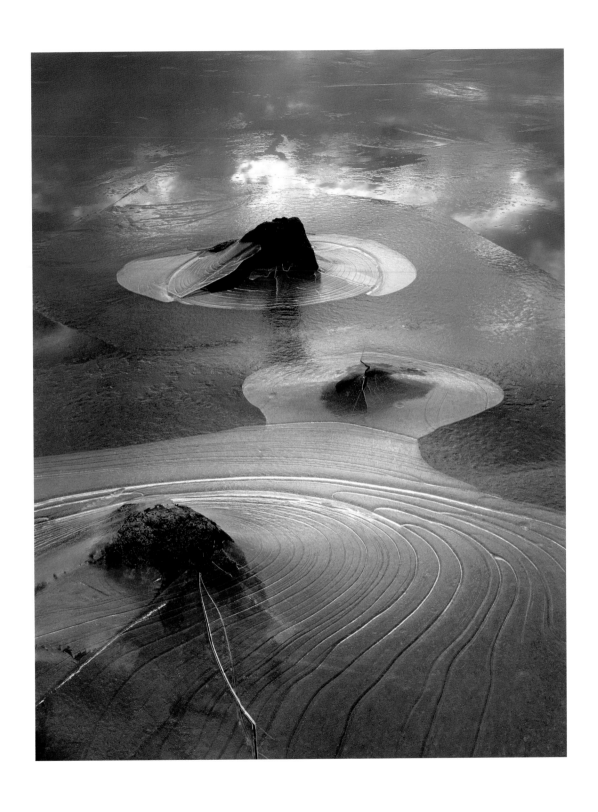

LOCHAN NA STAINGE

Ice contours

38

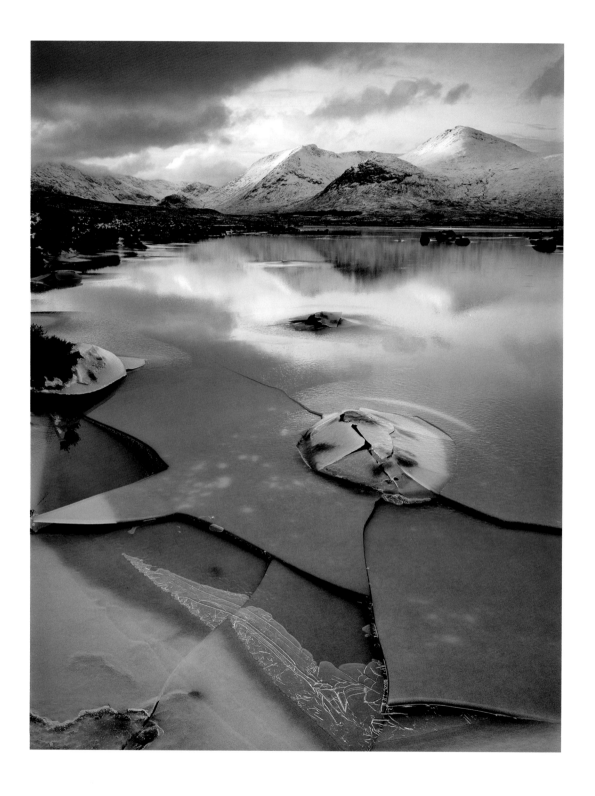

LOCHAN NA STAINGE

Clach Leathad, Meall a' Bhùiridh beyond

STOB NA DOIRE

Snow wave

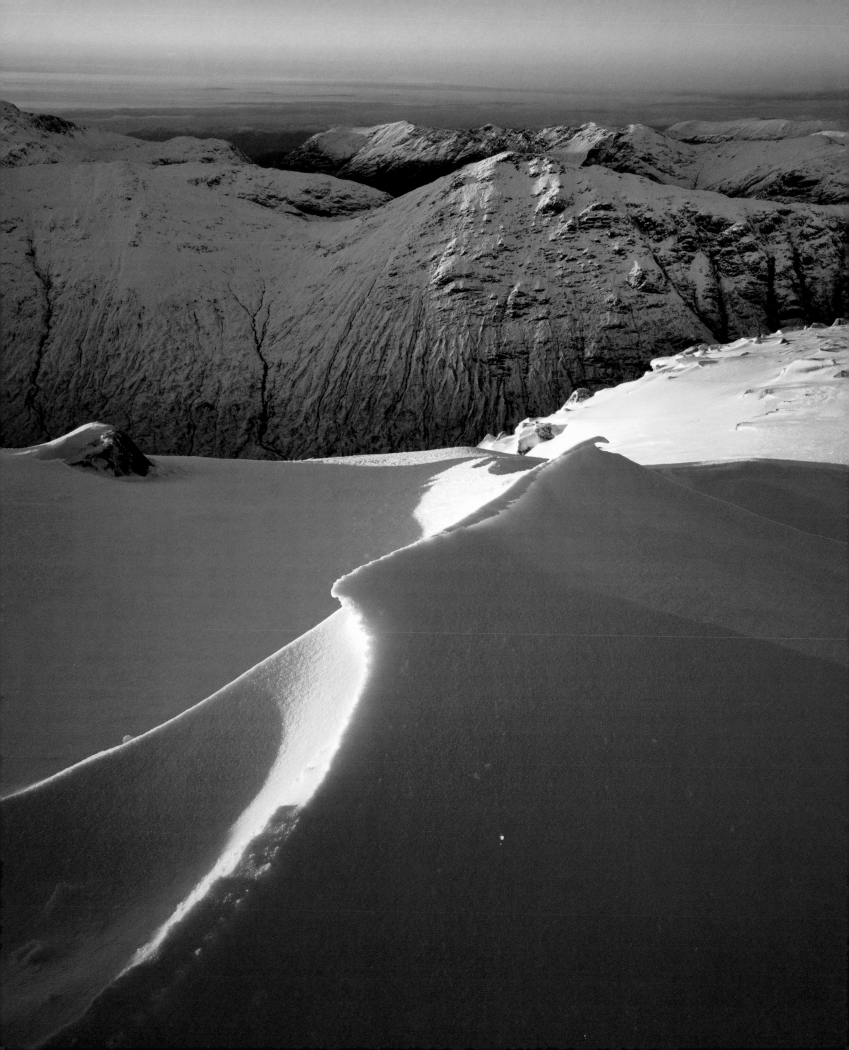

ISLANDS AND WESTERN APPROACHES

The southernmost significant mountains in Scotland are found on the beautiful island of Arran, lying in the Firth of Clyde. Most of the Inner Hebridean archipelago boasts rugged landscapes, from the curvaceous Paps of Jura and Ben More on Mull to the electrifying ridges and peaks of the Cuillin of Rum, which is but the gentler sister of the brutal Cuillin of Skye just to the north. Skye is regarded by many as the apex of Scottish mountaineering, the legendary Black Cuillin being the least forgiving and most extreme range in the British Isles. The island is also home to the Trotternish Ridge, a unique landscape of collapsed ancient lava flows whose features make it a landscape photographer's paradise. The mountains of the western Mainland include the Glen Shiel and Kintail ranges, and the remote areas of Moidart and Knoydart.

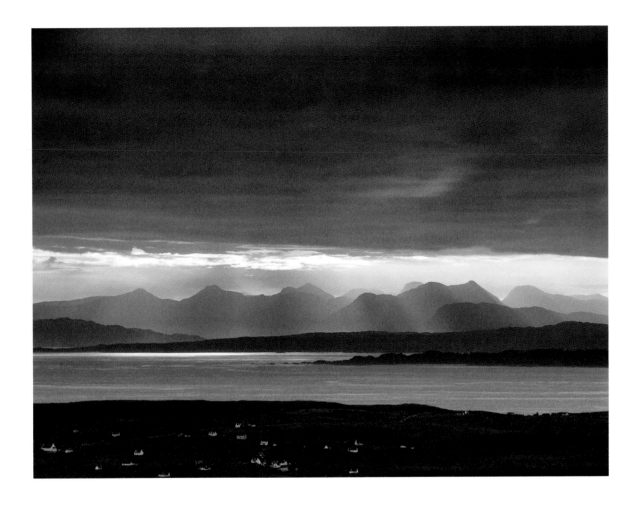

TORRIDON MOUNTAINS
from the Quiraing, Skye

TROTTERNISH | High points in the long Trotternish Ridge of Skye, the Storr and the Quiraing are not really mountains in the obvious sense. Their gentle western slopes may seem tame, but the severe eastern flanks of cliffs, towers, pinnacles, gullies and steep knolls are entirely mountainous in character. These remarkable landscapes are the result of landslips, where layers of lava from ancient volcanoes have collapsed and slumped away from the main ridge.

Access to the Old Man of Storr and onto the ridge of the Storr itself is really very straightforward, though that is not to underestimate the exposure on the ridge itself, which is certainly severe. While a vigorous ascent walk (perhaps 300 metres) is required to reach the Old Man, the Quiraing is an easy stroll in from the road that passes over a saddle between Staffin and Uig. This easiness makes it immensely attractive to visitors; its paths are well-trodden, and its views popular and much photographed. Both these Trotternish miniature mountains, the Storr and the Quiraing, are so spectacular that it is hard not to associate them with imagined landscapes from fiction such as Middle Earth (*Lord of the Rings*), or Narnia. They make a wonderful walking and photographic opportunity for anyone who might find climbing onto higher mountains a little intimidating.

The Sanctuary at the Storr is well-named; a miniature Shangri-La, it is a lost valley, hidden from the world by giant cliffs to the west and a barricade of rock towers to the east. The Old Man, with its adjacent primeval stacks, makes a compelling sight, and the complex hollow of the Sanctuary demands exploration. Sheltered from the westerly gales that frequently lash Skye, it is a shady and damp habitat, favouring slow-growing mosses and lichens. An absence of trees suggest that itinerant sheep and deer also find it a convenient mountain restaurant. The Sanctuary feels timeless, but this is an illusion; its intrinsic instability is evident everywhere in the fresh falls of rock and scree that fringe the daunting cliffs of the Storr itself.

There are several remarkable geological attractions at the Quiraing. One is the Prison, which rises apart from the main cliffs of the ridge, like some geological Tower of Babel. Ascending onto it requires no great skill, and the views and angles it offers north, east and south are breathtaking. The much more secluded Table is harder to find, hidden deep within the recesses of the main cliffs. Visitors must ascend the steep screes guarded by the (aptly named) Needle (opposite) to reach it. As its name would suggest the Table is a flat-topped platform, accessible at one

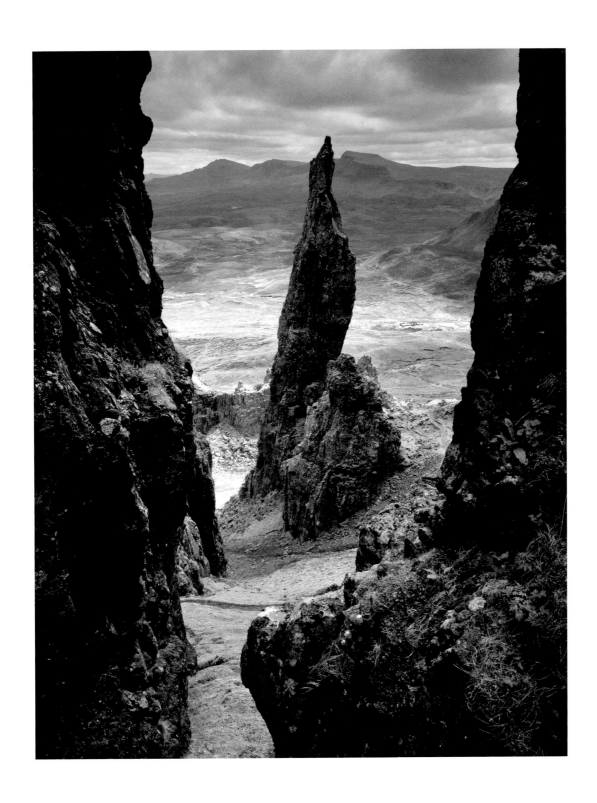

THE NEEDLE

Quiraing, Trotternish Ridge beyond

point only, yet curiously enclosed by the Quiraing itself. Beautifully covered in a soft lawn of wild grasses (occasionally mown by sheep), and virtually impossible to photograph, the atmosphere of the Table has to be experienced to be understood. It is also the feature from which the word Quiraing originates. Loosely translated from the gaelic, Quiraing means either 'pillared enclosure' or 'Frank's enclosure'. If the latter I can't help feeling envious of Frank, although whenever he lost a sheep or cow from the Table I imagine he might well have cursed the rugged steepness of this fabled landscape.

The Trotternish range looks east over almost half of mainland Scotland's western ranges. On a clear day from the Quiraing I have positively identified many of the Assynt hills, including Suilven to the far north. As the eye wanders south, An Teallach frames the northern border of the Great Wilderness. Slioch stands out clearly, then Beinn Eighe and Liathach, The Beinn Damh hills south of Torridon and the Glen Shiel hills beyond that. The most southerly visible major mountain is Ladhar Bheinn in Knoydart. From any Trotternish high point the prospect of mountains beyond the sea is the best grandstand view in Scotland (page 41).

If you could only explore the hills visible from here you would still have adventures for a lifetime.

ARRAN | I first visited Arran in my twenties. Its coastline inspired me at once, and subsequently I have been back many times, on assignment, on holiday, and leading workshops. Arran's exceptional geology, a fascinating cross-section of igneous, sedimentary and metamorphic rock is brilliantly exposed on the coast (page 141), and hammer-wielding geology students are frequently seen here. Brodick, Lamlash and Whiting Bay on Arran's sheltered east coast are a curious blend of palm trees, pretty whitewashed houses, hotels, tourist shops and businesses. There is an air of quiet, almost suburban prosperity, framed by manicured golf courses that is quite different to the rural, rough-hewn crofting life of the Outer Hebrides for example. But on this beautiful island, where 'The Isle of Wight meets the Scottish Highlands', as my friend Richard Childs' memorably described it, its mountainous interior comes as a dazzling surprise.

Driving west from Brodick to Machrie and Blackwaterfoot, the high pass of the road gives tantalising views of a different, distant landscape. The northern skyline

bristles with sharp rocks and shapely summits, but they remain a long way away, across a bleak prospect of trackless moorland. There must be a better way to reach these tops.

Accompanied by Richard and fellow landscape photographer Ted Leeming, we chose the route from North Glen Sannox leading to the most northerly and second highest of Arran's mountains, Caisteal Abhail. This peak is covered in granite tors eroded into giant blocks. The perfection of these tors makes them seem the work of some mythic giant architect or sculptor, rather than the random consequences of natural erosion. Not that I am questioning the certainties of geology and arguing for the hand of a divine Creator at work here. Rather, I stand in wonder at the astounding and fertile originality of rock as a creative force, when left to the sculptural mercy of ice, rain, sun, wind etc., and a suitably long period of time. I suppose the photographic pursuit does give me an art-focused view, but in this place especially I had the surreal sense that I was in a giant outdoor art gallery. We arrived at the summit mid afternoon, knowing we had plenty of daylight left for the evening's photography. Exploring the top of Caisteal Abhail took hours, however, so there was little time for the rest that is always a bonus after climbing a big hill.

Fantastic views unfold all around, the most scintillating of these being to the south. From here the sharp pyramid of Cir Mhor is the focal point of Arran's range, and like some monumental conductor, its curving knife-edged ridges become arms orchestrating a mountain symphony (page 53). We all agreed that while this might have been our first time on these summits it most certainly would not be the last.

Islands and Western Approaches
Portfolio

EXPLORATION | Curiosity drives creativity (or is it the other way around?). I want to know what lies around the next corner, beyond the far ridge, on top of the summit, below the gorge lip. Part of that is driven by the thought that I might find a more intriguing angle, a more dynamic view, a better composition. But there is also the simple desire just to see what it all looks like, to know it better. Discovering a place for the first time is not always the best moment photographically; but it can be, because the novelty of first encounter brings energy and enthusiasm, and if conditions converge then we may be rewarded. The spirit of exploration remains authentically intact in the Scottish islands, and especially the islands with major hills: Arran, Jura, Rùm, Mull and Skye. The islands and their western Mainland approaches are among the most lightly occupied, remotest places in Britain; the Black Cuillin of Skye and the inner sanctuary of Knoydart encourage an expedition-style approach, for any other encounter will inevitably be distant, or all too fleeting. The surrounding sea, never lapping far from the feet of the mountains, is an ever-present invitation to set sail, to explore, to discover; to continue life's journey.

GLEN ROSA

Arran, cascade

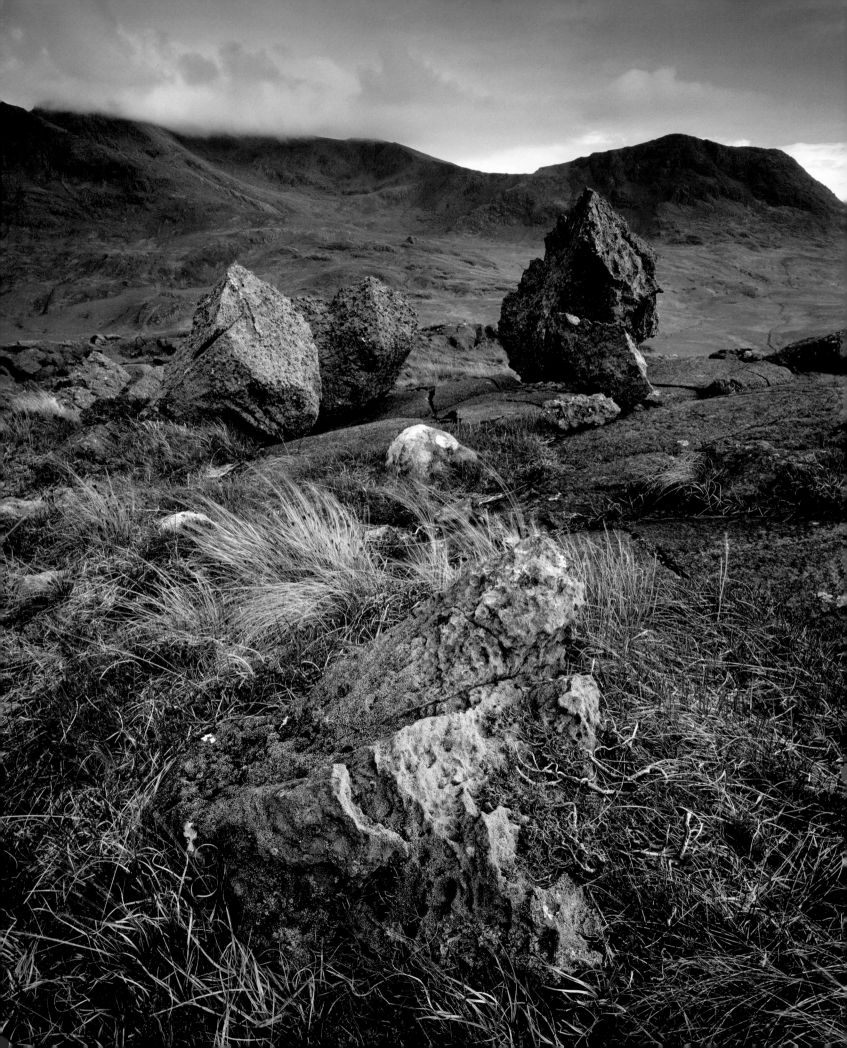

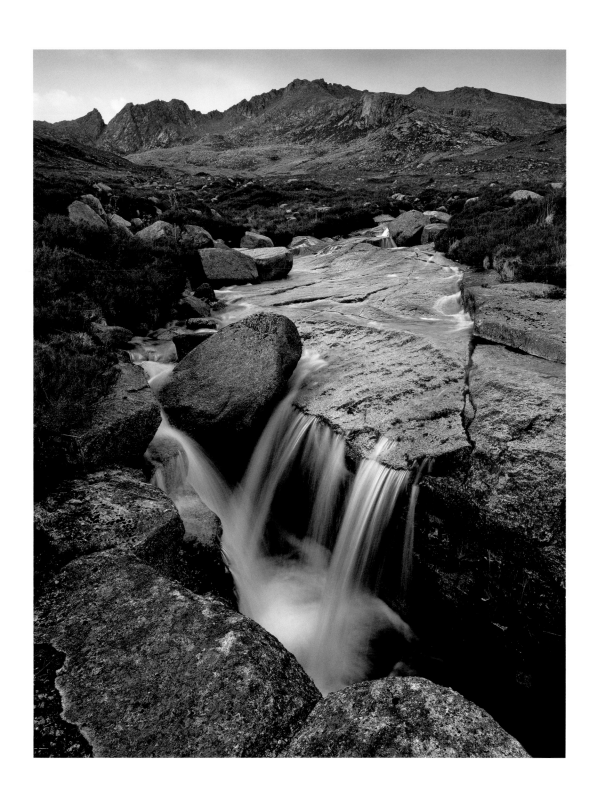

RUINSIVAL

from An Dornabac, Rùm

CAISTEAL ABHAIL

North Sannox burn, Arran

50

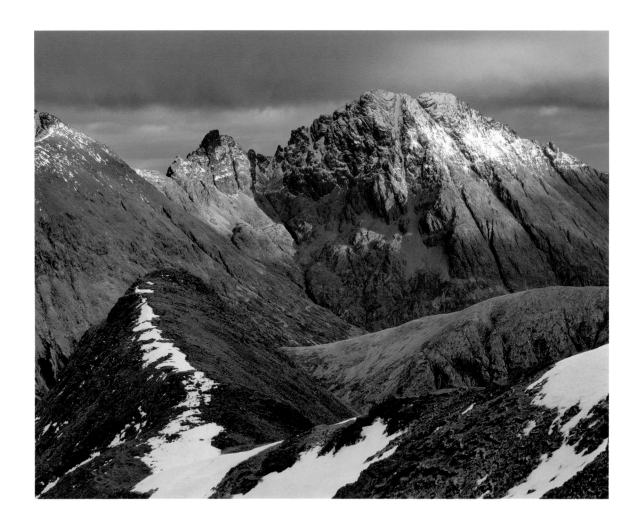

BLÀ BHEINN

from Marsco, Skye

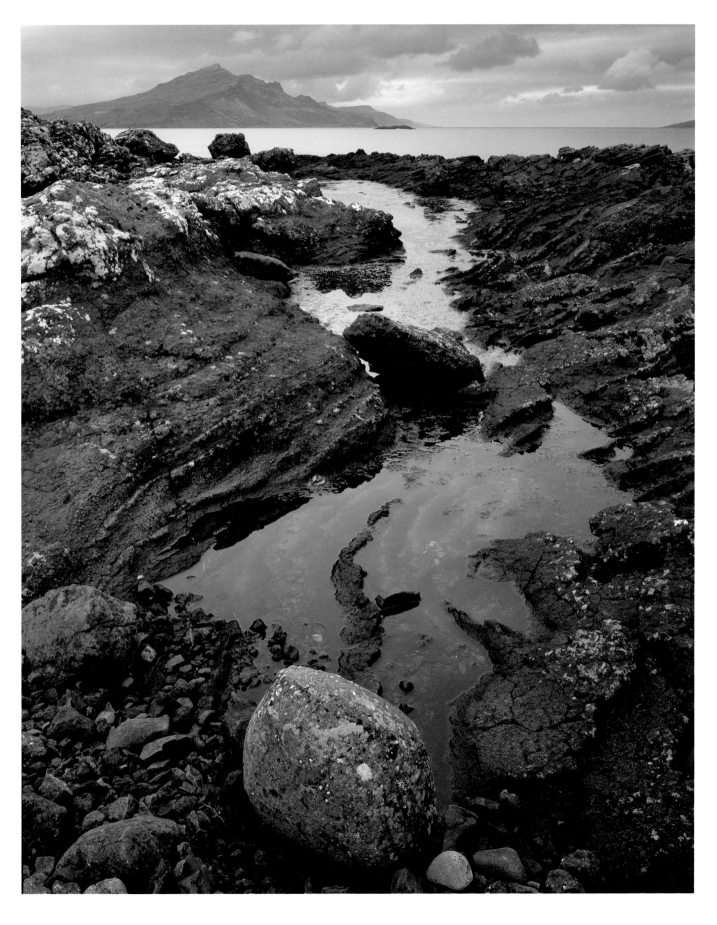

BEN TIANAVAIG

from Balmeanach, Skye

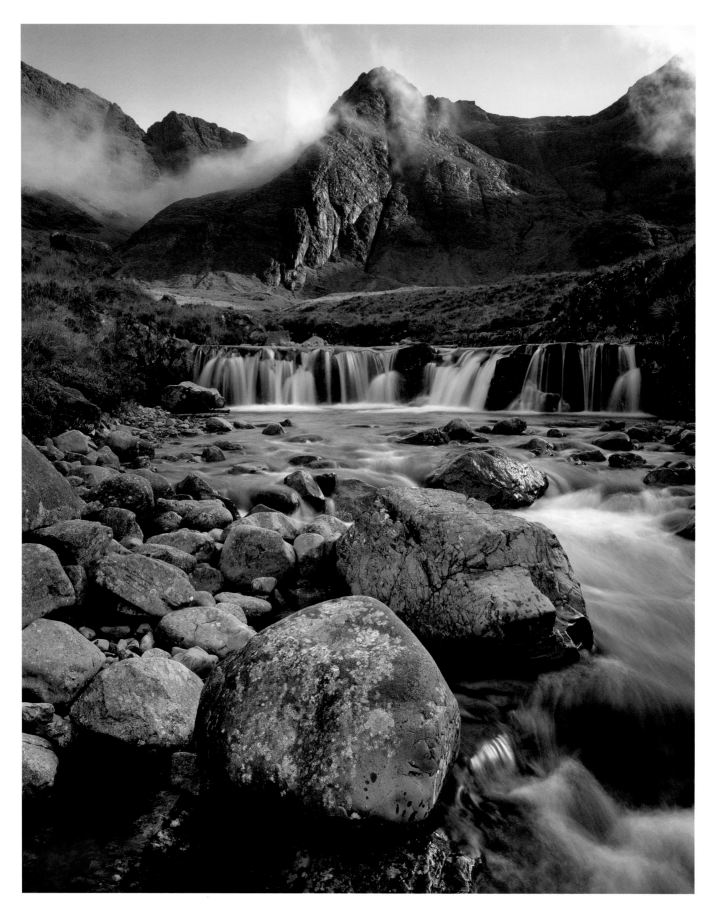

SGÙRR A' FHEADAIN

Allt Coir' a' Mhadaidh, Glen Brittle, Skye

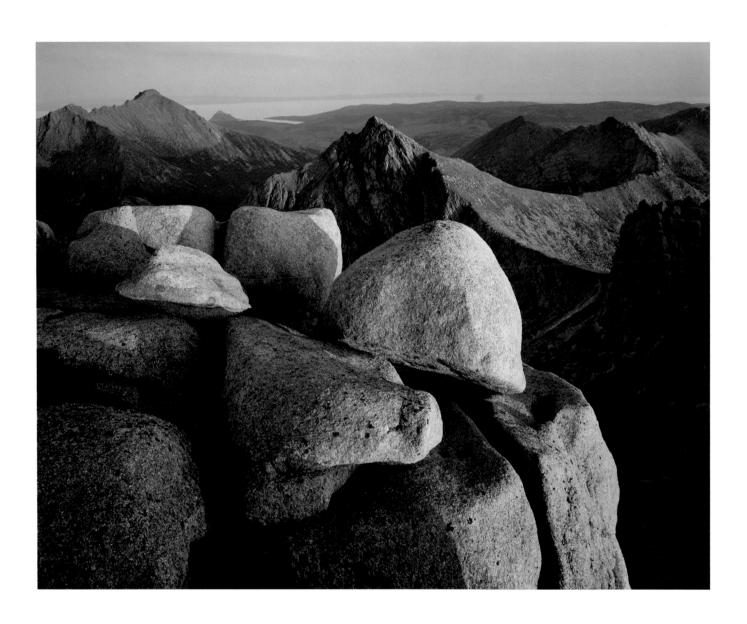

53

GOATFELL AND CÌR MHÒR
from Caisteal Abhail, Arran

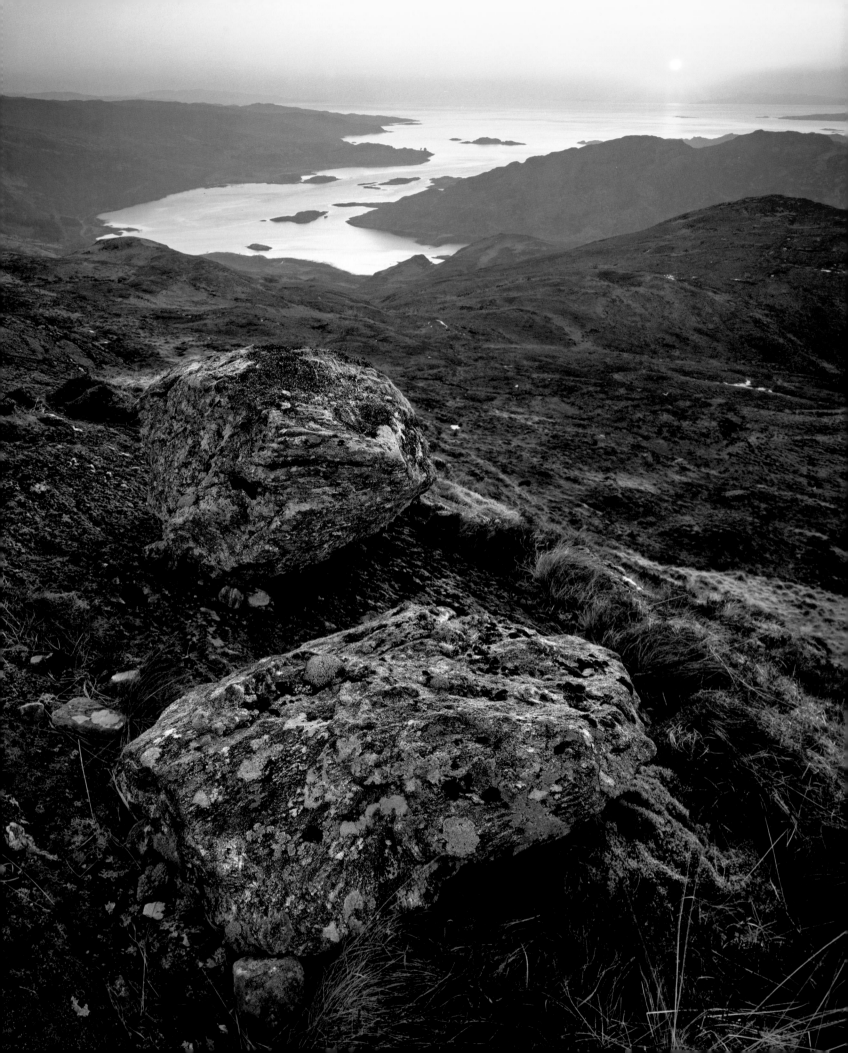

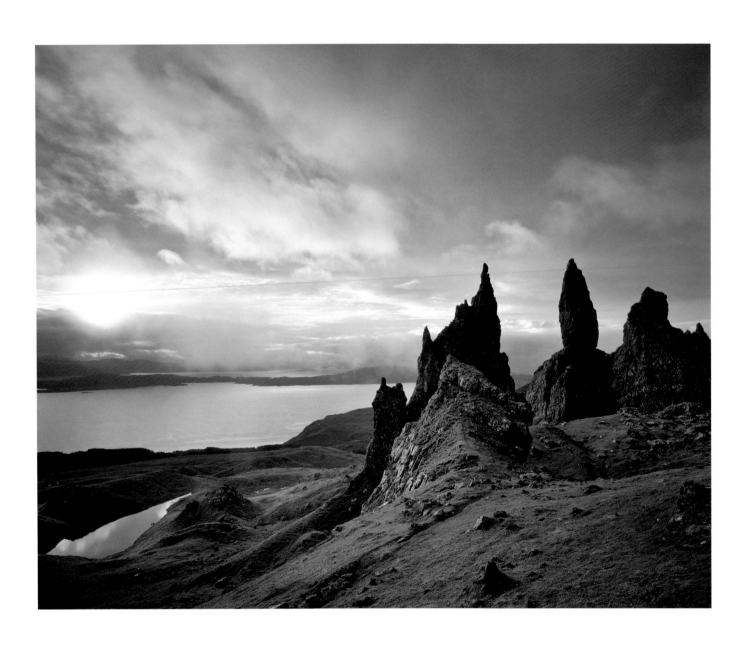

LOCH AILORT

from Sean Cruach, sunset

OLD MAN OF STORR

Skye, sunrise

56

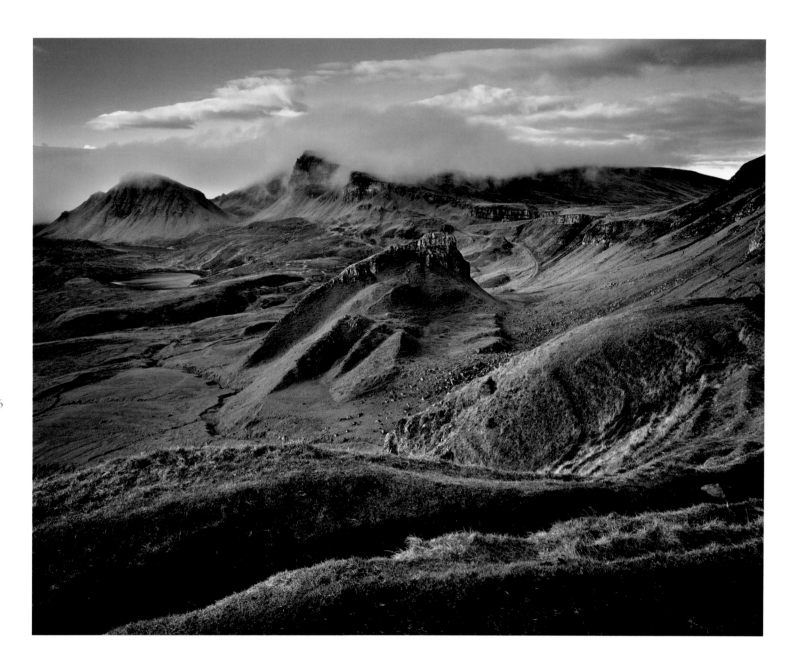

CLEAT, DUN DUBH, AND CNOC A MHÈIRLICH
from the Quiraing, Skye

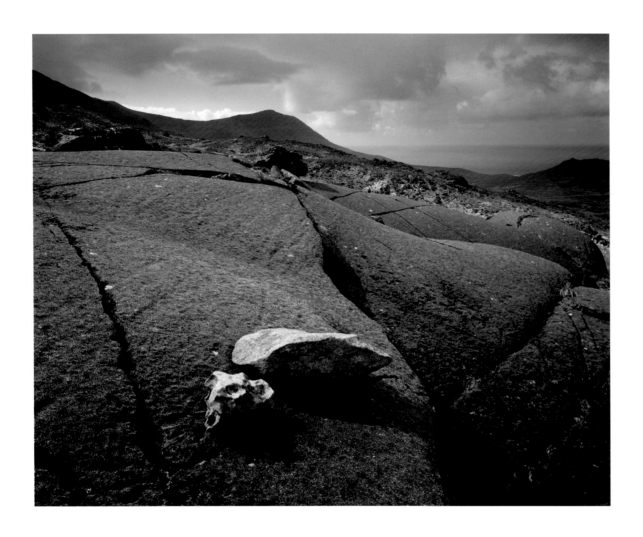

RUINSIVAL
from Barkeval slopes, Rùm

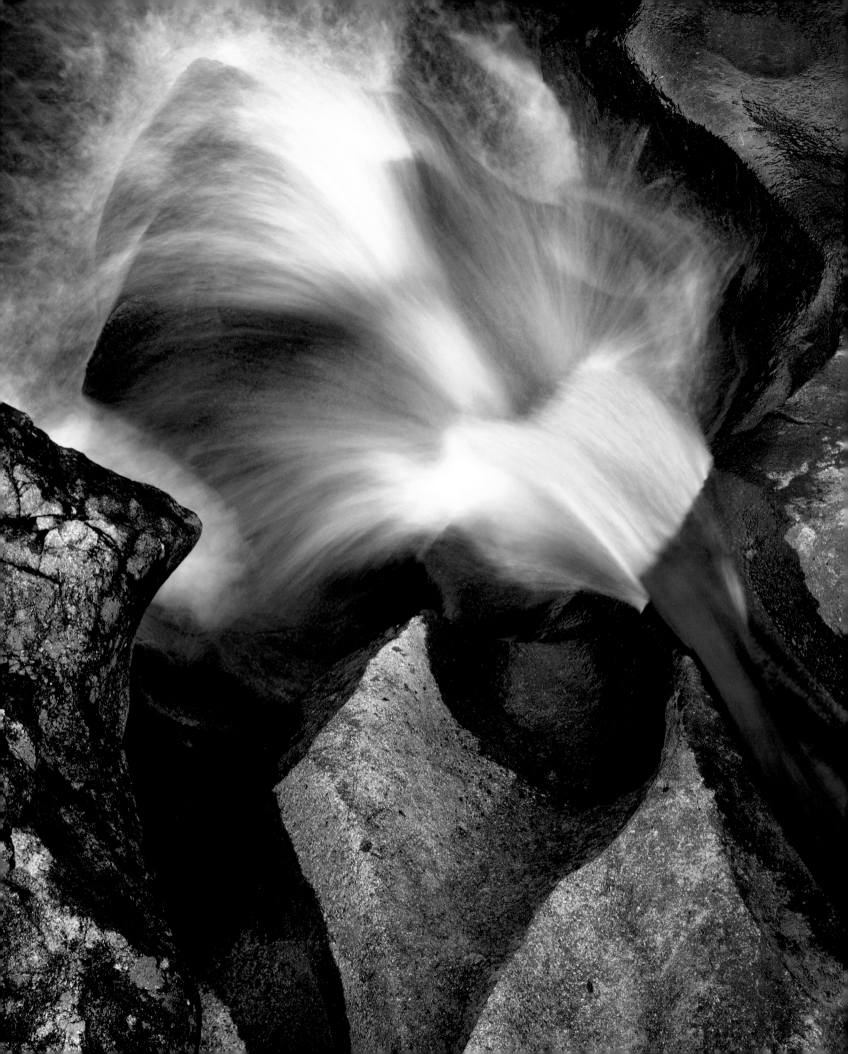

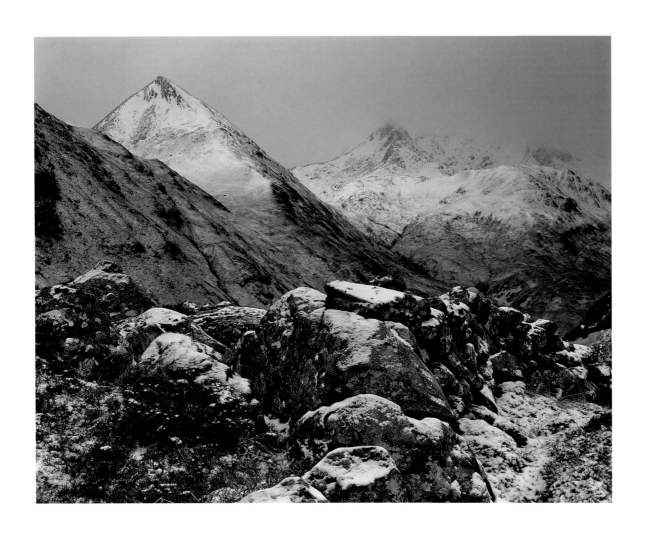

ALLT COIR' A' MHADAIDH

Cascade, Skye

FAOCHAG AND THE SADDLE

from Glen Shiel battle site

60

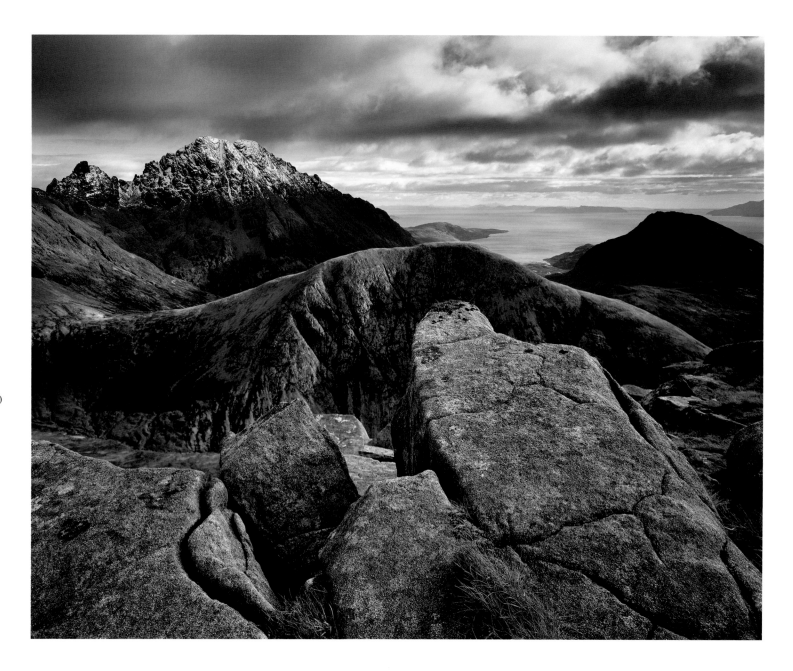

BLÀ BHEINN
from Marsco, Skye

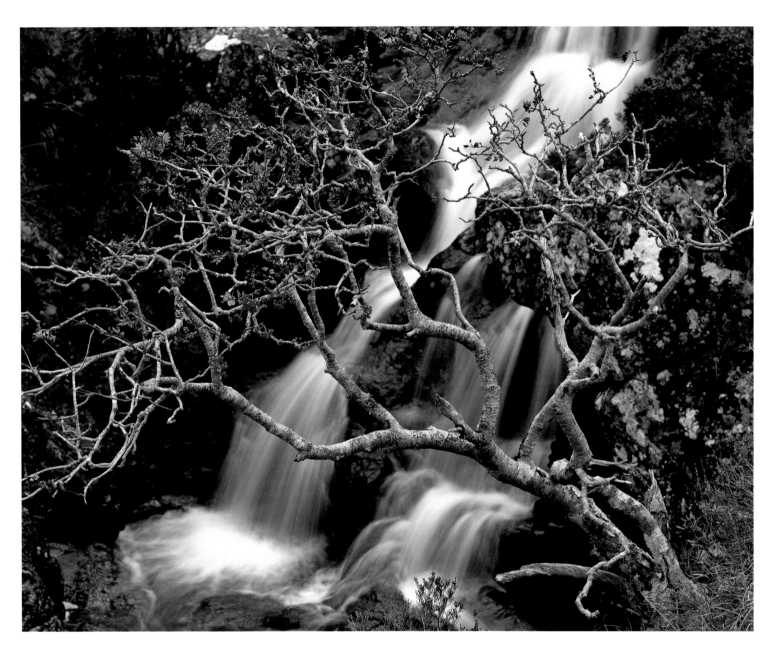

ALLT COIRE NA BANACHDICH
Waterfall, Glen Brittle, Skye

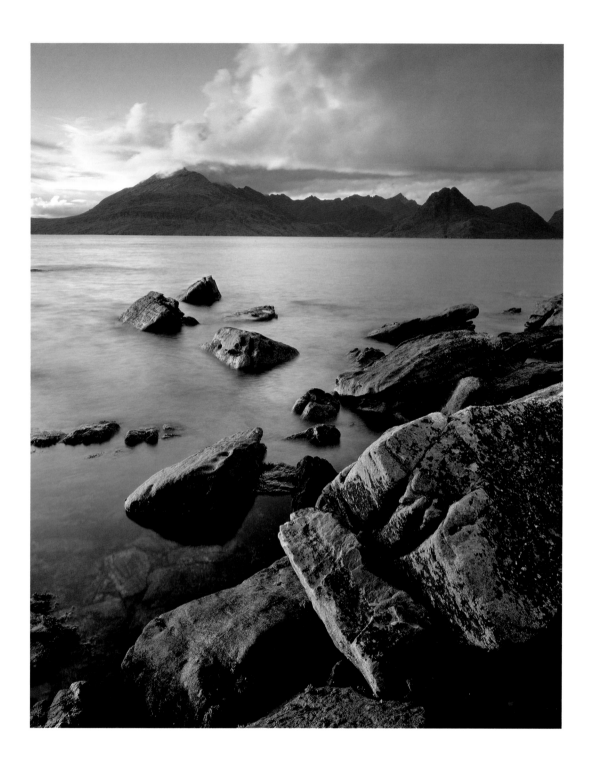

62

GARS-BHEINN, SGÙRR NA STRI

from Elgol, Skye

SGÙRR NAN GILEAN

from Allt Dearg Mòr, Skye

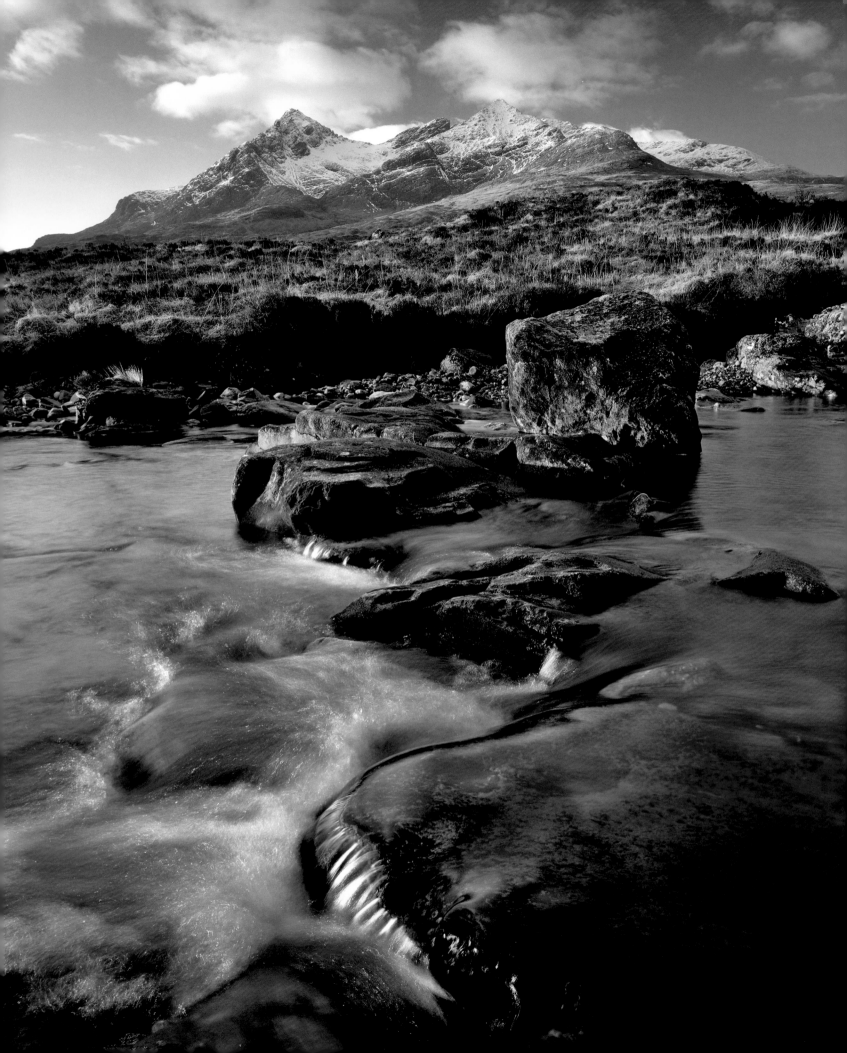

THE CAIRNGORMS

The Cairngorms include most of Scotland's highest mountains apart from Ben Nevis. Ben Macdui, Braeriach and Cairn Toul, Britain's second, third and fourth highest hills respectively, lie clustered together around a glaciated glen called the Lairig Ghru. Yet its summits are less celebrated or recognisable than those further west due to their smooth and rounded appearance, for much of the Cairngorm is a high plateau. Smoothness is a deceptive quality. Comparatively land-locked, the weather here is more extreme than in the hills further west, where the sea moderates temperatures. And on close inspection there is also an abundance of steep cliffs, gorges and rugged features to remind the walker that these are indeed real mountains. Road access is quite limited, and this helps to preserve the comparatively pristine quality of a landscape where remnants of ancient Caledonian forest still stand proud.

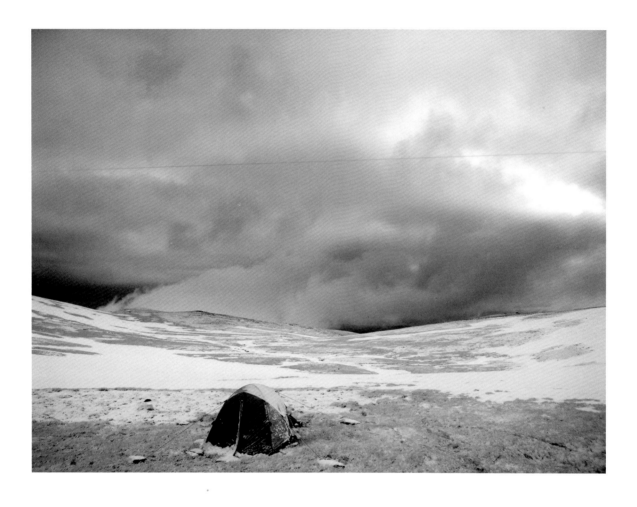

LOCHAN BUIDHE

Cairngorm plateau, 3712 feet above sea level

LAIRIG GHRU | Deep down I was dreading it. Early January, this was the depths of winter. But it seemed as good a time as any for a first visit to Braemar to explore the Cairngorms, the highest mountains in the British Isles (Ben Nevis apart). The fact is, I doubted there would be a good time to photograph these burly flat-topped hills. But some map-reading and a study of Colin Baxter's aerial photographs convinced me that one minor summit, the Devil's Point, might inspire.

Mild, wet and windy weather blew me north up the A1 and A9, but by the time I arrived at Spittal of Glen Shee the air was freezing, it was night, and what little I could see of the hillsides was covered in snow. The road had become utterly deserted. An evacuation appeared to have taken place in preparation for impending catastrophe. Scots are hardly intimidated by the weather, so what could it be? Nuclear attack? Volcanic eruption? The wrong kind of snow? The road became increasingly treacherous as the wrong kind of snowflakes increased in ferocity, and the road kept climbing higher and higher. But with its nose scrambling nervously in the accumulating slush my van managed to squeeze over the Cairnwell pass. The locals had had the good sense to stay indoors. I arrived shaken, stirred, relieved and very late at Braemar.

High winds and driving sleet greeted me in the morning, and Richard Childs, who was due to join me, called to say he was stuck at Glen Shee, the road now closed by snow. Richard's second mobile phone call was to say that the police had no idea when the road would re-open; he had little choice but to head home to Oban. Braemar was effectively cut off. I would be exploring this snowy landscape on my own.

Any route in to the Devil's Point and the Lairig Ghru, that deep glaciated glen that divides the highest summits in the Cairngorm range, is a long walk. There are no roads, and now the paths would be largely snow-covered. By way of acclimatisation with this slightly daunting prospect I decided not to be too ambitious too soon. That afternoon I parked at the Linn of Dee and set off up Glen Lui with just a handheld pocket digicam, to explore. The high wind and sleet did start to abate around 3pm, leaving a startling combination of wind-driven snow coating majestic trees, and dramatic light.

To make progress in this terrain, through many miles of snow, I felt I should be better equipped. Based on an earlier experience with them in the Pyrenees, snow

66

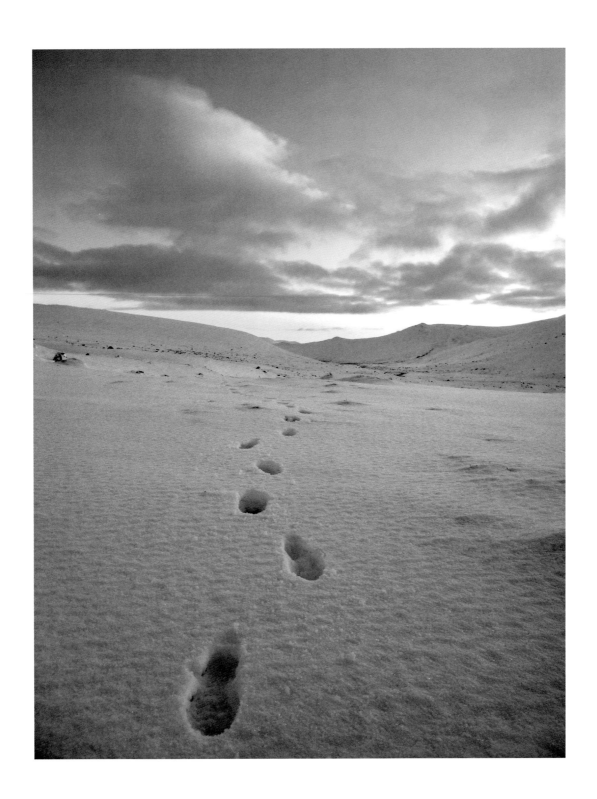

GLEN DEE

Looking back on the walk to the Lairig Ghru

shoes seemed a good idea. Braemar had a small but excellent mountain sports shop, which would still be open.

But back in Braemar the shop regretted they had sold out of snow shoes. The alternative was cross-country skis, bindings and suitable boots; I was unconvinced that would work with a 20kg pack on my back, and several hundred pounds was too big an investment for something that I could not test in the field. Instead, I bought an £8.99 plastic sled and some bungee cord on which I planned to save my back by pulling the camera bag (on the sled) for at least some of the long walk in. In my van that evening I skewered holes into the sides of the sled before lacing the bungee cord through them, knowing very well a sled drag would be no walk in the park. The elasticated cord would hold my bag in place. After a brief pasta meal I was tucked up in my sleeping bag by 9.30pm.

The following day's forecast was positive. Rising in the dark, at 6.20am, I set off in hopeful mood, back into the snowy glen. My goal was the Corrour bothy beneath the Devil's Point, and my plan was to stay there overnight. As time wore on the darkness of night slowly lifted to the gloominess of an overcast day. Light but persistent snow began to fall. My sled and bungee cord rig worked, up to a point. But about three miles in, as the going got rougher I decided to abandon the sled and continue the journey with pack on back. The sled fitted neatly under a fallen tree, and I resolved to collect it on return. I pressed on, optimistic that a clearance was inevitable, based on the forecaster's prediction.

However, they were not (it seems) forecasting the microclimate of Glen Lui. The mountaintops were invisible through the low cloud, and if anything the weather was worsening. Snow-plastered trees provided me with a welcome intermission (page 81) but that was not what I had walked so far to photograph. I continued, more and more slowly as the snow settled, the going ever harder. A point came on the slopes of Glen Luibeg when I realised that even if I did get to the Lairig Ghru, I would have little chance of seeing much of the landscape. In spite of the now deep snow I broke through into damp bog on a couple of occasions. Oh for snow shoes! My feet were soaking, and so was my camera gear. The prospect of being lost as the darkness closed in held little appeal. I made another photograph of a snow-covered log in the almost depthless whiteness, and realized I was getting cold. My survival instincts anchored me. I decided to turn back.

As if by a trick of the light, two figures materialised through the falling snow and joined me for the walk out. Paul and Tom had occupied the Corrour bothy the preceding two nights; their descriptions and advice proved helpful and reassuring for future reference. They stopped at another bothy on the exit route, so I was alone again approaching the Linn of Dee towards dusk. The sky finally began to clear, and a sublime sunset ridiculed my efforts. Now I was in completely the wrong place at absolutely the right moment. Now I should be photographing the Devil's Point!

I had walked ten miles for two bleak close-ups. A sense of futility and desolation was hard to avoid. Yet I was safe, and though wet, I had learned more about the territory. It was no time to be defeatist.

That evening I took the luxury option (after two nights in my van) of a room in a guest house. A warming supper at the only open pub in Braemar, and the complicated task of drying out the entire contents of my camera bag kept me entertained that evening.

The TV weather forecast was promising; in spite of the previous days' experiences (and with little choice) I remained childishly hopeful. A high pressure window would provide light winds and clear skies for around 36 hours before all going downhill again, declared the forecasters confidently…

It was now or never.

After a welcome cooked breakfast I set off a third time from the Linn of Dee, this time taking the Glen Dee approach route. The weather was indeed fine, and the first hour's walk was straightforward, a snow packed Land Rover track. The second hour was across more challenging territory with deeper snow, and my pace slowed, but on the whole conditions were good. Finally, after three hours my objective appeared.

The Lairig Ghru is a stupendous ice-carved pass through the mountains, and defending its southerly approach is the Devil's Point, like Cerberus at the gates to Hades. What Buachaille Etive Mòr is to Glen Coe, so the Devil's Point is to the Lairig Ghru. Yet now, with deep snow softening its forbidding cliffs, I felt underwhelmed and tired. In theory, the winter wonderland-scape and the River Dee, with its snow-covered boulders, should have been easy, but I struggled (page 86). The previous days' labours and physical exhaustion were getting the better of me.

I ploughed on through increasingly deep and crusty snow. A Chinese proverb says that a journey of a thousand miles begins with a single step; right now a single

step was beginning to feel like a thousand miles. I was vaguely hallucinating about snow shoes, when a couple of cross-country skiers approached in the late afternoon sunlight. We stopped for a brief conversation. They were doing a circuit of Glens Lui, Luibeg and Dee; it was clear that their method of travel was well-chosen. The exhilarating ease of their pace seemed jet-propelled compared to my laboured efforts; it was walking, but not as I knew it. I bid them a safe onward route, but couldn't help resenting their speed, and felt even more weary and frustrated at my lack of photographic success.

Eventually the Corrour bothy appeared, a dark speck in the snowfields. The daylight was dying and I was now managing less than one mile per hour. Breaking trail laden with camera and survival gear was taking me to the brink. As the afterglow became night I reached the bothy, utterly exhausted, with few photographs made in spite of my labours. Before I could allow myself the luxury of relaxation I had one more task to fulfil. Although the darkness made focusing impossible I set up my view camera and tripod a short distance from the bothy, set the lens to f/11, loaded a sheet of film, opened the shutter, then walked indoors.

Coal had been left beside the fire, and a small tea candle by the window. I gave silent thanks to the coal bearers, wondering what sort of selfless heroes had carried in and then not burned the coal. Paul and Tom perhaps? I felt briefly guilty that I could not reciprocate for those following me. With fire and candle lit, I settled into the single roomed space, about the size of a decently large garden shed. It was warm enough, and with a meal inside my sense of humour and optimism returned. A night on my own in this extraordinary place would be unforgettable.

The darkness was profound with a tea candle and occasionally my wind-up head torch the only source of light for miles. An hour later I stepped outside into the polar cold darkness to see the most majestically clear, starry sky I have ever seen in Britain, framed by Scotland's second, third and fourth highest mountains either side of the Lairig Ghru. I closed the shutter of my view camera, and wondered briefly what it had captured during its hour gathering starlight from the night sky (opposite).

And approaching the bothy, I saw not one but four head torches.

The new arrivals spread themselves out, and conversation started to flow. It turned out that the tiny tea candle in the window had been enough to guide them

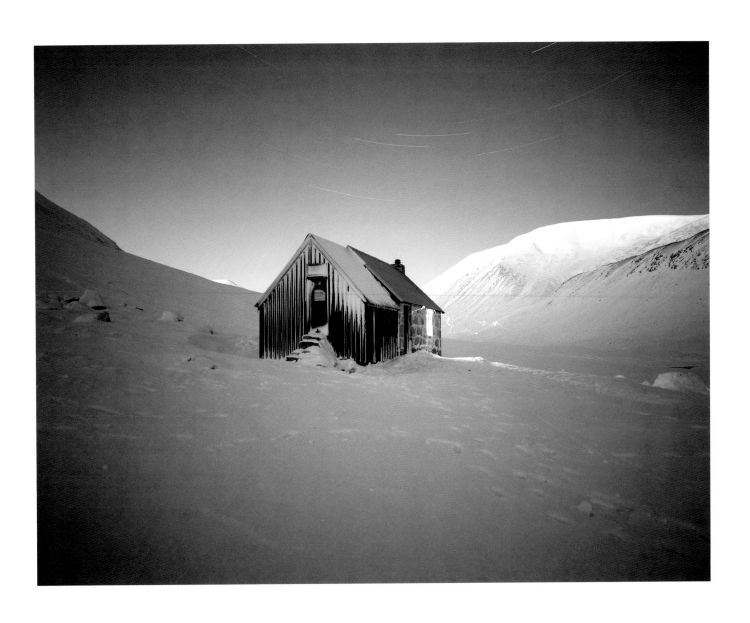

CORROUR BOTHY

Lairig Ghru, starlight

from miles away in the darkness, and although they would doubtless have found the bothy eventually, the candle light had made the task easier.

There was a group of three English mountaineers who, like me, had approached from the Linn of Dee to the southeast. And also a German fellow, arriving coincidentally at the same time, who had walked in alone from the north. Not only is that even further, but when I tried lifting his enormous rucksack I found he was carrying very nearly twice the weight which I had in mine. The mountaineers explained they would be climbing onto Cairn Toul the next day, then walking out again. A brief topic in our conversation was the avalanche risk; given all the recent snow I was concerned for them. It was level three, or, moderate apparently, which they clearly considered inconsequential. While not quite so extremely laden, they too had heavy loads of technical climbing gear, food and survival essentials. If I had thought my own efforts fairly hard core, this encounter put them into perspective.

The following day I rose an hour and a half before dawn, trying hard to avoid stepping on the snoring sleeping-bags spread about the floor. Outside the bothy I boiled water, and added oats by head torch; then kicked over my stove accidentally, spilling most of the porridge onto the snow. I cursed my luck, salvaged what I could and wolfed it down, then set off into the eerie luminance of the snow dark landscape. It occurred to me I had almost no idea of what my fellow bothy dwellers looked like; all we had seen of each other was head-torched silhouettes in the pitch darkness.

The sky was excessively clear for my liking, but there was little wind and having reached a point beside the river Dee with good prospects north and south I started making photographs (page 87). Dark blue turned lighter, and pink mists deep in the Lairig Ghru foretold the rising sun; dawn emerged from the twilight, and eventually golden sunlight lanced across the brilliant snowfields. A mile away I noticed the mountaineers making their departure from Corrour. For three hours I worked in the shadow of the mountains, before the sun finally reached my position. It was now midday. Confident I had something I could use, and conscious of the seven or so miles ahead of me, some of which would (as the day before) be breaking trail through metre-deep snow, I started the return journey.

A small number of possibilities encouraged me to stop and photograph en route, and by the time the setting sun melted into approaching cloud I had run through

72

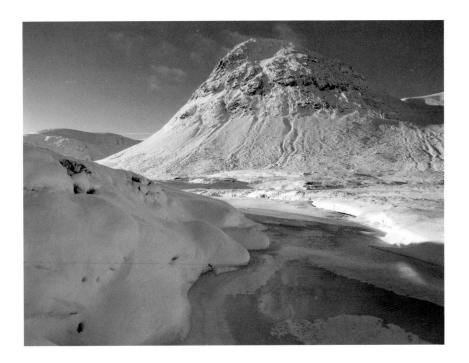

THE DEVIL'S POINT
Snow and sunlight

my small ration of 5x4 inch sheet film. I reached my van, head torch on once again, to find it covered in heavy frost inside and out. Ten minutes ice scraping followed, and when the engine sprung into life the outside temperature on the instrument panel indicated minus 9°C. Having no desire to sleep in a freezer I put the heating dial up to maximum and set off very slowly down the road, which resembled a skating rink. By Braemar the van was warm; by Glen Shee it felt like an oven. The outside temperature was rising too as an Atlantic weather system encroached from the west. I returned the heater dial to its normal position and drove on, hoping to get south of Edinburgh. It started to rain. By Blairgowrie fatigue had begun to overwhelm me.

My economic conscience told me, 'Stop, layby, sleeping bag, now.'

A familiar sign appeared in the distance, and my economic conscience evaporated at the prospect of a comfortable night's sleep. I have never been so grateful for a Travelodge.

The Cairngorms

Portfolio

TRANSFORMATION | I admit that before getting to know the Cairngorms I harboured preconceptions about them, not all flattering. Distant glimpses from the road, and overviews from adjacent ranges had told me these were dull hills, flat or round-topped, that would be photographically difficult. Their prodigious height made them an essential component of this book, but my first visit was made with a feeling that this would be, photographically, an uphill struggle. I had uphill struggles, but they were more physical than aesthetic; my expectation of scenic tedium proved utterly unfounded. Summer and autumn walks revealed colour, detail and beauty I had not anticipated, and in winter the landscape was majestically transformed by snow and ice. My attitude, too, was subjected to its own transformation. It was in the Cairngorms, beside the wintery fringes of the Fèith Buidhe (page 79) especially, where I really learned the importance of keeping mind and heart open to whatever I would find in a landscape. Without the benefit of fine weather or conventionally photogenic lighting, I discovered subtle beauty in the windswept plateau, crystallized in jewel-like structures of ice. Moulded by aeons of glaciation, scoured by winter snows, battered by storms, and blessed by the profusion of robust plants, trees, and animals that make it home, the Cairngorms' seasonal extremes transformed my understanding of what Scotland's mountains are really like.

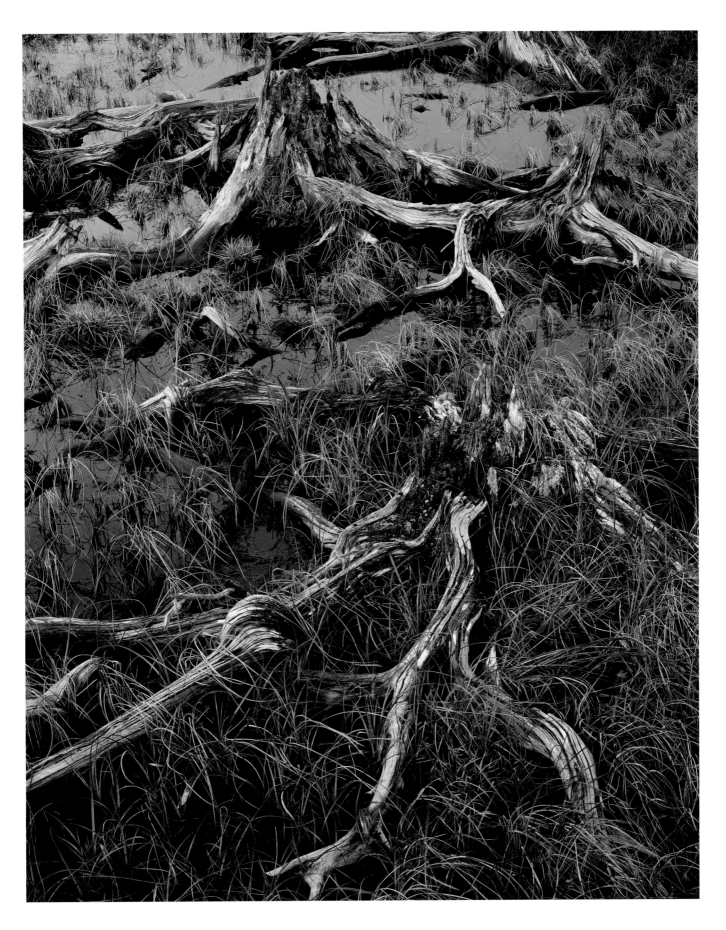

LOCH A' GHARBH-CHOIRE

Drowned tree stumps

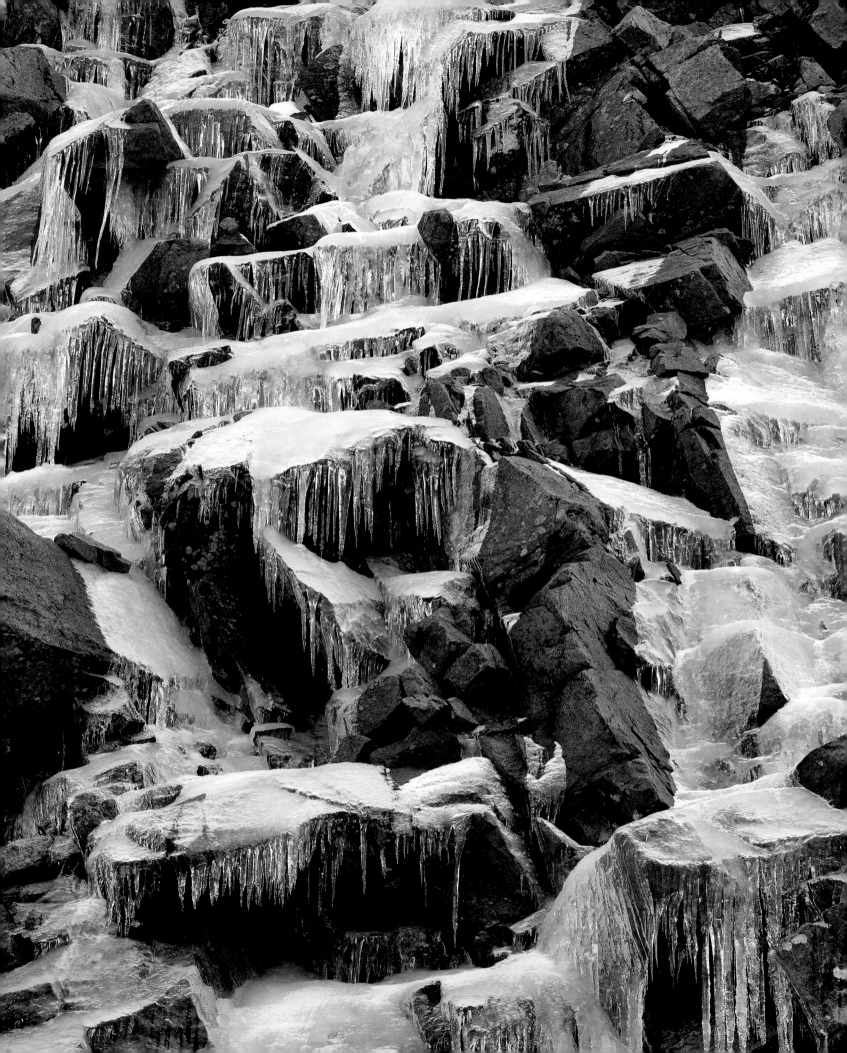

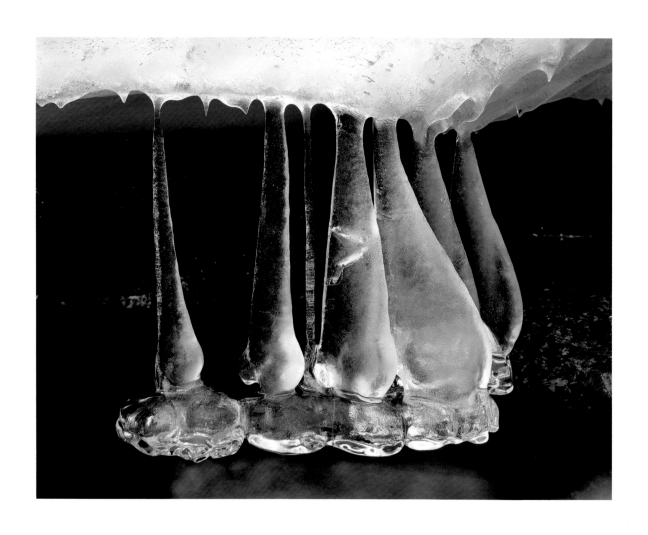

STACAN DUBHA

Icicle cascade

COIRE AN LOCHAIN

Pendulum icicles

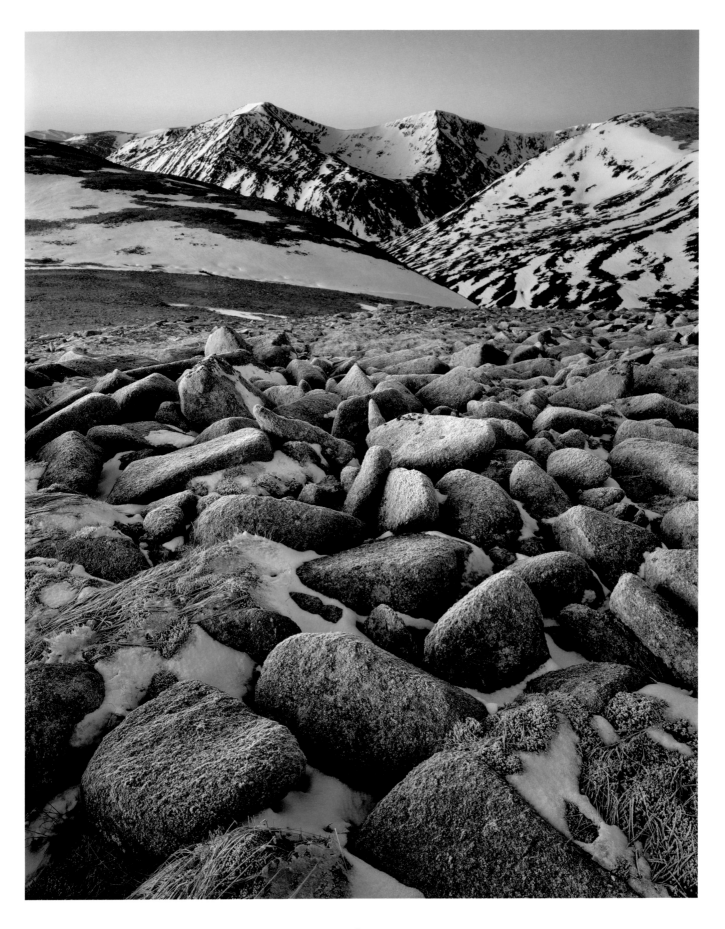

CAIRN TOUL AND SGÒR AN LOCHAIN UAINE

from Cairn Lochan

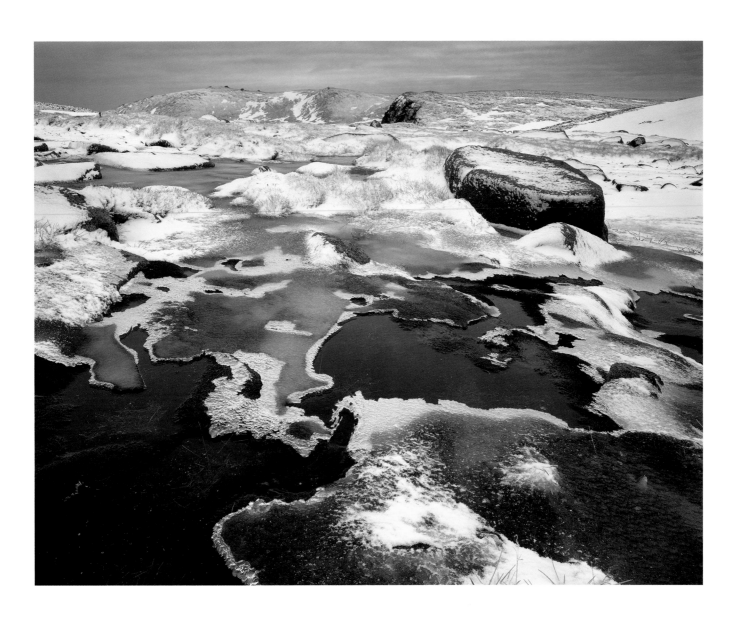

FÈITH BUIDHE

Beinn Mheadhoin beyond

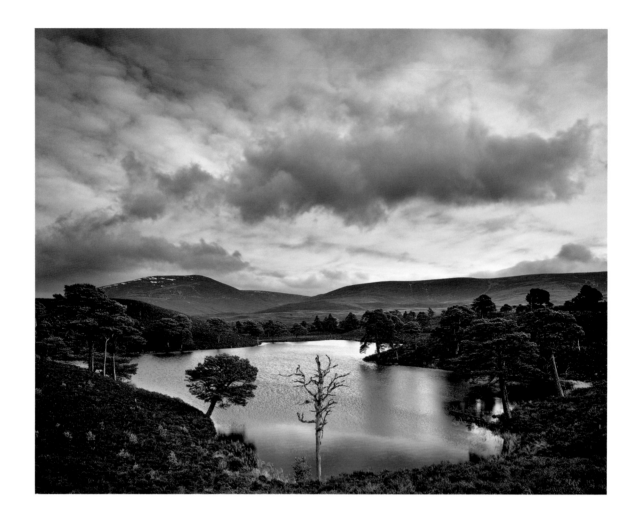

LOWER STRATH NETHY
Unnamed lochan

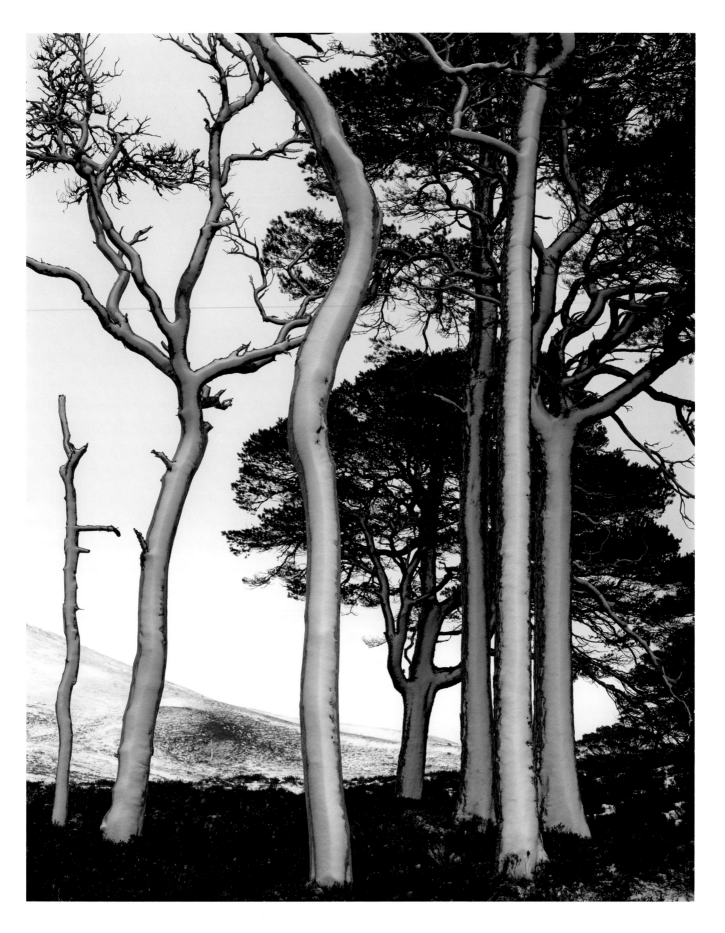

GLEN LUIBEG

Snow-clad pines

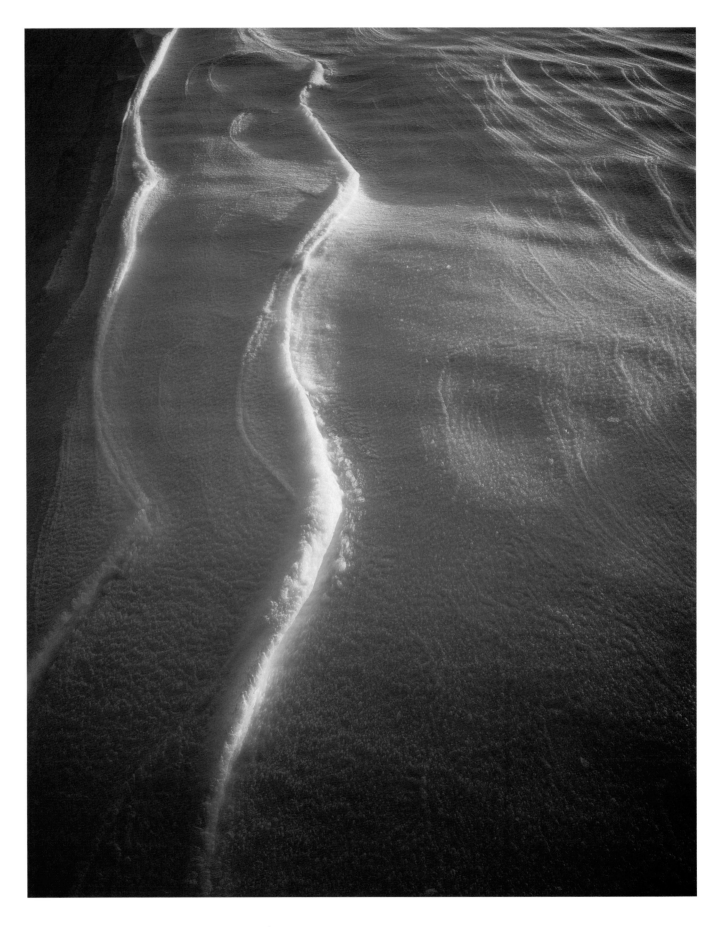

BRÀIGH COIRE CHRUINN-BHALGAIN
Snow cornice at sunset

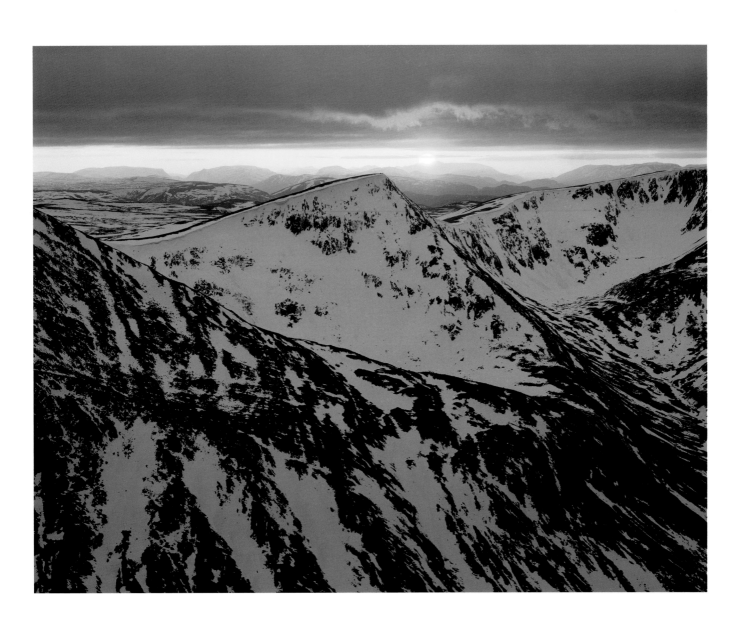

SGÒR AN LOCHAIN UAINE
Mid-winter sunset

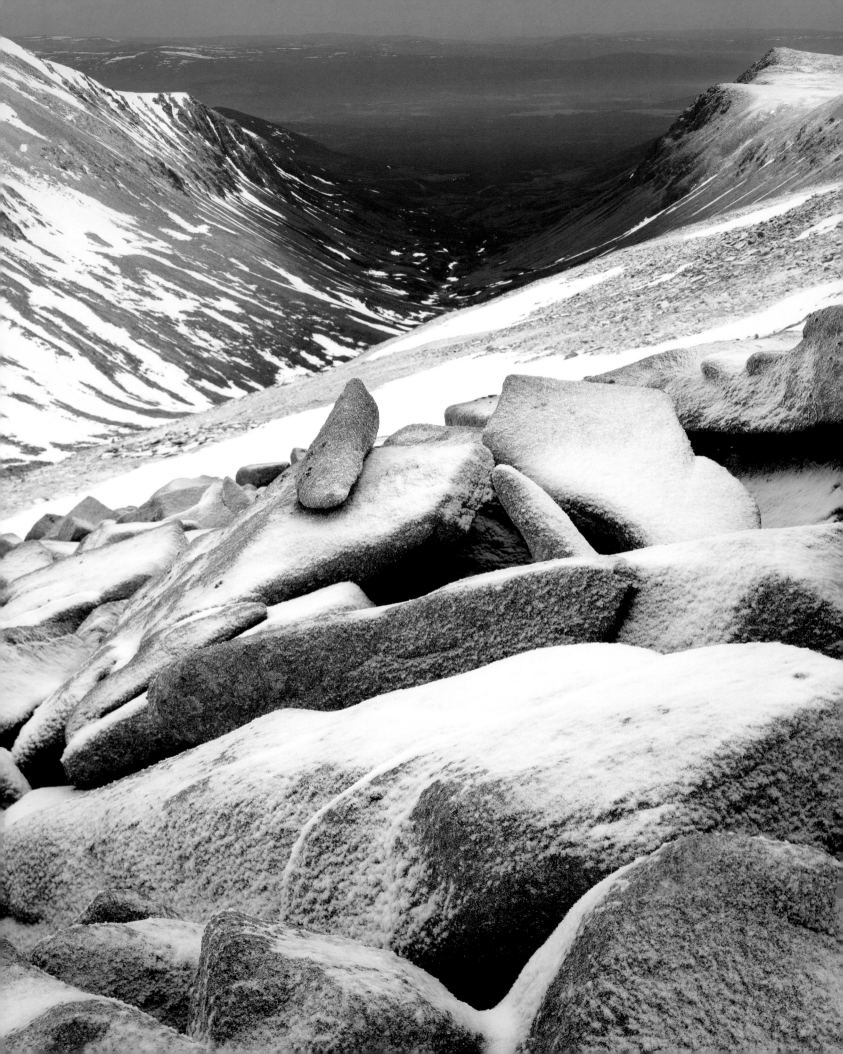

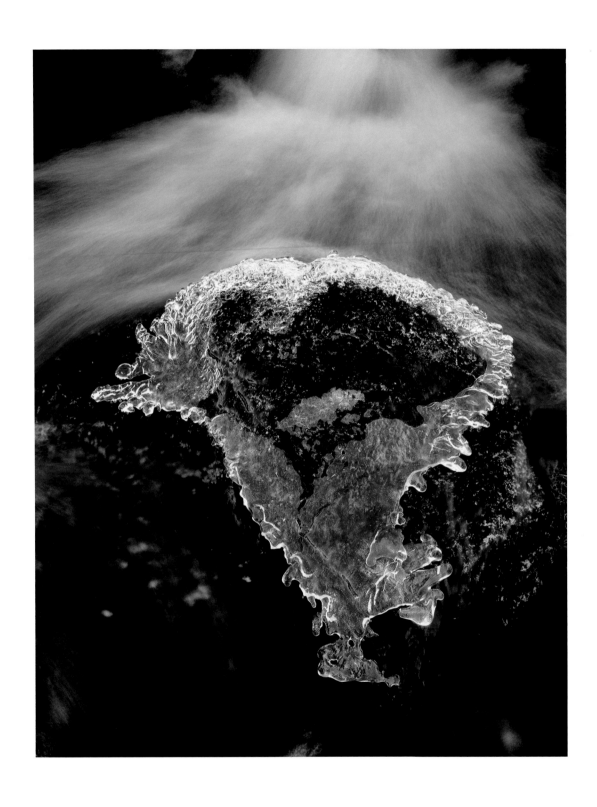

LAIRIG GHRU

from Ben Macdui

COIRE AN LOCHAIN

Ice heart

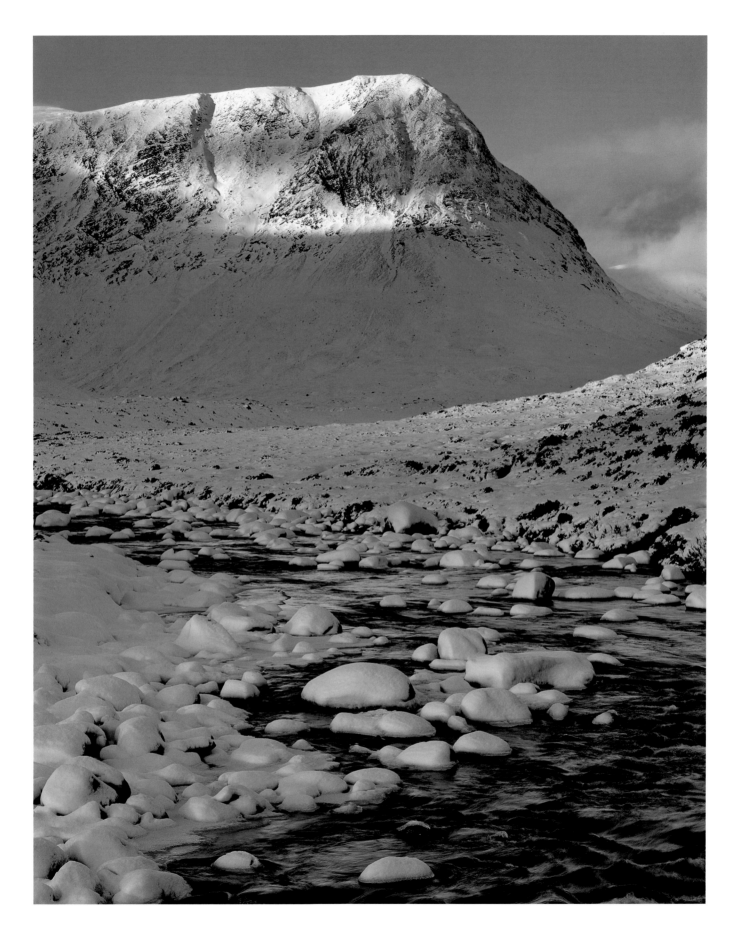

DEVIL'S POINT

River Dee, afternoon sunlight

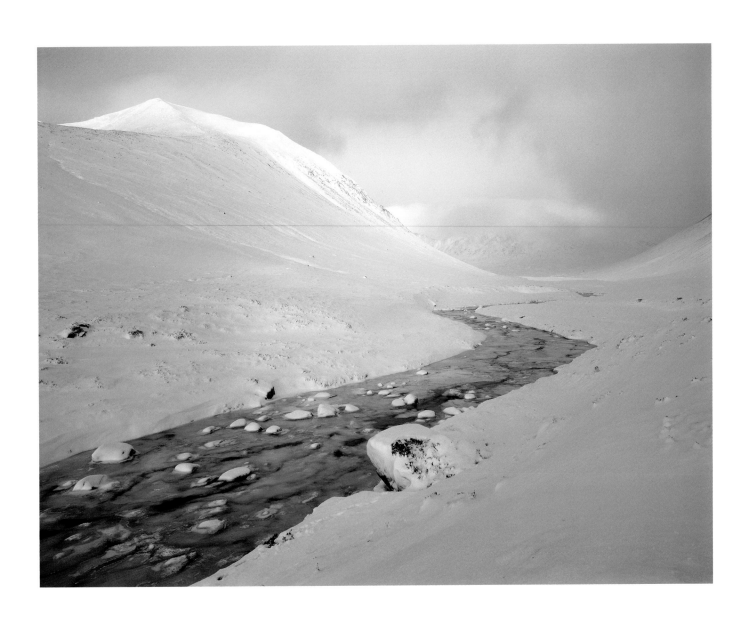

LAIRIG GHRU

River Dee, before sunrise

88

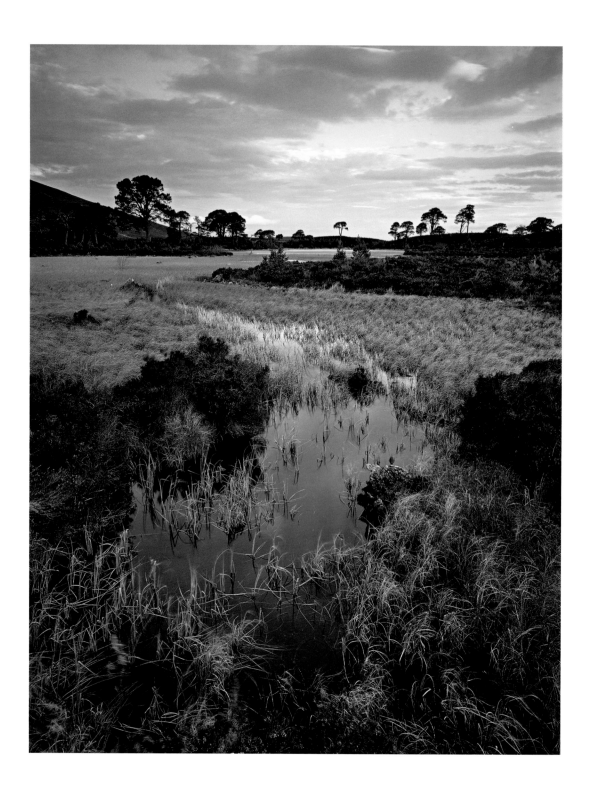

LOCH A' GHARBH-CHOIRE

Lower Strath Nethay

CÀRN LIATH

Range of Beinn a' Ghlo

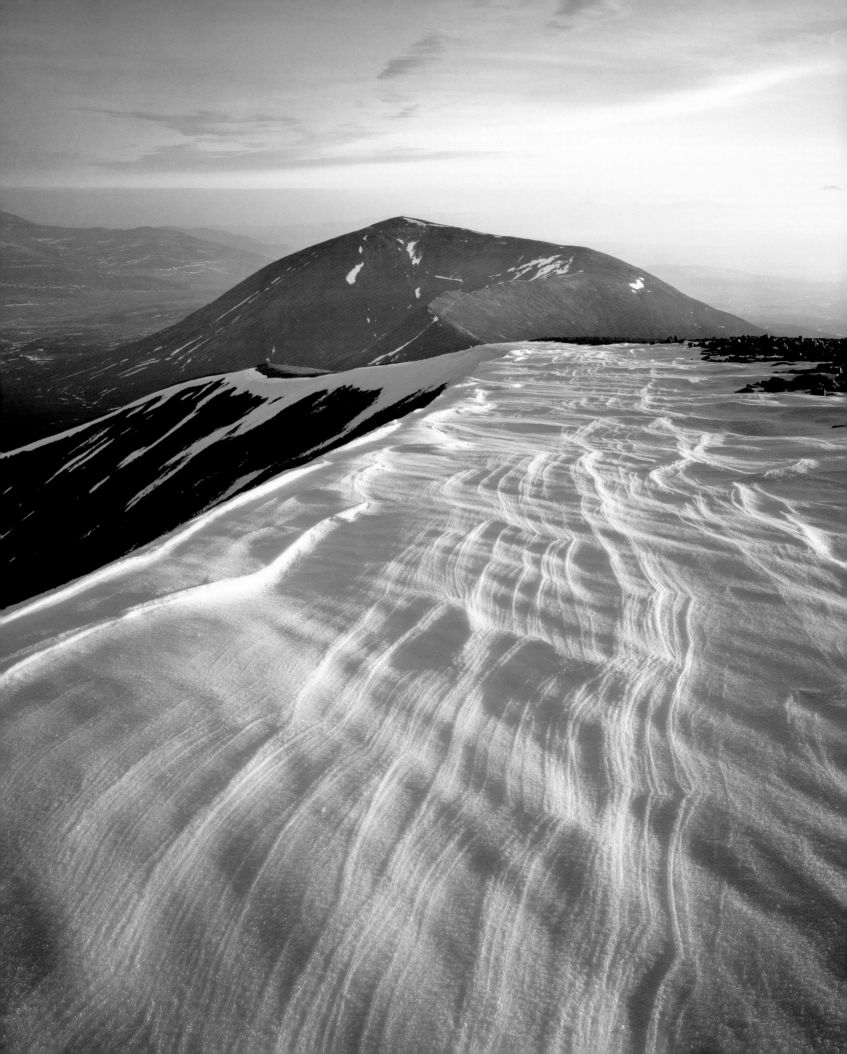

TORRIDON AND THE GREAT WILDERNESS

From the shores of Loch Torridon and its glen to the east rise some of the most spectacular mountains in Scotland. These giants of sandstone are exemplified by the burly hulk of Liathach, which seems impregnable from below. The gleaming quartzite slopes of Beinn Eighe lie just to its east; north of these two peaks, lonely glens and slightly lesser hills frame the beautiful shores of Loch Maree, from which rises the majestic spurs of Slioch (the Spear). Some of the remotest land in Scotland spreads north of Slioch; the Fisherfield Forest is also known as the Great Wilderness. The northern exclamation mark of this landscape is An Teallach, regarded by many as Scotland's finest mountain, if not its highest.

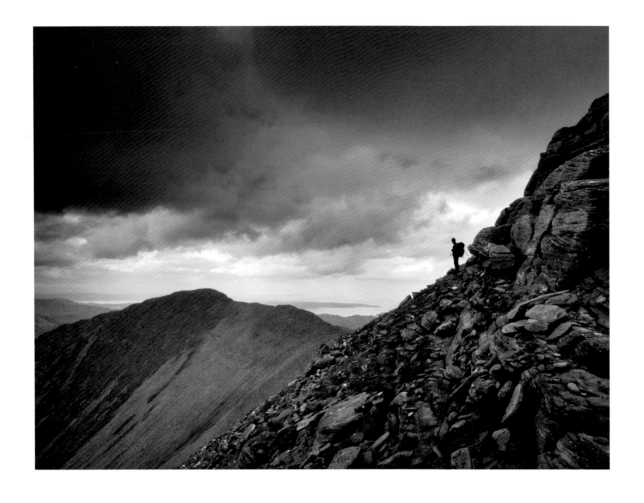

AN TEALLACH

Walker on Sgurr Fiona

AN TEALLACH | From a distance – from the north and the west especially – An Teallach is a large hill of rounded sloping shoulders like many others in Scotland (page 116). A glimpse of sharper features near its summit gives a subtle clue that this is not just another big brute of a hill like its lofty but unloved neighbour, Ben Wyvis. To really appreciate its rugged summit ridge it is best to approach from the south and east from the (gloriously entitled) Road to Destitution. Even so you will be lucky to see it, given how frequently it is covered by cloud, and the bulk of the mountain disappears as you approach, increasingly concealed by encircling rock ramparts as the road descends to the sea.

There are various routes onto the mountain, and I speculated long and hard about which would be the best over many months beforehand. Knowing this climb would deserve as much time as I could give I organised for my friends Ken Jaquiery and Nicky Kime to join me and provide moral and logistical support. It was around midsummer when our date with destiny arrived; I still wasn't sure of the right approach. In the end we set off from the road near Dundonnel House. It was not an auspicious start, through thickets of rhododendron and over squelchy peat bog under overcast skies. But after the first hundred metres or so of ascent, An Teallach rose into view, simultaneously forbidding and enthralling. This route revealed its northern corrie first; the ruggedness and steepness of its cliffs amazed us. Our goal was Coire Toll An Lochain; encircled by the highest peaks, visually this is the heart of the mountain. The clouds were off the summits as we arrived, but the sky was still an unbroken funeral blanket. In the absence of light the sheer cliffs of the corrie appeared almost black. I have rarely experienced a landscape so oppressive, so menacing.

A dryish spot was found in the (mostly soaking) landscape and we pitched tents, making our campsite in a geological cathedral. Architecturally-speaking that would definitely be a gothic cathedral. The beautiful loch that fills some of the corrie is a stage for drama in a theatre of light and dark, and indeed Coire Toll an Lochain is a truly ancient amphitheatre. Right now the forces of darkness most definitely had the upper hand. Yet if Romantic philosophers had sought a perfect example of the Sublime among the Scottish mountains, they would have found it right here at An Teallach, 'The Forge'.

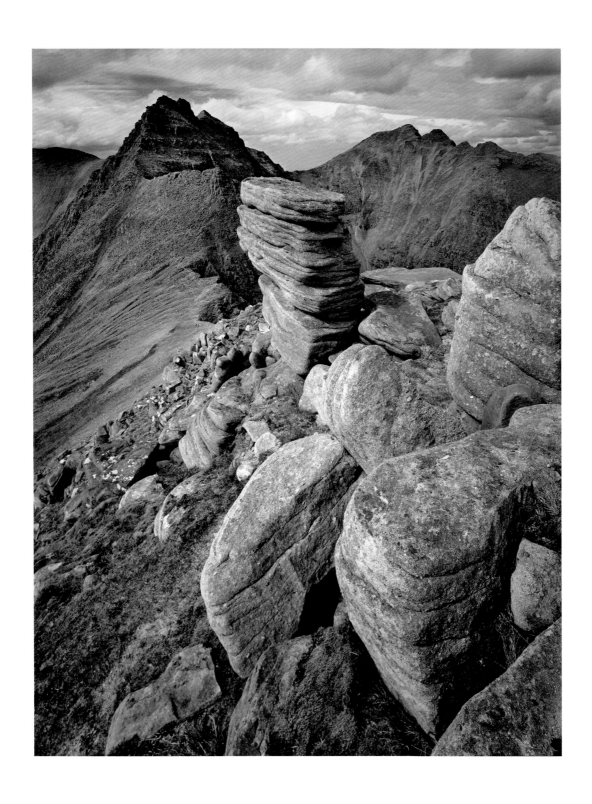

STOB CADHA GOBHLACH
An Teallach beyond

That night torrential rain and buffeting winds passed over us. Inside my lightweight tent was like being within a fabric kettle drum beaten by malevolent mountain spirits. It seemed that our campsite would be ripped up and hurled into the loch at any moment.

The storm passed, and by 4am came an uncanny quiet; I dressed reluctantly, fully aware of my responsibilities.

A landscape photographer's life can be memorable, but it is rarely if ever easy, and this was to be a dawn more fraught with frustration than blessed with success. I prowled the land east of the loch, seeking juxtapositions of form among boulders, all the while watching the sky. Cloud concealed the rising sun. An hour after sunrise, sunlight struck the main cliff face of An Teallach, but when it did so a huge shadow was projected by an eastern arm of the mountain. I knew the contrast would be too much for the resulting photograph to be effective.

Later that morning I caught up on some much-needed sleep, and not long after midday we began to climb. There is no easy line onto the main ridge from here, and it took us the best part of an hour and a half before we were finally on the quartzite-covered summit of Sail Liath, An Teallach's most southerly top. Views are the great reward of climbing any Scottish mountain, but these particular sights came as a special revelation, giving glimpses into the heart of the Great Wilderness to the south. Beyond the Fisherfield Forest the Torridonian giants, Beinn Eighe and Liathach, were clearly visible.

The ridge path from here is highly eroded, a result of the mountain's fragile geology, and its popularity. It is difficult to imagine how this damage might be mitigated, for constructing any kind of permanent path here would be technically close to impossible, hugely expensive, and anyway, who would want it? Yet it means that those who love the mountain most (myself included) are also contributing to its increased erosion and instability. Is that not just a simple acceleration of geological inevitability? Perhaps, but the visual scarring caused by this high human footfall also undermines what should (one would hope) be a thrilling experience of wilderness.

We continued our journey, heading clockwise around the ridge, marvelling at natural sandstone sculptures on Stob Cadha Gobhlach (page 93), and enjoying a

mixture of thrill and fear at the exposure on the Corrag Buidhe buttress. But when presented with the prospect of climbing Corrag Buidhe itself, discretion seemed the better part of valour, and we took the traversing bypass. We rejoined the ridge below the fang of rock that is Lord Berkeley's Seat, and made a picture from the summit of Sgurr Fiona. As sometimes happens, this picture did not make the final selection for the book; however, a family album image of Nicky and Ken appears on page 157.

From An Teallach's highest top (and our last), Bidein A Ghlas Thuil, it is possible to finally gain a perspective on the sheer complexity of this awesome mountain with its four huge buttresses, its dizzying pinnacles and incomparable viewpoints. The sun had barely showed itself since midday, and now it was giving up the unequal fight to penetrate spoiling clouds firmly entrenched over the western horizon. The final photograph of the day was made around 9.45pm in gusty winds. Knowing the picture might well be ruined by camera vibration, I still held faint hopes this composition might capture some of An Teallach's synergy of moody malevolence and ethereal beauty (page 110). We retreated downhill quietly in the gathering gloom, and cooked supper in the shadows of the summer twilight.

The following morning, after another short night, dawn proved benign with beautiful early sunlight. This time the shadow cast on An Teallach's amphitheatre was softer, allowing me to make an exposure (page 104). We had breakfast then descended the mountain quite rapidly, and celebrated our experience with a full immersion in the cascading river that flows from Loch Toll An Lochain, and a bar of soap. Although summer the water was bitterly cold; 'invigorating' would be much too benign a description. But the pain was temporary and cathartic, and set us up for the long drive home.

Sleeping in that most spectacular of 'campsites', feasting on its views, seeing the sun come and go and the cloud build and clear, feeling the rain fall and the wind rage on this prince of peaks – these experiences will never leave me. Three of us spent two days together on that one mountain, exhilarated, exhausted and saying little. An Teallach is beyond explanation, beyond words. And surely beyond photography too.

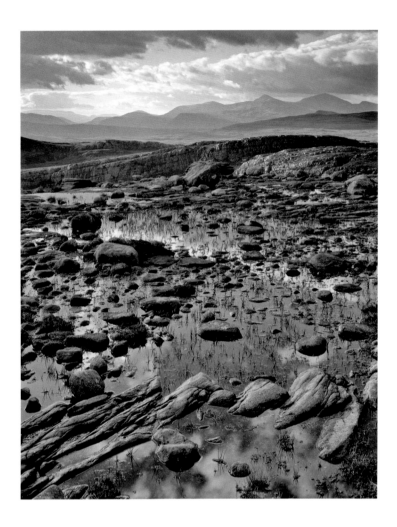

FANNICH RANGE
from Loch Toll an Lochain

TRIPLE BUTTRESS | To reach the Choire Mhic Fhearchair is a five-mile walk, either from Glen Grudie to the north, or Glen Torridon to the south. The latter was chosen. A defined path made progress straightforward and navigation simple. There is a continuous uphill gradient, but 500 metres of ascent spread over five miles is easy.

Beinn Eighe's spectacular Triple Buttress rears abruptly on the south side of the Choire Mhic Fhearchair's loch; it is immediately apparent that the lighting for this

north-facing feature will be difficult. Sàil Mhòr and Ruadh-stac Mòr are both higher than the Triple Buttress and enclose it to east and west. Because it is mid-summer I was hoping that the evening sun would rake past Sail Mhor, and illuminate at least some of the Triple Buttress cliffs. In my dreams I had imagined the corrie loch dead flat calm with a beautiful reflection. But wishful thinking never made a good photograph.

To the north magnificent views open up all round, especially to the northwest over a vast glaciated basin of lochan-drenched wilderness framed by mountains. The tumbling waterfall that drains the main corrie loch links the foreground to the wilderness beyond. In the striking light of the late afternoon I made my picture of this, more for reference than with any high expectation (page 103). The rock platforms of the corrie are covered in erratics, some Torridonian sandstone, others sharp-cut quartzite blocks, tumbled from the mountain's grey-white summit ridge. Scattered on the sandstone bedrock, they look like the rough offcuts of temple building from some ancient classical civilization (page 101).

A strong convection wind developed into the evening, cold air tumbling down the mountainside and rippling the loch waters as the day grew cooler. So no idyllic reflection. Nor did the setting sun evenly illuminate the Triple Buttress. Surrounded by colossal facts of geology and reasonable weather the photographic possibilities should have been infinite. But the light and environment seemed in conflict and I realised inspiration had deserted me for the day. I just could not adequately photograph this awesome scenery.

By 11.00 pm the sun had disappeared behind the mountains and I began the long walk out, puzzled by my apparent inability to capture the potential of this exceptional place. For much of the walk the mighty walls of Liathach, luminous in the summer twilight, filled my view and my tired imagination, silently bidding me to return.

In the end my photographs this mid-summer afternoon were not a hopeless failure, but rather a fair reflection of work begun. The Triple Buttress experience was evidence for me that time (not the location itself, as some believe) is the most important part of photography. To truly tune in to the complexity and depth of such a landscape is not the endeavour of a few hours, but the study of a lifetime.

Torridon and the Great Wilderness

Portfolio

———————

ENDURANCE | It only requires a modest interest in geology to realise that some of Scotland's mountains have a vast chronology out of proportion to their modest heights. It is really impossible to speculate with much accuracy how they looked at various times past, but the current appearance of the monoliths framing the north side of Upper Loch Torridon and Glen Torridon gives the impression they have been there forever. And in human time that is literally true. For the base of these hills, being Lewissian Gneiss, is actually 2.7 billion years old. The comparatively 'fresh' rocks of the mountains themselves were laid down (through sedimentary deposition) a mere billion years ago. Yes, that is one thousand million years. In geological time, nothing is permanent, and in future as yet unimagined glaciations and earth tremors will despatch these mountains the way of all things. But for now, from our viewpoint, these rocks are permanent. They have truly endured, steadfast, aloof, a timeless backdrop to the brief turbulence of human history. Endurance, resilience – staying the course, not giving up – are qualities needed to climb these hills too. They are necessary in so many ways, in mind, body, and spirit; indeed, perhaps these are the most important lessons the mountains teach us.

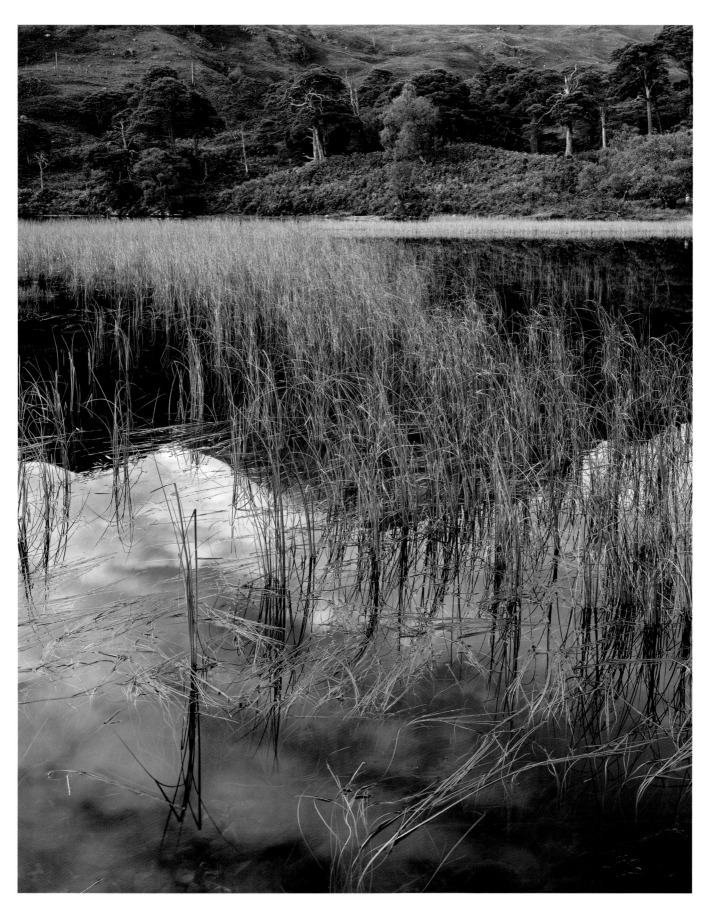

LOCH CLAIR

Reeds and reflection of Sgùrr Dubh

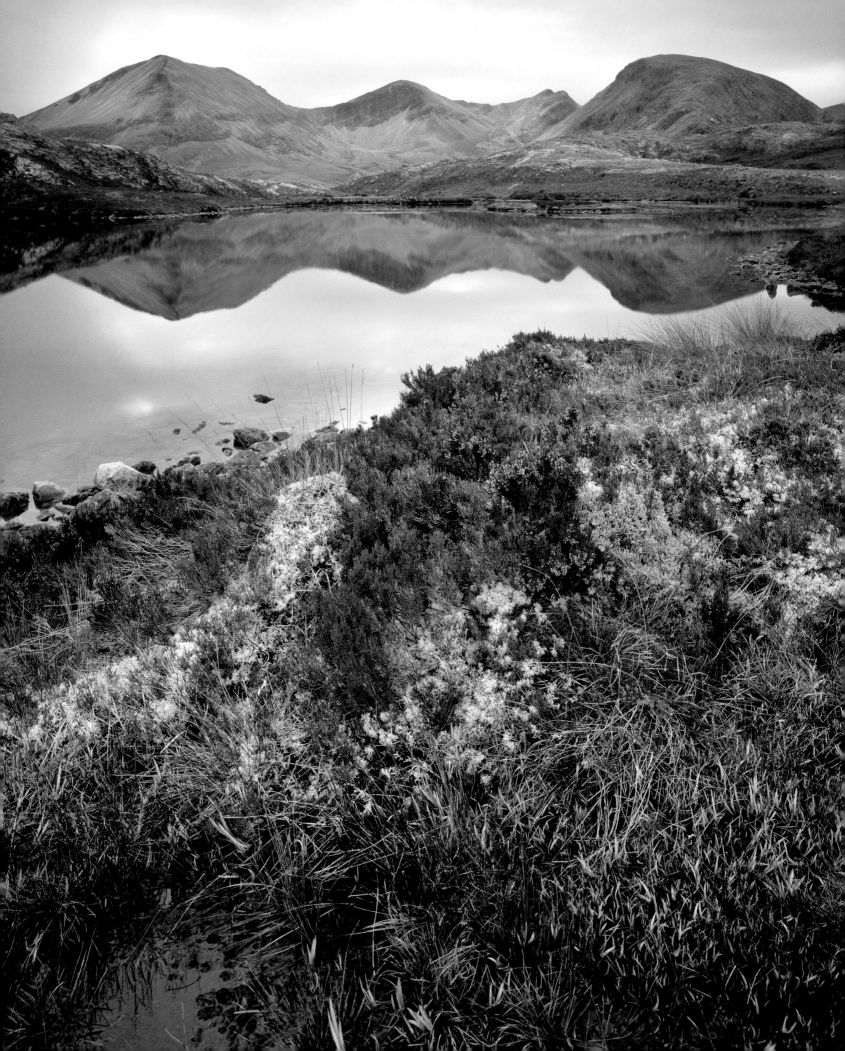

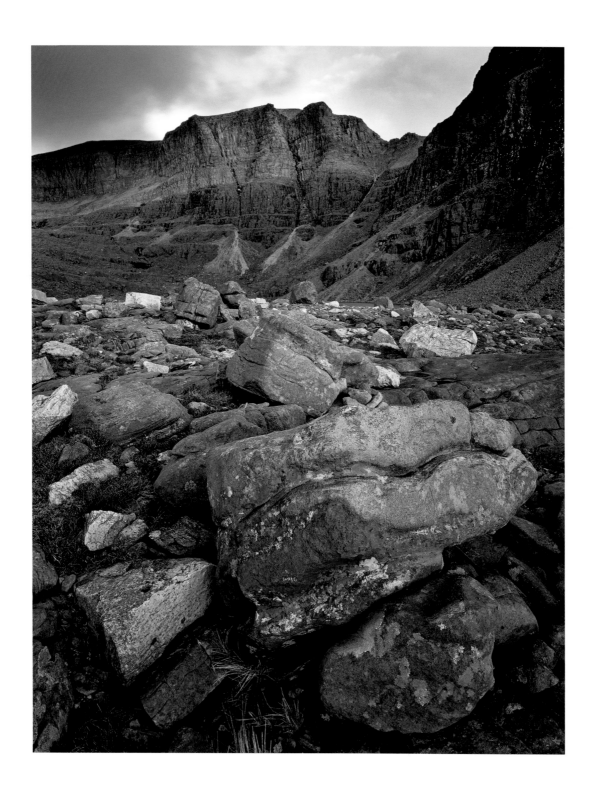

BEINN EIGHE

from Loch Allt an Daraich

BEINN EIGHE

The Triple Buttress from Coire Mhic Fhearchair

102

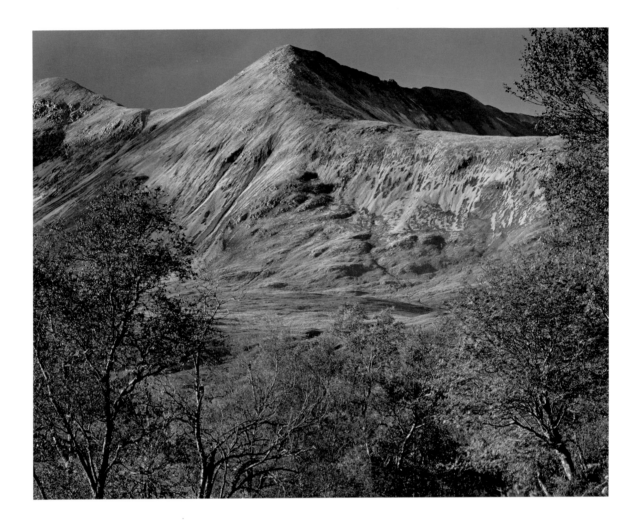

BEINN EIGHE

Sgùrr Nan Fhir Duibhe, from the shore of Loch Clair

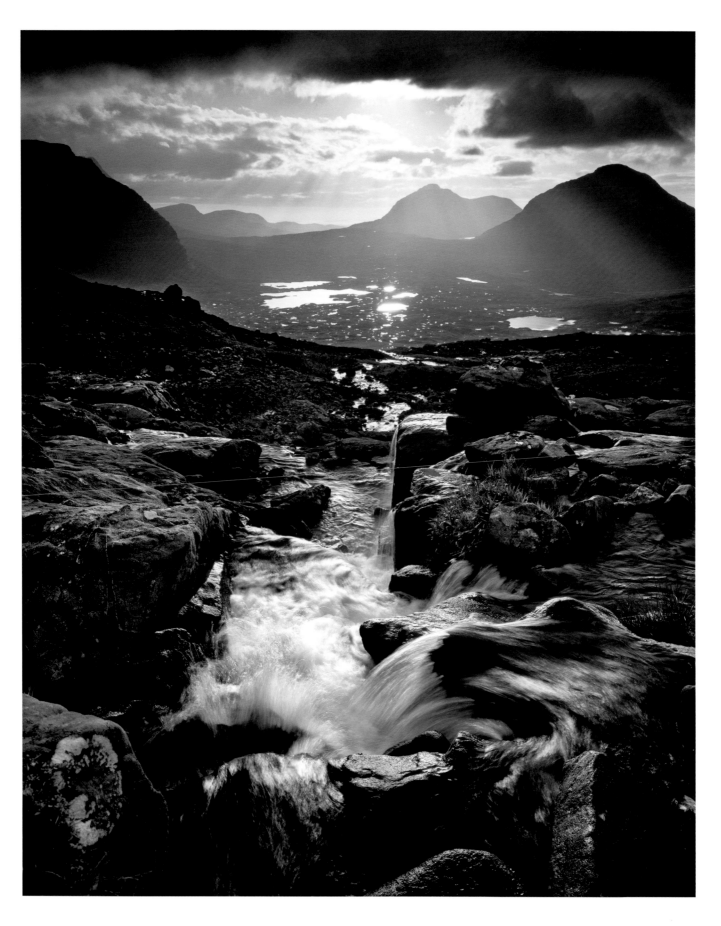

ALLT COIRE MHIC FHEARCHAIR

Mountain stream with Beinn Dearg, Baosbheinn and Beinn an Eòin beyond

104

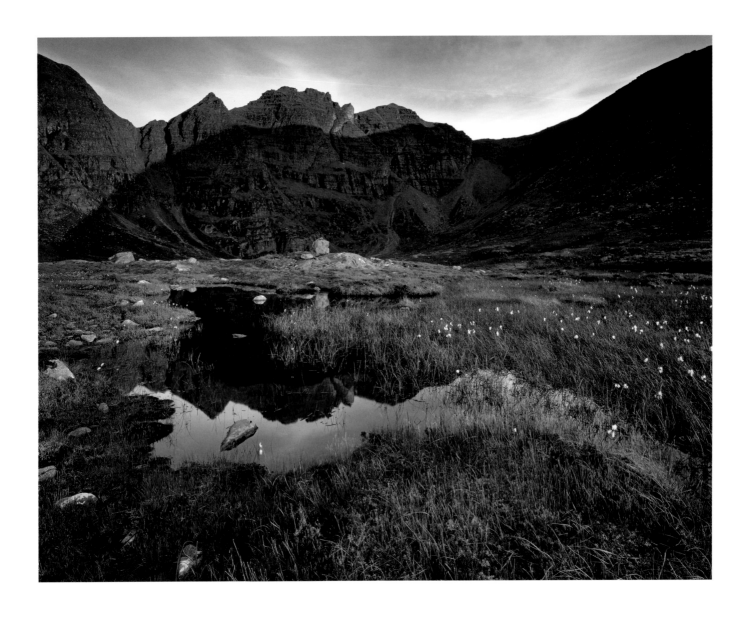

AN TEALLACH

from Loch Toll an Lochain, summer sunrise

STRATH LUNGARD

and Beinn Àirigh Chàrr from Beinn a' Chearcaill

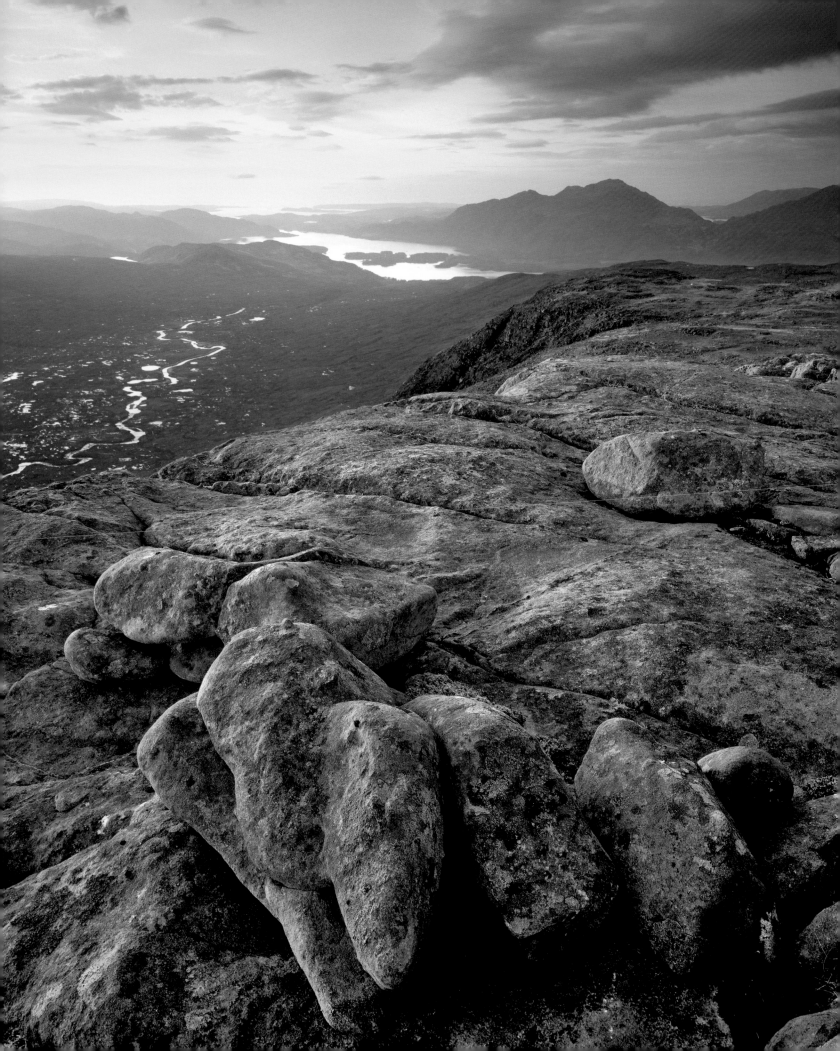

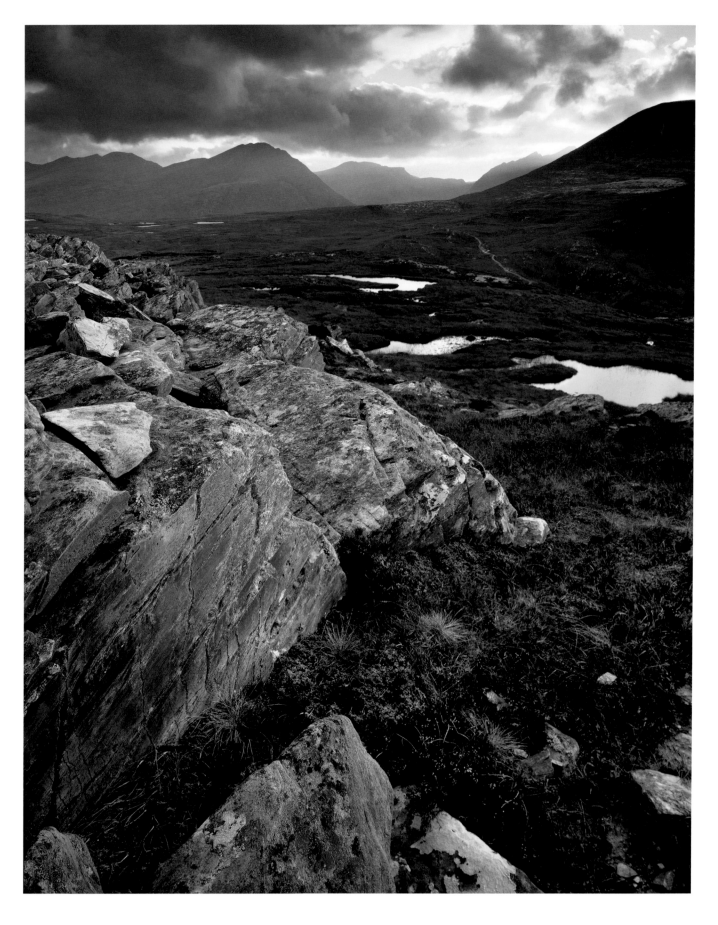

BEINN A' CHLAIDHEIMH

from Carn a' Bhreabadair

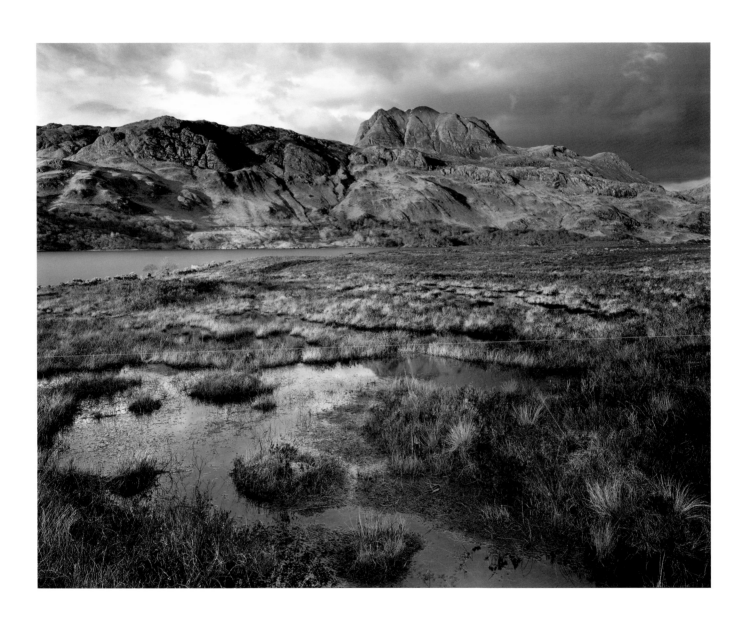

SLIOCH
and Loch Maree

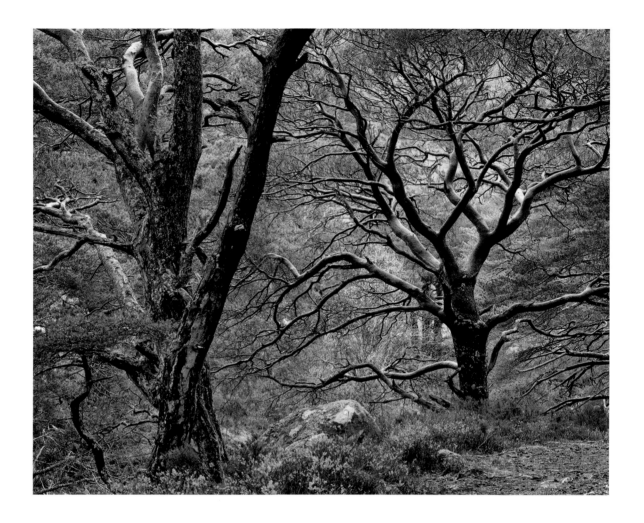

GRUDIE BRIDGE

Caledonian pines, drizzle

LIATHACH

Beinn Eighe and Loch Clair

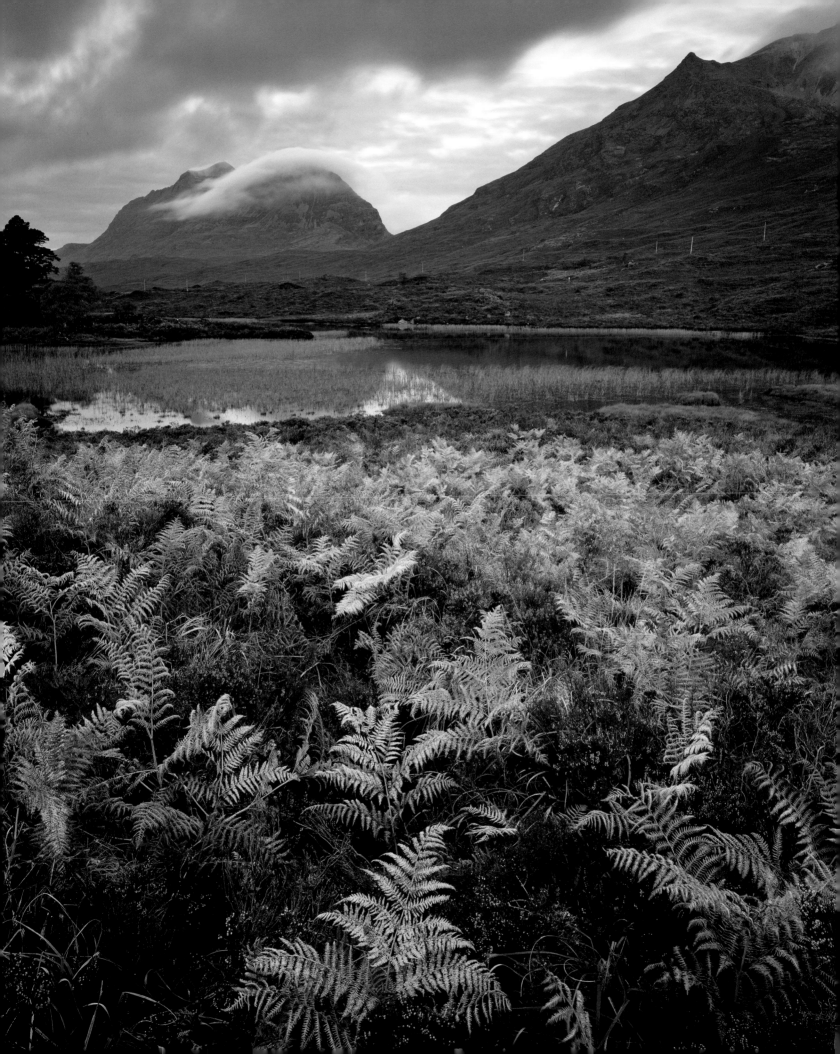

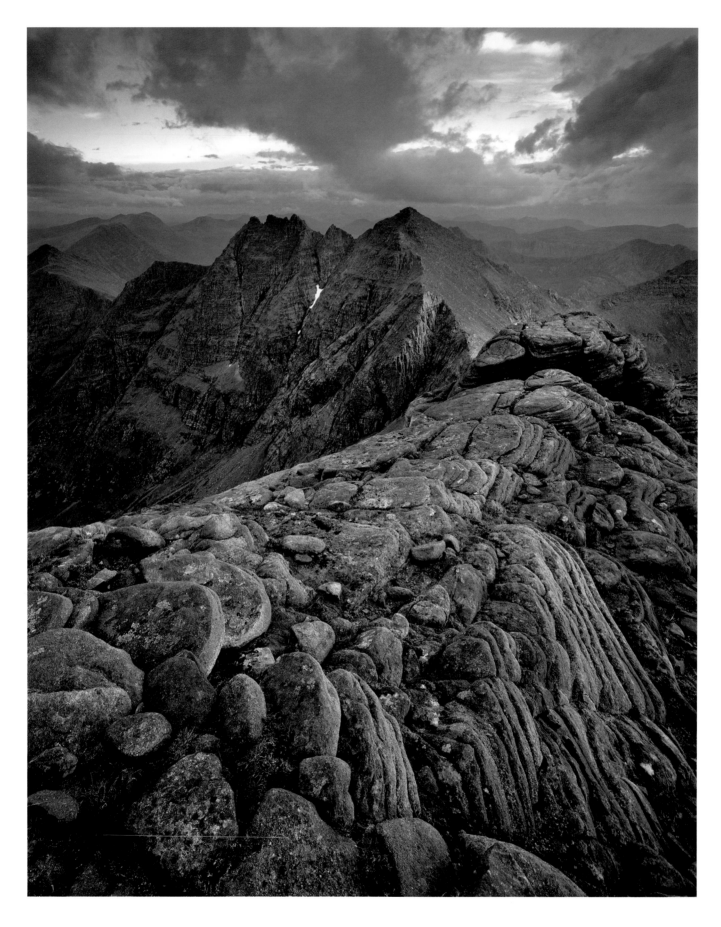

AN TEALLACH

from Bidein a' Ghlas Thuill

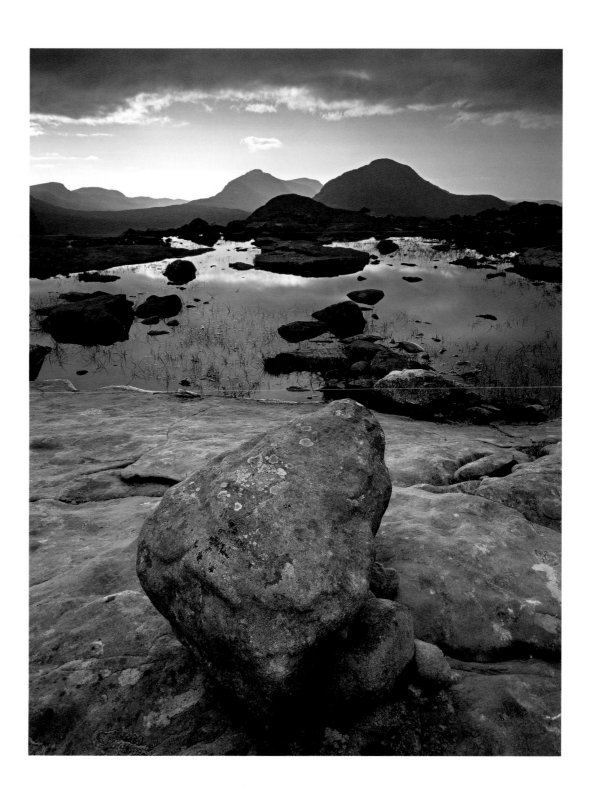

BAOSBHEINN AND BEINN AN EÒIN
from Coire Mhic Fhearchair

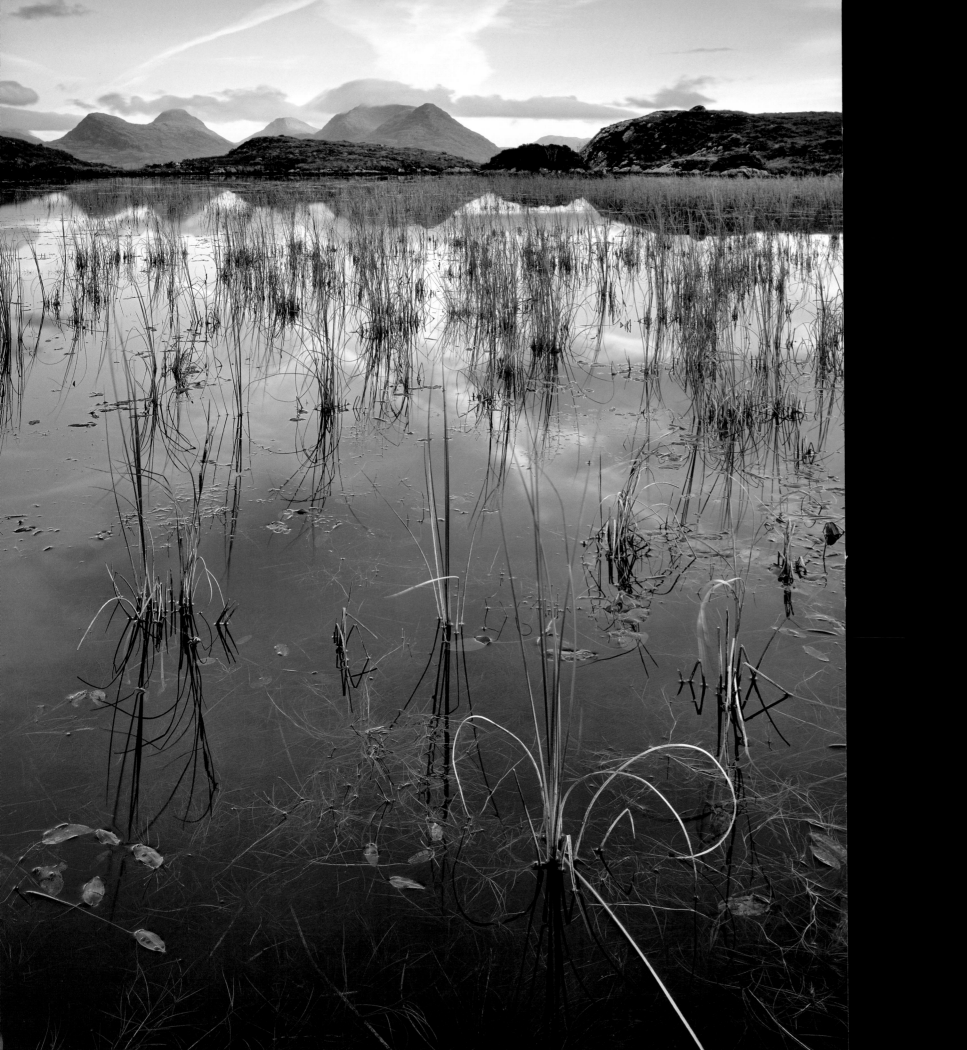

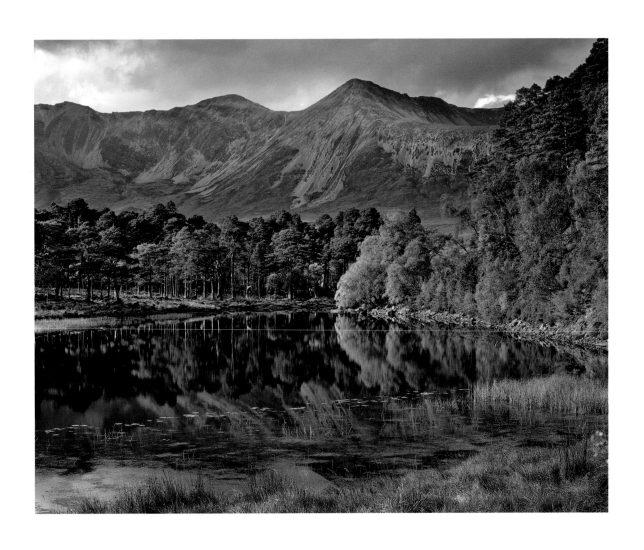

BEINN DAMH

from Bealach na Gaoithe

LOCH COULIN

Beinn Eighe beyond

114

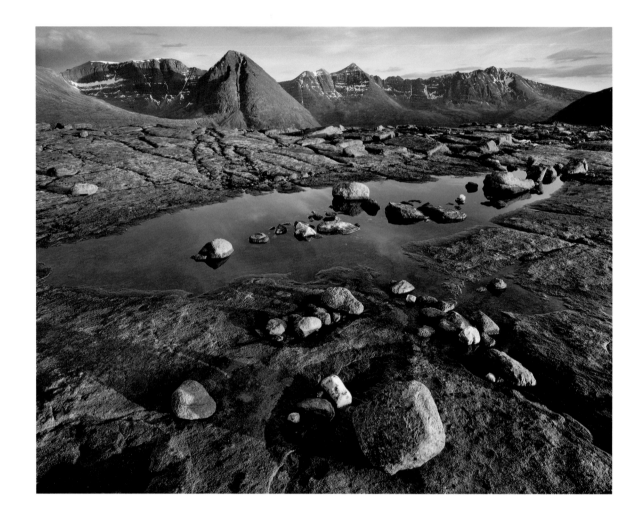

SÀIL MHÒR AND LIATHACH

from Beinn a' Chearcaill

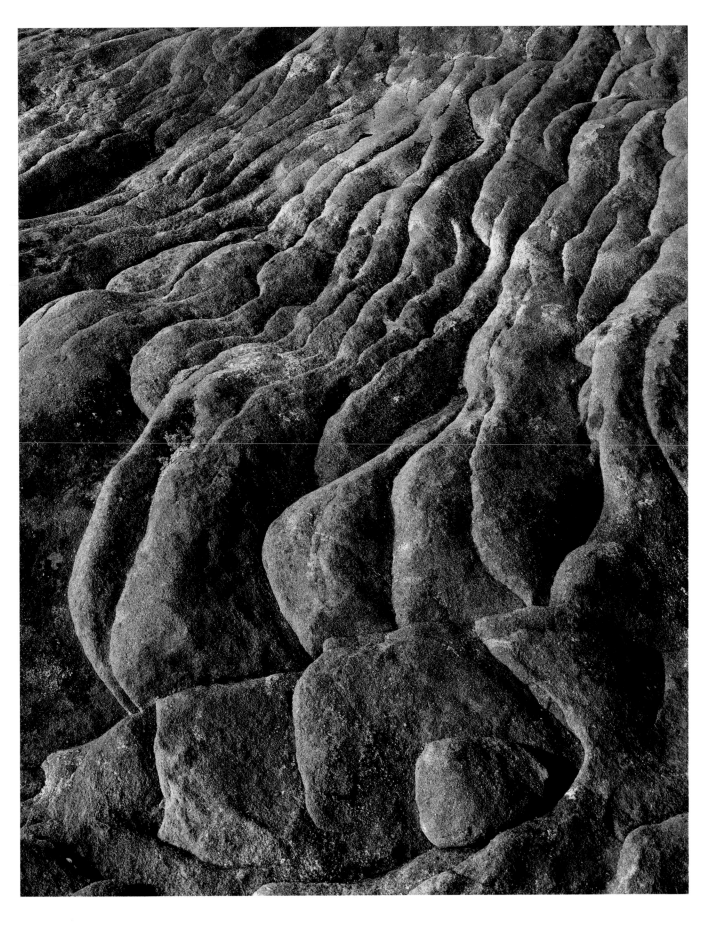

AN CEARCAILL

Torridonian sandstone

116

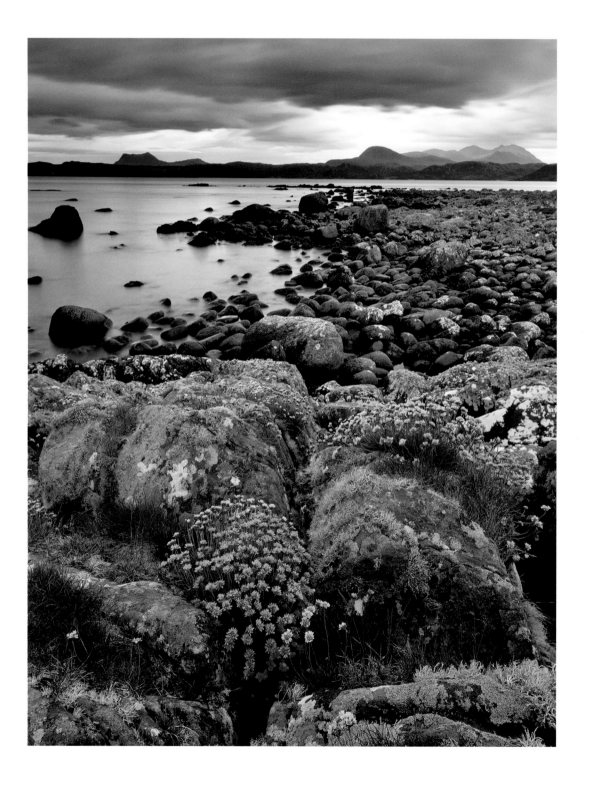

AN TEALLACH

from Gruinard Bay

BEINN A' CHEARCAILL

Summit plateau, Slioch beyond

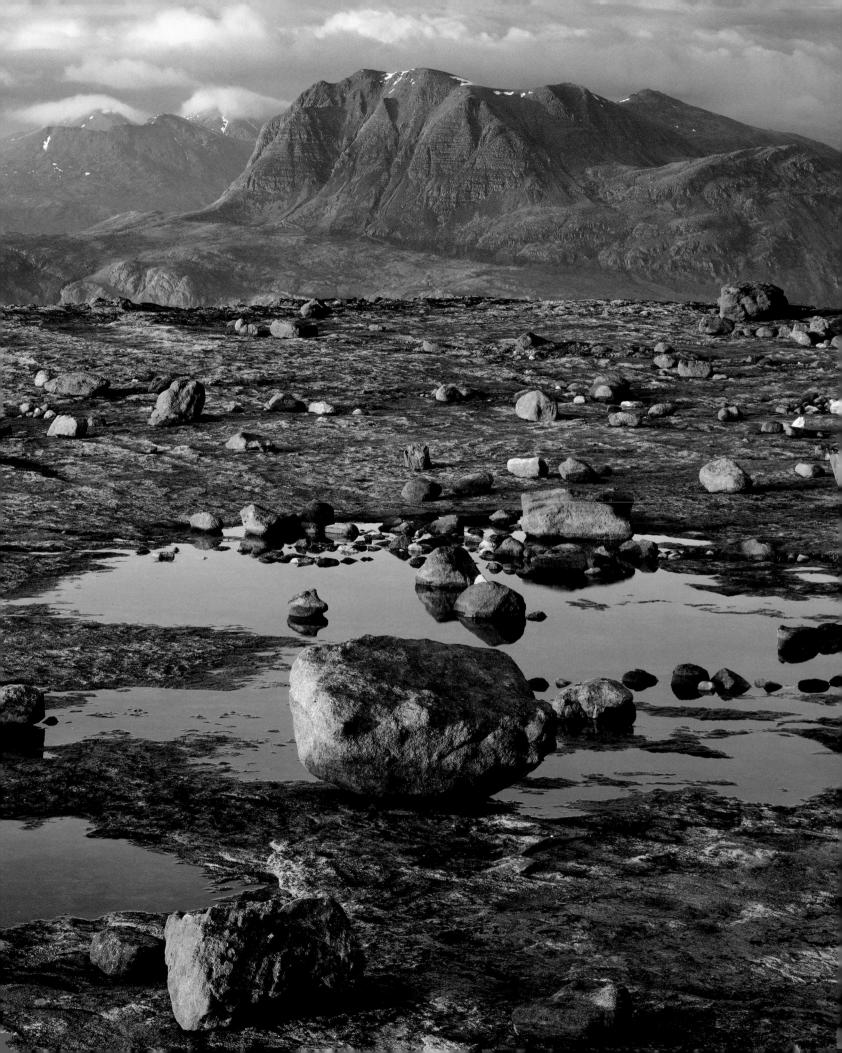

THE FAR NORTH

The remote northern regions of Scotland include some isolated summits in the east which reward the visitor with their wild setting. Morven is the highest of these, and probably the most distinctive in a landscape of generally vast, windswept moorlands. The west of the region offers an embarrassment of riches, with remarkable-looking mountains, each unique and spectacular in its own way, dominating the landscape from Ullapool in the south to Durness and Tongue on the north coast. In any other place, Ben Mor Coigach, Cul Mor, Quinag, Foinaven, Ben Hope and Ben Loyal would be outstanding mountains; here they form a magnificent supporting cast for diminutive, yet charismatic, Stac Pollaidh and awe-inspiring Suilven.

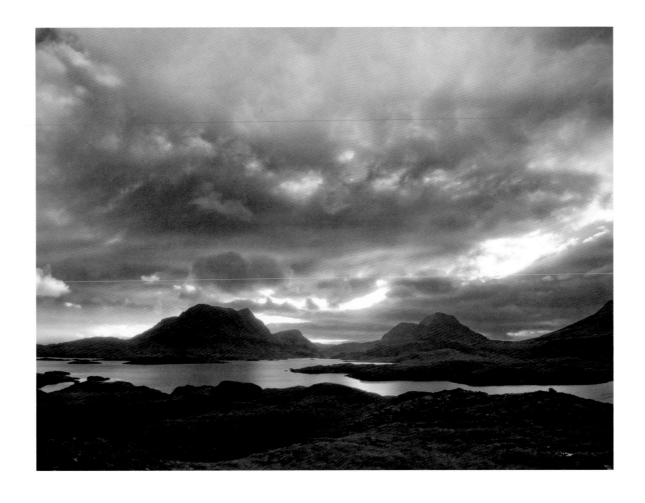

LOCH SIONASCAIG
Cul Mor and Cul Beag in the distance

SUILVEN | A kilometre of tarmac road led to the start of a rough stalker's track. Then followed seven or eight kilometres of stony, twisty switchback, eventually arriving at a footbridge. The way seemed endless. Suilven remained aloof, remote, and increasingly to the right. Finally, once the bridge was crossed, a direct route led to the centre of the mountain's northern flank. Rising from a plateau ringed with rocky bluffs and soaked in lochans this is a well-defended location; Suilven seems a true fortress of a mountain. This impregnable appearance suggests it is accessible only to serious rock climbers. But not so. A few hundred metres of ascent over black peaty bog and abrupt rocky banks brought us to the foot of a long, steep slope; a stone scree chute leading directly to the bealach, or pass.

The angle is probably 37°, like a staircase, but instead of steps, lots of slippery rock, exposed soil and scree. We put our heads down and worked hard. Twenty-five minutes and nearly 300 metres of ascent later we were on the ridge, almost a knife edge. Looking over the other side, a near mirror image of the slope we had just climbed appeared in an uncanny symmetry. A well-preserved wall crosses the bealach here, like a stone strap lying over the saddle of a giant horse; defying logic and gravity it seems more a work of wall-building art than a functional land division to manage grazing sheep. I wondered, did landscape sculptor Andy Goldsworthy get here first?

Although we were not yet at the top, the worst was over, and the remaining ascent was enjoyable, if occasionally exposed. I was only interested in reaching Caisteal Liath, the western summit, mainly for photographic reasons, and also because I was quite dubious of my ability to climb Suilven's eastern summit. This would indeed be an airy (hairy?) scramble. I was grateful that my assistant for the climb, the redoubtable Stuart Parker, showed no particular inclination to climb it either.

The view of Meall Mheadonach, the eastern end of the mountain, was almost beyond description; its profile is like a medieval church spire, its monumental scale more that of the Great Pyramid (opposite).

Caisteal Liath, the summit of Suilven, is a shallow dome of soft, mossy, springy, dry turf; surely a civilised surface on which to hold a gathering of the gods. On this fortress mountain it does not require a huge leap of imagination to visualise a clan leader with elders, warriors and their consorts holding a magnificent midsummer banquet. Bearing the food, mead and wine (not to mention tables and chairs) up

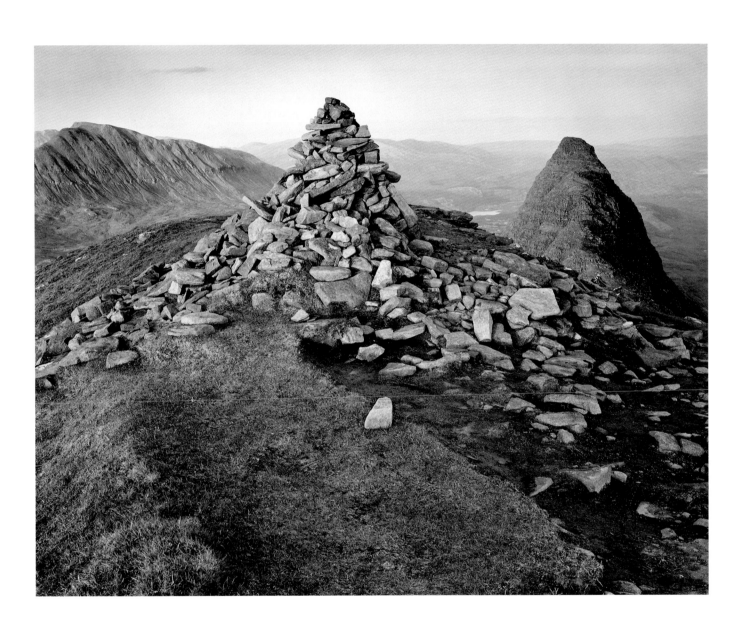

SUILVEN

Summit cairn and Meall Mheadonach

here would have been interesting. But whereas many mountain summits are hostile, broken precipices of shattered rock, Caisteal Liath is a comfortable, superlative balcony, which invites such speculation of a mythic age.

At risk of resorting to hyperbole Suilven delivers an incredible 360° panorama of Assynt and beyond, in this most magical and still mysteriously beautiful of all Scotland's landscapes. So long as you happen to be up there (as we were) when the prevailing gales, rain, snow and cloud are in temporary abeyance. The surrounding moorland glistens with hundreds of lochans, and Matisse himself might have drawn the sinuous lines described by the edges of Fionn Loch to the south (page 138). Most of the Munros and Corbetts of the north are visible from here; Foinaven, Arkle, Ben Stack, and Quinag to the north; Canisp and Ben More Assynt to the northeast; Suilven's own eastern spire; Cul Mòr, Cul Beag, Ben More Coigach and Stac Pollaidh to the south. The western horizon is filled with the coast and sea, headlands, bays and scores of islands.

Stuart and I had intended camping at the foot of the bealach ascent slope. But we had not reckoned on the dampness left by days of rain. There was literally nowhere to pitch a tent. Not only that, the warm summer daytime temperatures had obliged us to drink more water than we had expected, and although there was plenty of lying water, very little was flowing. Without the means to boil or sterilise, and with thirst an insistent and growing anxiety, we realised that we had to walk out again that night. The exit hike began at sunset, just after 10pm. With only a couple of five minute rest breaks, since there was nothing left to drink, we walked, and walked, and walked through the not-quite-darkness of the summer night. By 1.30am we were back at the van, utterly dehydrated and grateful for the stash of water we had left there.

I awoke briefly at 4am. I saw Suilven in the distant light of a soft dawn, and wondered briefly whether I should head out to see the sunrise with my camera, before falling back into an abyss of sleep.

Suilven may just be an anti-social, stubborn, brawny relic of billion-year old sandstone, chiselled by glaciers in the last Ice Age. As Scottish mountains go, it is far from the highest, or largest; nor is it the most difficult to climb, or the most elegant. But if any of Scotland's mountains could be named sacred, as is Mount Kailash in Tibet, Suilven would be my choice.

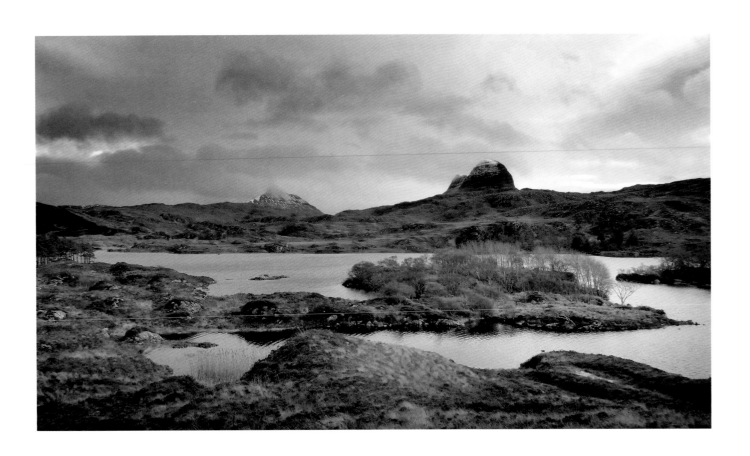

CANISP AND SUILVEN
Loch Druim Suardalain

The Far North

Portfolio

IMAGINATION | It is in the far northwest of Scotland where the mountains 'thin out'. Here they are divided not just by glens but by moorlands too. These tracts of land are bleak, and to the modern western eye forbidding, unwelcoming. Yet here the mountains achieve a new perspective in isolation from one another, and their distinctive presences fire the imagination in a way consistent with a landscape at 'the end of the world'. It was on Suilven's summit plateau that I had a transcendent moment, a sense of the mountain as a balcony, where I was surrounded by sky and distant mountains that could surely exist only in fiction. Yet there they were! A small leap of the imagination was all that would have been needed to cast oneself off and soar like an eagle (although without a parachute, best not to try!). It was a place where the trivia and worry of everyday life were not just put into proper perspective, but forgotten (albeit temporarily) altogether. We need all our faculties for mountains; our minds to engage with them, our bodies to take us up them, our spirits to experience them. Wherever the imagination exists within us, it is ultimately the imagination that elevates the experience, makes the hard graft worthwhile, and prompts us with the certain belief that, whenever it may be, we will return one day.

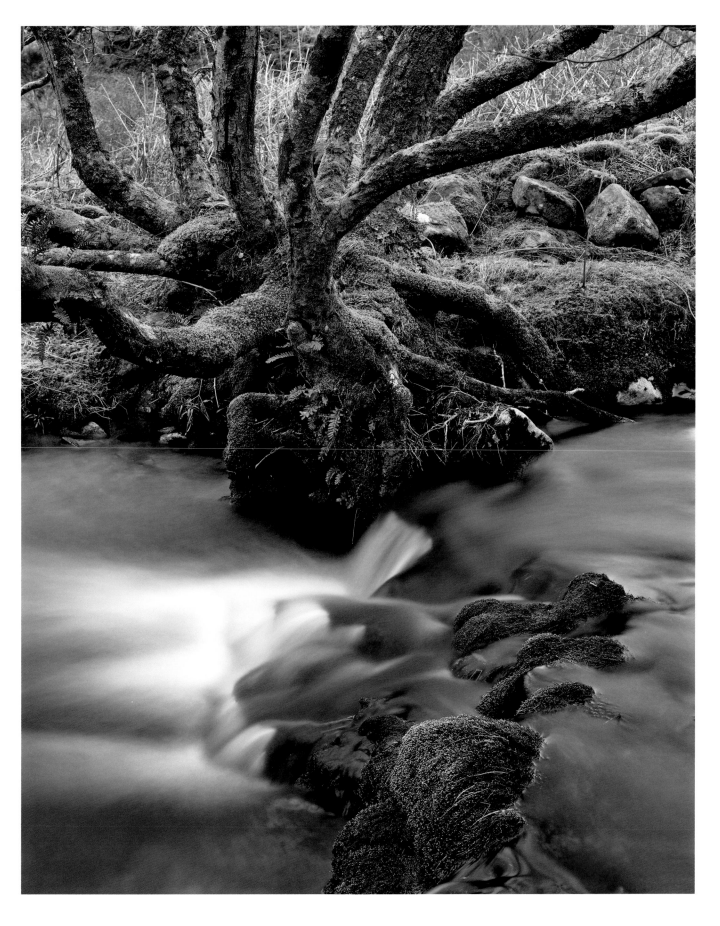

COIGACH

Stream near Culnacraig

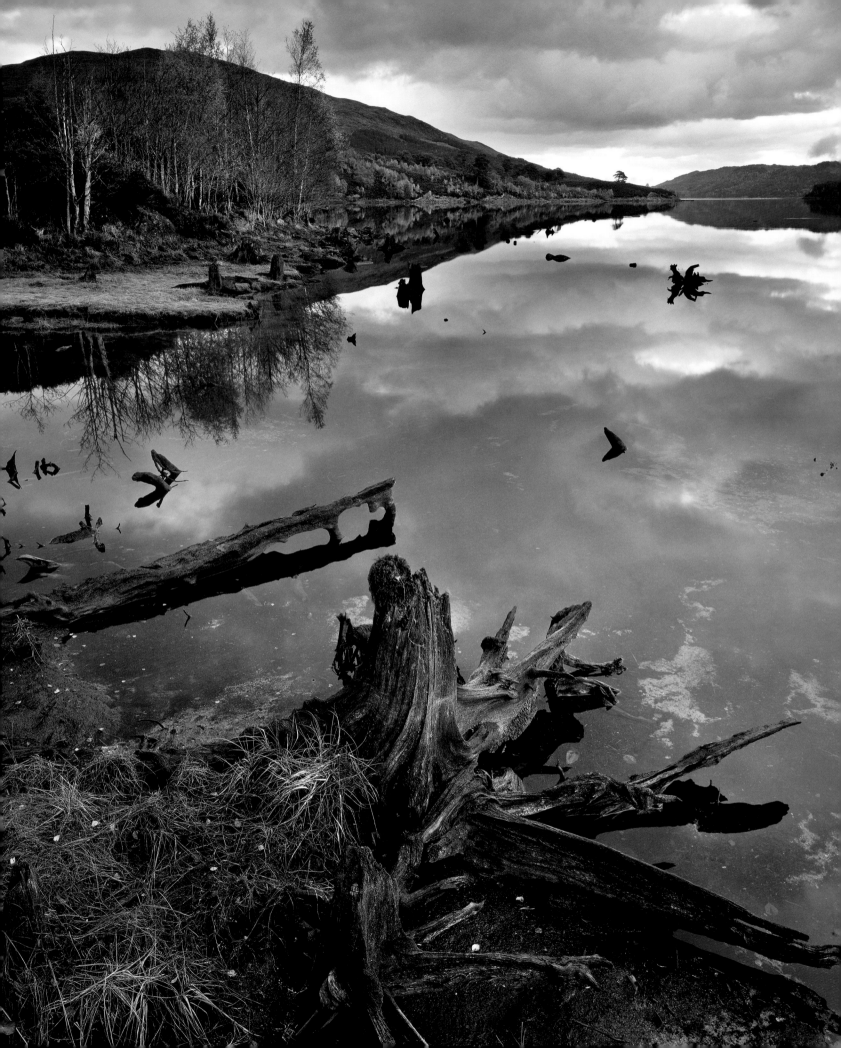

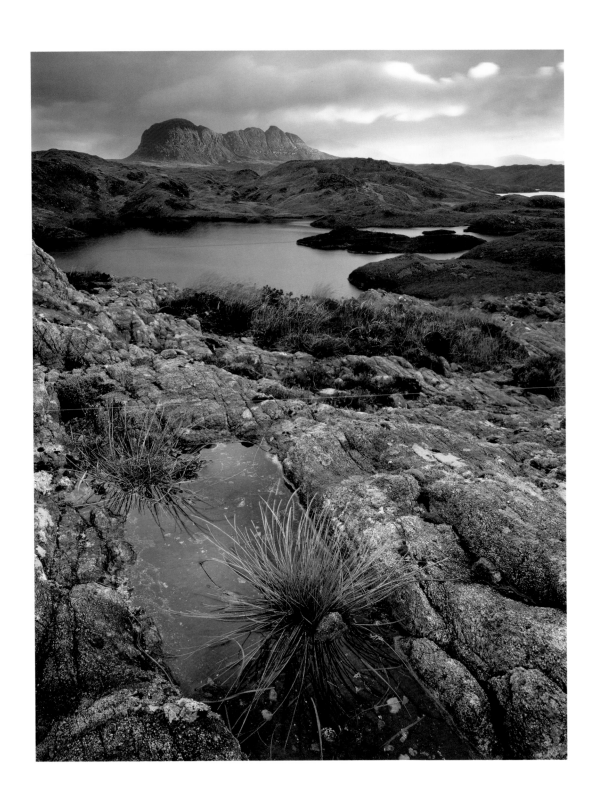

127

LOCH BEINN A' MHEADHOIN

Dark afternoon, Glen Affric

SUILVEN

beyond Loch Sionascaig

128

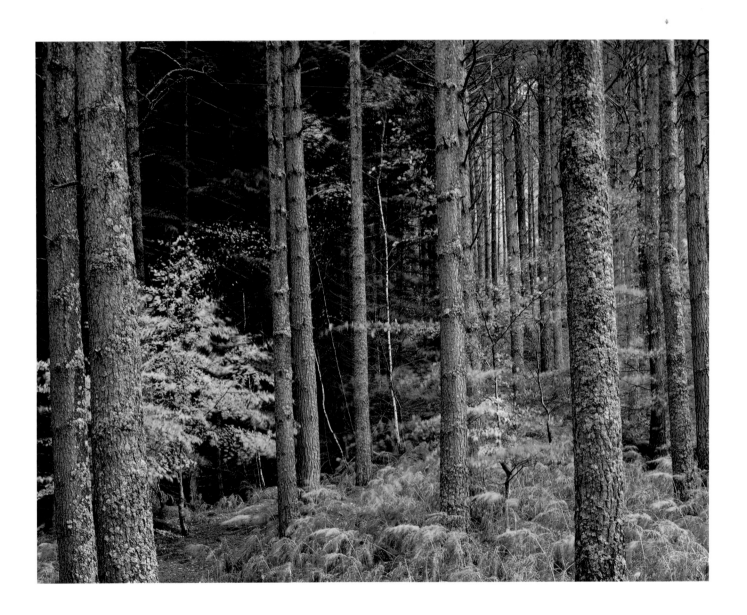

LAEL FOREST

Autumn on the slopes of Beinn Dearg

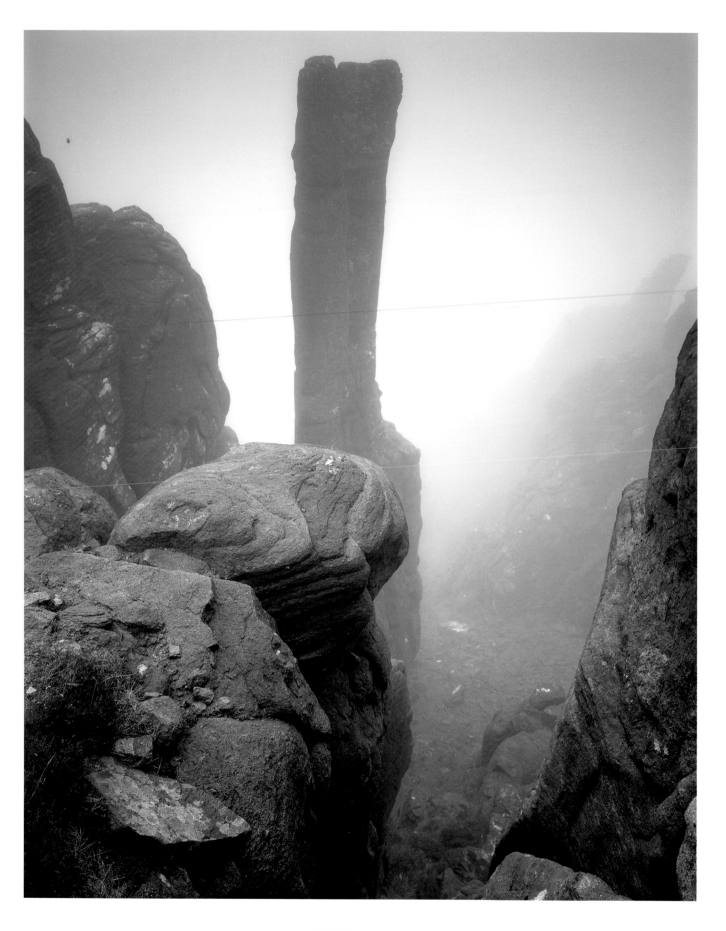

STAC POLLAIDH

Summit sandstone, mist

130

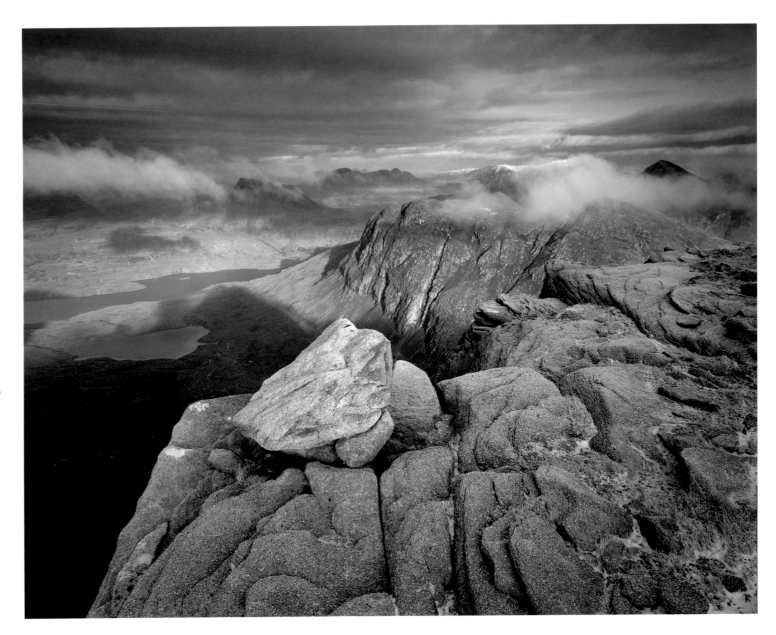

SGÙRR AN FHIDHLEIR

Summit view looking north

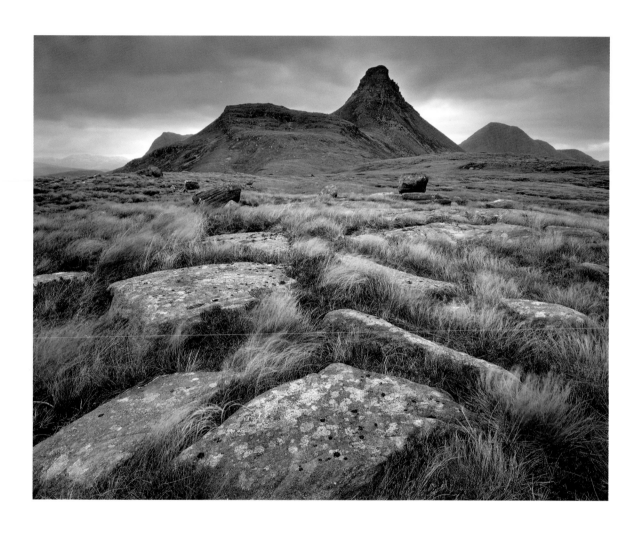

STAC POLLAIDH

from Druim Bad a' Ghail

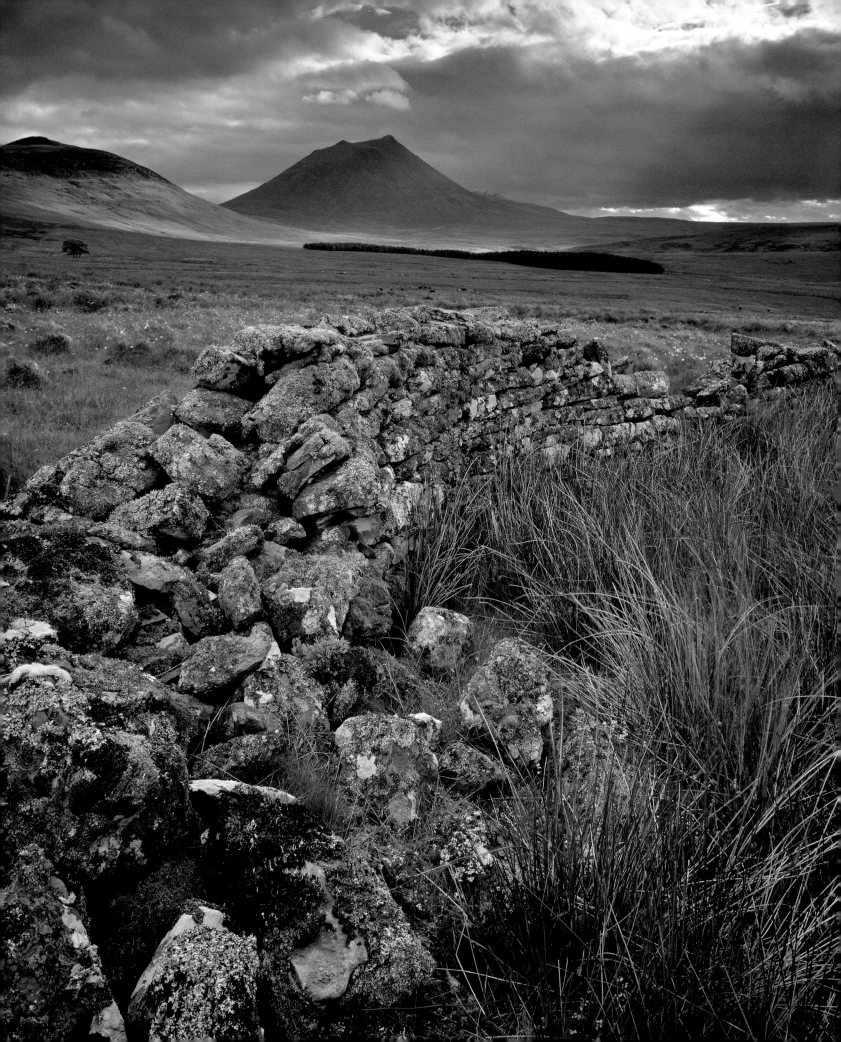

MORVEN

LOCH DRUIM SUARDALAIN

Ruined sheep enclosure

Deer skull

134

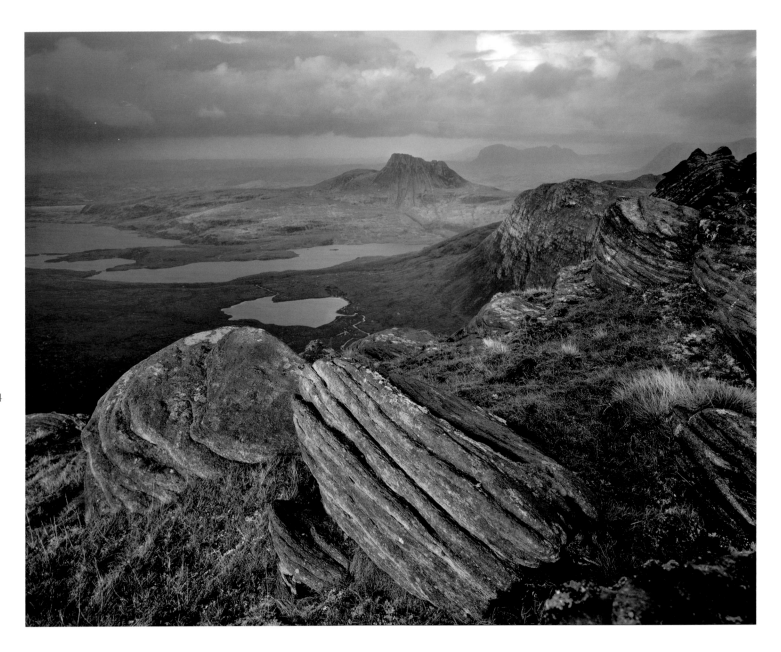

STAC POLLAIDH

from Sgùrr an Fhidhleir

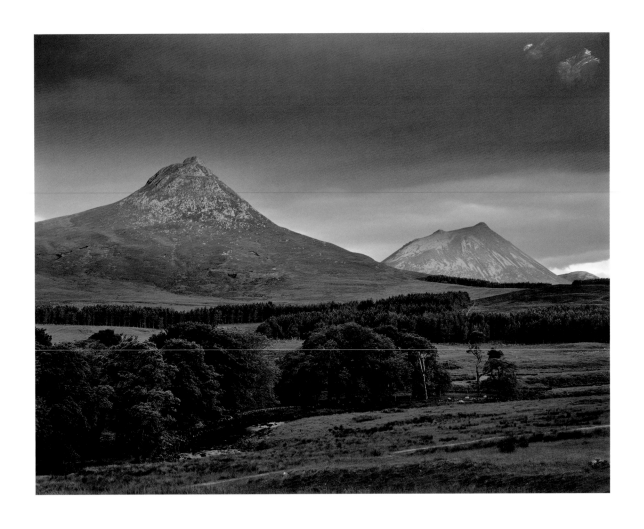

MAIDEN PAP

and Morven beyond, summer sunrise

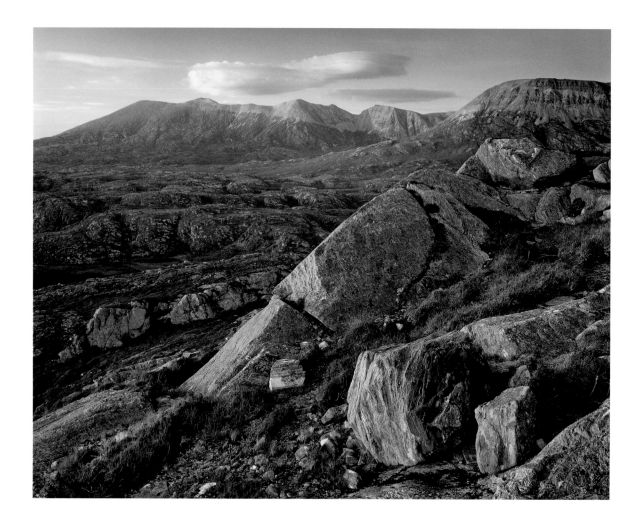

FOINAVEN
and Arkle from Cnoc Bad na h-Achlaise

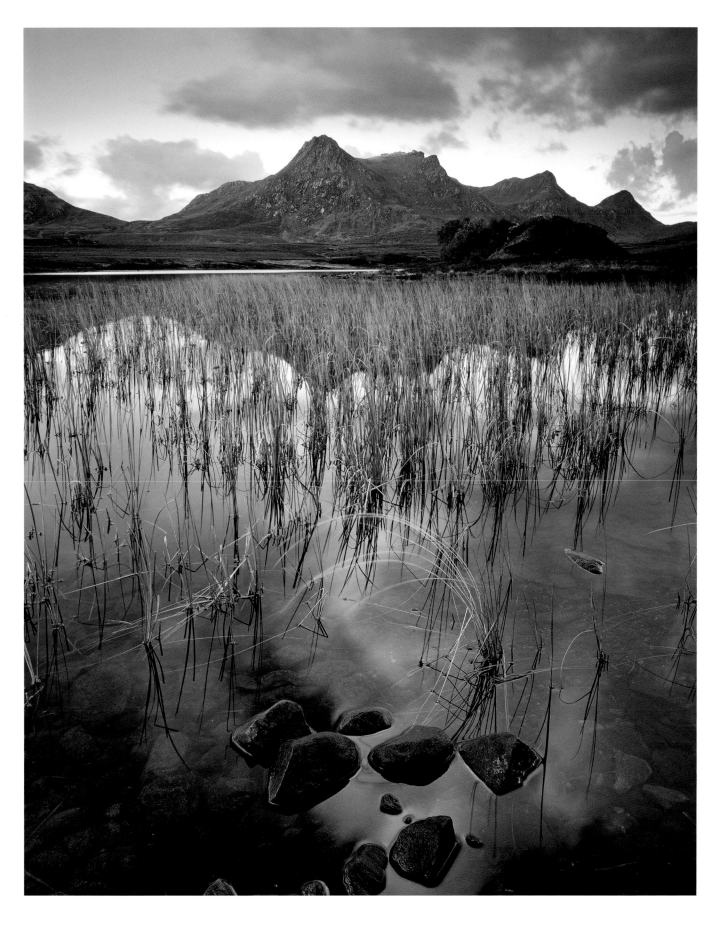

BEN LOYAL

from Lochan Hakel

138

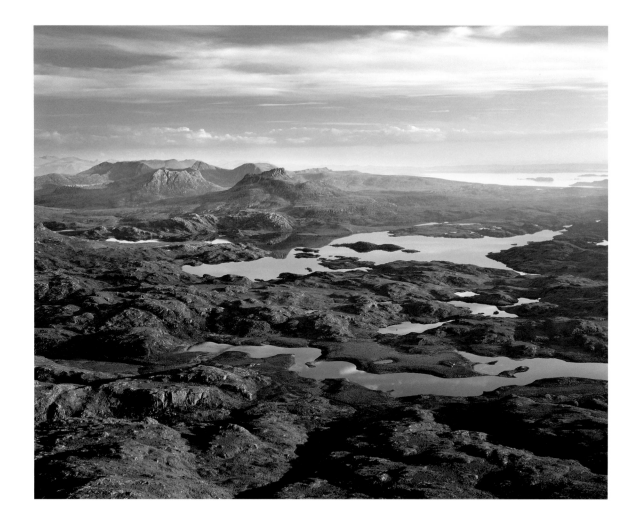

INVERPOLLY

from Suilven

ASSYNT HILLS

from Druim Bad a' Ghail

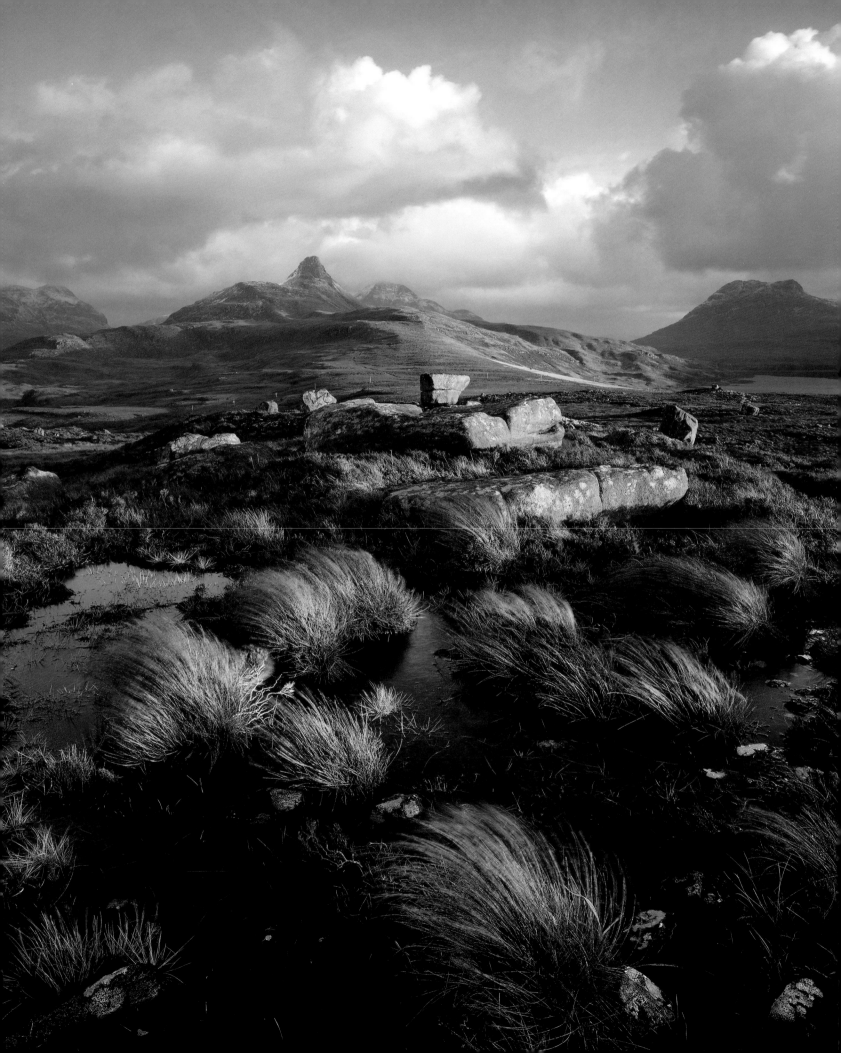

AFTERWORDS

CAMERAWORK
FIELDNOTES
FIELDWORK
THANKS

COASTAL SANDSTONE
Arran

CAMERAWORK

ALMOST ALL THE PICTURES in the book were made with an Ebony 45SU, a wooden 5x4inch field camera. I used many different lenses for the images, including 72mm, 90mm, 110mm, 150mm, 210mm and 300mm. I always mount the camera on a Gitzo tripod for this type of photography, measure the light with a handheld spotmeter (Minolta or Pentax), and use Lee neutral density graduated filters for balancing exposure. The film is Fuji Velvia or Provia, in Quickload sheets.

Initially I wondered whether it made sense to use a 5x4 camera in such demanding conditions; but once I made a start it became apparent that all that would stop me was fear and laziness, and that there is no less reason to be using such an instrument here than anywhere else. The special controls the camera offers, and the disciplines imposed on the photographer function just as well up a mountain as elsewhere, though the frustrations caused by the cumbersome workflow (and picture possibilities missed) are acute. After all, it is very difficult to 'pop back' on another occasion to try again.

I have always felt inspired by photographers who have been obliged by circumstance to suffer greatly in pursuit of their art, yet have triumphed through adversity. Frank Hurley, photographer of Earnest Shackleton's *Endurance* expedition in Antarctica, is perhaps the most conspicuous example. To have compromised my approach on the grounds of convenience would have been to betray this tradition.

There is a proper sense of occasion and significance setting up a big camera on a tripod. I liken the process to a painter setting up a canvas on an easel, and working with paints and brushes, *en plein air* (as the Impressionists described it). The process itself, with its laborious workflow, reinforces a sense of respect for photography and for the landscape. This in turn helps me make pictures that I feel do justice to the subject. It is impossible to snap, to take, to point and shoot and walk away.

Although I do not record my shutter speed and aperture settings, it is simple enough to guess what was used in most cases because I generally use the same apertures on the lens, and alter the shutter speed to suit the light. Almost invariably I use f/22 – f/32 on my view camera lenses. A shutter speed of 1 second is probably the most common, with longer and shorter than that somewhat less so. The shortest I used in this book would have been around 1/15th sec; the longest around one hour.

As I write this, the logic of shooting digitally becomes ever harder to avoid, for the quality and convenience of modern digital cameras are absolutely compelling. I have already begun the task of investigating these possibilities for the future, and indeed a small number of the images here were made digitally. But the vast majority were made with my Ebony, and I am glad that I was able to complete the project almost exclusively in this way. I realise it may be the last time.

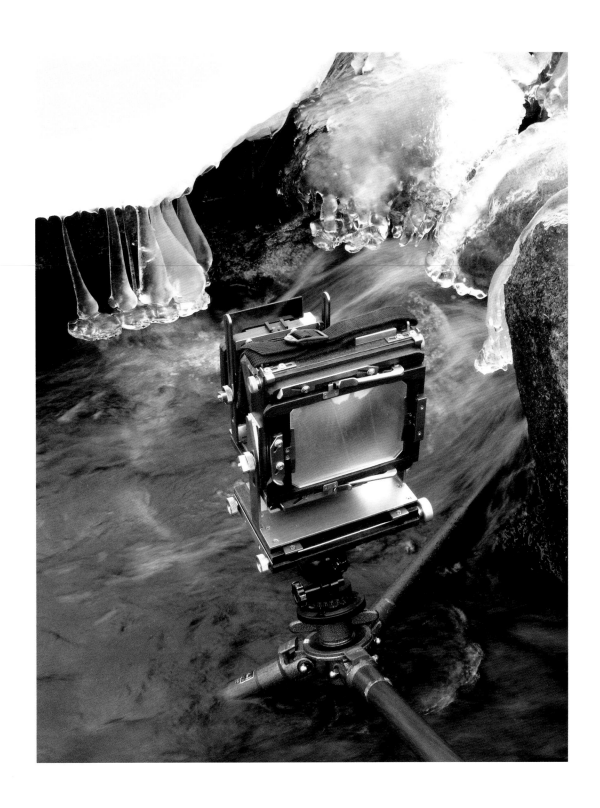

EBONY CAMERA

Taken with a Ricoh GX100, as were a number of the black and white photographs

FIELDNOTES

Page 1. Slioch (The Spear), Loch Maree
October, setting sunlight, looking northeast
Ebony 45SU, 90mm, Fuji Velvia 50
Loch Maree is described by many as Scotland's finest loch. Slioch presents an irresistible attraction on its eastern shore, its ferocious northwestern buttresses belying the rather easy ascent that can be made from the south east.

Page 3. Ben Arthur (aka The Cobbler) from Beinn Ìme
March, midday sunlight, looking south
Ebony 45SU, 300mm, Fuji Provia 100F
Following a blizzard, remarkable vistas of the snow-covered landscape appeared all around. The relatively high sun (March, and midday) made a strong blue colour cast inevitable.

Page 4. Glen Etive, Sgùrr Dubh (Dark Peak)
February, mid afternoon, looking southwest
Ebony 45SU, 90mm, Fuji Velvia 50
The river Etive is subject to huge variations in flow, due to the high mountains that frame its catchment. Consequently it is an abrasive character, busy polishing its granite bedrock with regular fury. In dry spells, a subtle flourish of colour and texture is revealed.

Page 7. Cnoc a Mhèirlich, the Quiraing, Skye
October, mid afternoon, looking south
Ebony 45SU, 90mm, Fuji Velvia 50
Not many places offer such a distracting abundance of viewpoints as the Quiraing does. This was a day of constantly changing weather. Sunlight across the middle distance inspired the timing of the picture.

Page 8. Hallival and Askival, Rùm
April, evening sunlight, looking due east
Ebony 45SU, 210mm, Fuji Velvia 50
Rùm's wildness made hunting for viewpoints hugely challenging. Ken and I camped two nights near the Barkeval Bealach, and spent a long day walking the wild heart of the island in search of angles and detail. This was almost the only moment when the cloud rose enough to reveal the major summits.

Page 11. Loch Bà, Beinn Achaladair, Beinn an Dothaidh
June, evening, looking south
Ebony 45SU, 90mm, Fuji Velvia 50

Cotton grass is tiny and the technical difficulty of resolving focus in relation to the distant mountains preoccupied me. So I was lucky to capture the last rays of warm light before the sun disappeared behind thickening cloud.

Page 13. Ben Cruachan (Conical Mountain), Loch Etive
June, sunset, looking north
Ebony 45SU, 90mm, Fuji Velvia
Cruachan is quite an expedition to climb, so to make best use of our efforts, Roger Soep and I bivvied near the summit for the dawn that followed this elusive evening light. Although midsummer, frost covered our bivvy bags when we woke an hour before sunrise (around 2.40am).

Page 23. Glen Nevis, Birch
March, late afternoon (getting dark), overcast
Ebony 45SU, 90mm, Fuji Provia 100F
Late winter presents serious challenges for landscape photography, with vegetation dead and often damaged by winter frosts and storms. This birch with its sinuous, taut lines seemed to rebuke the sleeping landscape and say, 'I am alive!'

Page 24. Ben Lomond (Beacon Hill) and Highland Fault
October, late afternoon, looking west
Ebony 45SU, 90mm, Fuji Velvia 50
The rock outcrop in the foreground is quite literally on the Highland Fault. Since Ben Lomond is the first major mountain in the southern Highlands as we journey north, and the lochs in the middle distance effectively the Highland Fault boundary, this angle seemed to sum up: 'this is the Highlands'.

Page 25. Rocks on Am Bodach (Old Man), Ring of Steall
April, late afternoon, looking north
Hasselblad 503CW , 40mm, Phase One P45+
Fine weather makes an enjoyable day out on the hill, but it can be frustrating, with haze cutting colour and tonal variations, and mood. Considering this climb is a major undertaking and not easily repeated I was relieved this cloud came to my rescue.

Page 26. Stob Dearg (Dark Peak) from Stob Beinn a Chrulaiste (Rocky Hill) March, sunrise, looking south
Ebony SW45, 90mm, Fuji Velvia 50
Stob Dearg is the public 'face' of Buachaille Etive Mòr, its highest

summit, and is instantly recognizable from below. I was seeking a completely novel angle on it that would also be photographically coherent, lighting-wise.

Page 27. **Benderloch, shore detail**
March, late afternoon (getting dark), overcast
Ebony 45SU, 110mm, Fuji Provia 100F
On an overcast day, the mountains were concealed by low cloud, so I photographed this summit-shaped rock with its dark stripes of drying seawater on the shore instead.

Page 28. **Ben Lomond western slopes, woodland waterfall**
April, late morning, drizzle
Ebony 45SU, 150mm, Fuji Velvia 50
If you aren't prepared to venture out into the rain, then inevitably many Scottish days will pass you by completely. Yet the subtle intensity of the colours and the soft light can be extremely rewarding, especially in woodland.

Page 29. **Stob a' Ghlais Choire**
October, late afternoon, looking southwest, rain
Ebony 45SU, 110mm, Fuji Velvia 50
Autumn colour is spectacular in Scotland most years; it 'peaks' in soft light, and when wet. It may not be much fun setting up a view camera on a tripod in the pouring rain, especially when it is windy too. And it condemns the photographer to an evening spent drying out gear. But the results make it worth a try.

Page 30. **Loch Etive and Ben Cruachan**
March, morning, looking southwest
Ebony 45SU, 90mm, Fuji Velvia 50
Photographers revere Glen Etive. At it's foot is Loch Etive whose tidal waters run far inland, lapping below several mountains. When the light is frustratingly elusive, foreground texture often becomes the focus of my camera.

Page 31. **Glen Nant**
March, early morning, soft sunlight
Ebony 45SU, 300mm, Fuji Provia 100F
Very little of Scotland's ancient woodland remains, but in quiet nature reserves such as Glen Nant it is making a healthy return. Flourishing hanging mosses such as this old man's beard is a testament to the air quality of the region.

Page 32. **Glen Nevis, Caledonian pine**
June, evening, looking southwest
Ebony 45SU, 110mm, Fuji Velvia 50
Since I never managed to photograph Ben Nevis, which is Scotland's highest mountain when all is said and done, it was quite pleasing to record its shadow, which covers the foreground grasses here. It very soon after swallowed up the tree as well.

Page 33. **Glen Orchy, river bank**
June, early morning, in shadow of trees, sunshine and blue sky
Ebony 45SU, 150mm, Fuji Velvia 50
Glen Orchy has a well-founded reputation for spectacular rock formations, carved by its river, which is frequently in spate. Two dry-ish months had left this sculpted rock exposed. The yellowish reflections in the river are of sunlit trees.

Page 34. **Beinn Trilleachan (Mountain of Oyster-catchers)**
March, early afternoon, looking northeast
Ebony 45SU, 90mm, Fuji Velvia 50
I had considerable difficulty setting up the tripod in a cramped space against a bank. The steep slopes of a mountain are often harder to shoot from than the comparatively comfortable flattish areas at the bottom or the top.

Page 35. **River Coupall, Buachaille Etive Mòr (The Great Hersdman of Etive)** February, sunrise, looking west
Ebony 45SU, 90mm, Fuji Velvia 50
With such beautiful ice formations to enjoy, this was always going to be a good morning. The mist playing over the mountain's summit was a bonus. I shot nine sheets of film of the same composition as the sun rose, an outrageous extravagance (but they are all subtly different).

Page 36. **Glen Etive, gorge**
February, midday, looking southwest
Ebony 45SU, 72mm, Fuji Velvia 50
Hemmed in by mountains, Glen Etive can be challenging when sunny, with deep shadows and an excessive contrast range. Perhaps counter-intuitively it is magnificent in overcast or drizzly conditions, when its granite bedrock and fast-flowing waters really come alive.

Page 37. **Lochan na Stainge, ice contours**
March,early morning, cloudy bright
Ebony 45SU, 210mm, Fuji Provia 100F
Ice is compelling, a living artwork of nature. Here, the soft yet directional light plays across its contours, revealing the shallow slopes created by retreating loch waters. Cloud (reflected in the water) covers the sun, moderating contrast.

Page 38. **Lochan na Stainge, Clach Leathad (Stone Slope), Meall a' Bhùiridh (Hill of the Roaring)** February, early afternoon, looking west
Ebony 45SU, 90mm, Fuji Velvia 50
Consciously or unconsciously I seek out edges and contrasts in the landscape. Here are the edge of a loch, the edge of the cloud and the contrast between the sharp edges of the cracked ice and the softly curved snow slopes reflected in the distant waters.

Page 39. **Snow wave, Stob na Doire**
December, setting sunlight, looking north west
Ebony 45SU, 90mm, Fuji Velvia 50

In spite of their beauty, unbroken fields of blinding white snow are not ideal subject matter. It is only when the sun is low and softer that depth can be effectively conveyed, and abstract gestures fully revealed.

Page 47. Glen Rosa Water, Arran
April, late afternoon, shadow of the mountains
Ebony 45SU, 150mm, Fuji Velvia 50
Minimalism isn't really my strength, but occasionally I come across something that demands that approach. The immutable motionlessness of granite beside the surging flow of river water presented a great theme for abstraction.

Page 48. Ruinsival (heap of Rocks) from An Dornabac, Rùm
April, mid afternoon, looking southeast
Ebony 45SU, 90mm, Fuji Velvia 50
Apart from remnants of a primitive road there are virtually no tracks across Rùm's wild landscape. I had the authentic sense that I might be the first person ever to have stood in this particular spot.

Page 49. Caisteal Abhail (Castle of the Fork), Arran
April, early morning, looking south
Ebony 45SU, 90mm, Fuji Velvia 50
As so often before, I was up and out long before dawn in the hope of a spectacular sunrise to illuminate the mountains. When that didn't happen I still felt grateful for being surrounded by beauty; and I still made a picture.

Page 50. Blà Bheinn (Blue Mountain), Skye
April, late afternoon, looking southeast
Ebony 45SU, 210mm, Fuji Velvia 50
Patchy snow makes smooth tonal gradations impossible. Making pictures of these 'brittle', broken, awkward tones is especially difficult, yet important, for this is a typical condition of Scotland's mountains.

Page 51. Ben Tianavaig, Skye
October, late afternoon, looking north
Ebony 45SU, 90mm, Fuji Provia 100F
It may not be very high, but I think Ben Tianavaig makes an unforgettable addition to Skye's mountainous landscape. The coastal foreground typifies the island's volcanic geology.

Page 52. Sgùrr a' Fheadain (Peak of the Water Channel), Allt Coir' a' Mhadaidh, Skye April, midday, looking east
Ebony 45SU, 110mm, Fuji Velvia 50
The Black Cuillin is a brutal and harsh mountain range of dark rock which while undeniably spectacular, makes no easy task for photography. So I was grateful here for the softening effect of cloud playing on the peaks and cool shadow in the foreground.

Page 53. Goatfell and Cìr Mhòr (The Big Comb) from Caisteal Abhail, Arran April, sunset light, looking south

Ebony 45SU, 90mm, Fuji Velvia 50
This mountain summit has amazing rocks, but no linking feature to draw the eye towards the background. Thus I found myself making the 'link' with shape and proportion, looking to reflect and echo the curves in the foreground granite with the distant ridges.

Page 54. Loch Ailort from Sean Cruach (Old Heap)
March, sunset, looking west
Ebony 45SU, 90mm, Fuji Velvia 50
Sometimes Scotland seems all rainy days with the odd sunny one, but there can be prolonged dry spells. Climbing mountains is safer and easier, but photography is more difficult. The absence of cloud on this day made the light uninteresting until a few moments before sunset.

Page 55. Old Man of Storr, Skye
October, sunrise, looking southeast
Ebony 45SU, 72mm, Fuji Velvia 50
What looks like great lighting was extremely short-lived, and accompanied by spitting rain, making this moment tricky to capture. Credit to my sturdy workshop companions, who laboured up the hill with me and witnessed all this before breakfast.

Page 56. Cleat, Dun Dubh, and Cnoc a Mhèirlich from the Quiraing
October, early morning, looking south
Ebony 45SU, 90mm, Fuji Velvia 50
While the Quiraing and the Storr are renowned for their vertical cliffs, towers and other craggy rock features, this view shows that the rhythms of the Trotternish Ridge are in fact curvaceous and softened by vegetation.

Page 57. Ruinsival from Barkeval (Precipice Hill) slopes, Rùm
April, morning, looking south
Ebony 45SU, 150mm, Fuji Velvia 50
It was a surprise to find this volcanic rock apparently billowing like blankets in the wind. The small rocks in the foreground were there exactly as seen, random additions to a crazy, surreal landscape.

Page 58. Allt Coir' a' Mhadaidh, Skye
April, early afternoon, cloudy
Ebony 45SU, 150mm, Fuji Velvia 50
Where water energy is high, and waterborne scouring rocks and grit abundant, then nature becomes a fantastic sculptor. This is why streambeds in the mountains are often so beautiful. Ironically it is when water levels are low that they make the best pictures.

Page 59. Faochag (Whelk Hill), The Saddle, from Glen Shiel battle site April, early morning, looking west
Ebony 45SU, 210mm, Fuji Velvia 50
The busy road to Skye runs through Glen Shiel, but the slopes above are remote and lonely, and in these conditions feel utterly desolate, consistent with a place where hundreds died in the Jacobean rebellion.

146

Page 60. Blà Bheinn from Marsco (Seagull Mountain), Skye
April, midday, looking south east
Ebony 45SU, 90mm, Fuji Velvia 50
Richard and I had fully intended to climb Garbh-bheinn, aiming to photograph Blà Bheinn from there. The approach slope looked a little dangerous though, and we opted for the more agreeable-looking Marsco instead. It proved a fruitful plan B.

Page 61. Allt Coire na Banachdich, Skye
October, afternoon, overcast
Ebony 45SU, 300mm, Fuji Velvia 50
This composition suggested itself to me because the waterfall was flowing on one diagonal, the tree 'flowing' on the opposite one.

Page 62. Gars-bheinn, Sgùrr na Stri (Hill of Strife) from Elgol, Skye October, late afternoon, looking northwest
Ebony 45SU, 90mm, Fuji Velvia 50
Geology and geometry are both important to me, and I am particularly pleased when I have both in one picture.

Page 63. Sgùrr nan Gilean (Peak of the Gullies) from Allt Dearg Mòr, Skye April, early morning, looking south
Ebony 45SU, 90mm, Fuji Velvia 50
On this fine morning the sun rose from a clear blue sky and was initially too stark. As it started to warm the air so cloud began to build around the mountains, and for a few magical moments, all was perfect. A polarizer, which I rarely use, intensified the sky.

Page 75. Loch a' Garbh-choire, drowned tree stumps
November, early morning, cloudy but bright
Ebony 45SU, 150mm, Fuji Velvia 50
Evidently, this small lochan raised its water level at some point in the recent past, drowning several trees that previously lined its banks. The stumps that remain may be dead but exhibit a stark, skeletal vitality that complements the grasses and water that surround them.

Page 76. Stacan Dubha, icicle cascade
February, midday, overcast
Ebony 45SU, 300mm, Fuji Provia 100F
This is not a subject that leant itself to a highly artistic interpretation, but as a phenomenon of nature it seemed essential to record it. A long lens helped isolate it from bright (and distracting) snow banks nearby.

Page 77. Coire an Lochain, pendulum icicles
February, afternoon, overcast
Ebony 45SU, 150mm, Fuji Provia 100F
A gravity-defying and short-lived creation of nature, the light refracting around the bulbous flares of these icicles was, for me, their principal attraction. The tripod was immersed in a mountain stream with the camera perched a few inches above the water surface.

Page 78. Cairn Toul and Sgòr an Lochain Uaine, from Cairn Lothan
February, dawn, looking southwest
Ebony 45SU, 90mm, Fuji Velvia 50
We camped two nights on the Cairngorm plateau, for 'being in the right place at the right time' remains axiomatic for landscape photography. Walking out from a tent at over 3,700 feet above sea level on a still, clear winter morning and seeing the sun rise was unforgettable.

Page 79. Fèith Buidhe (Yellow Bog Stream) and Beinn Mheadhoin (Middle Mountain) February, dawn, looking southwest
Ebony 45SU, 90mm, Fuji Velvia 50
Initially the blanket cloud cover seemed unhelpful, yet in a place regularly battered by hurricane force wind the still conditions made large format photography possible, and the soft light was ideal for this complex composition.

Page 80. Lower Strath Nethy
November, afternoon, looking southeast
Ebony 45SU, 90mm, Fuji Velvia 50
This dead tree seemed a wonderfully symbolic feature of the landscape, yet the light and its situation made isolating it impossible. A wide-angle composition showing the context and setting was the only alternative.

Page 81. Glen Luibeg
January, morning, looking east, overcast
Ebony 45SU, 210mm, Fuji Provia 100F
Trees plastered in snow were an artistic legacy from the previous days blizzard. While this composition may appear simple, it is the result of over half an hour of consideration and alignment, until everything fell into place. The unchanging overcast conditions helped.

Page 82. Cornice, Bràigh Coire Chruinn-bhalgain (Height of the Corrie of Round Blisters) April, sunset light, looking southwest
Ebony 45SU, 150mm, Fuji Velvia 50
Michael Fatali's great image 'Evening's Edge' has influenced a generation of landscape photographers, and I realize in retrospect that this photograph is very much an *homage*. At the time, though, I was more concerned with making the exposure before the sun disappeared over the horizon than whether I was indulging in wilful plagiarism…

Page 83. Sgòr an Lochain Uaine (Peak of the Green Lochan, aka The Angel's Peak) February, sunset, looking southwest
Ebony 45SU, 300mm, Fuji Velvia 50
Standing beneath cloud looking towards a clearing above the horizon, into which you know the sun will set, does sometimes generate unrealistic expectations of an awesome display of colour. As it turned out this one was subtle rather than spectacular.

Page 84. Lairig Ghru, from Ben Macdui
February, early morning, looking north
Ebony 45SU, 210mm, Fuji Provia 100F

147

Linking the textures and detail of the foreground to the broader shapes and gestures of the wider landscape has long been one of my missions. When the principal distant feature is the dark abyss of the Lairig Ghru that presents a particular challenge.

Page 85. Coire an Lochain, ice heart
February, afternoon, shadow of the mountains
Ebony 45SU, 150mm, Fuji Velvia 50
Cold conditions and cold light are often successful photographic companions. And where ice forms on and around river beds, its accumulation may be random but the resulting shapes can often lead to playful figurative interpretation.

Page 86. The Devil's Point, River Dee
February, afternoon, looking north
Ebony 45SU, 300mm, Fuji Velvia 50
The Devil's Point is as dramatic a mountain as any in the Cairngorms, yet height-wise it is but a modest sub-summit of Cairn Toul. For me it represented the gateway to the Lairig Ghru, and the focus of my most extreme mountain experience, a seven mile walk in alone to the Corrour Bothy in the depths of winter.

Page 87. Lairig Ghru and River Dee
February, before dawn, looking north
Ebony 45SU, 90mm, Fuji Velvia 50
Dividing Britain's second, third and fourth highest mountains, and 600 metres above sea level, the Lairig Ghru can fairly claim to be a glen above all others. The freezing river and slopes of almost unbroken pure snow made a scene of irresistible symbolism, especially in the misty luminescence before sunrise.

Page 88. Loch a' Gharbh-choire
November, dawn, looking north
Ebony 45SU, 90mm, Fuji Velvia 50
Isolated Caledonian pines are an outstanding feature of Lower Strath Nethy; this composition interprets their contribution to the skyline.

Page 89. Càrn Liath (Grey Hill), range of Beinn a' Ghlo (Hill of the Mist) April, sunset light, looking southwest
Ebony 45SU, 90mm, Fuji Velvia 50
Raking light across the cornice is vital here, but equally important for me are the shallow linear arcs throughout the landscape, connecting disparate elements in a subtle harmony.

Page 99. Loch Clair, reeds and reflection Sgurr Dubh
October, early morning, looking southwest
Ebony 45SU, 150mm, Fuji Velvia 50
Loch Clair is an understandably popular location for photography, with Beinn Eighe rearing up steeply to the north and Liathach framed beyond it. Its sheltered shoreline attracted me here, with the partly concealed reflection of Sgurr Dubh a challenge to the imagination.

Page 100. Beinn Eighe (File Mountain) from Loch Allt an Daraich
October, midday, looking south
Ebony 45SU, 110mm, Fuji Provia 100F
Ordinarily, such completely soft, flat light would suggest concentrating on details, but having climbed a long way to this interesting view of the north face of Beinn Eighe I wanted to illustrate the setting. The subdued colours evoke Peter Dombrovskis, whose work has long been a source of inspiration to me.

Page 101. Beinn Eighe, Triple Buttress from Coire Mhic Fhearchair
June, late afternoon, looking south
Ebony 45SU, 90mm, Fuji Velvia
By this point in the evening a powerful convection wind had developed so strongly that positioning the camera was as much dependent on finding a little shelter for the tripod as it was about selecting the best angle.

Page 102. Sgùrr nan Fhir Duibhe (Peak of the Dark Men)
October, late afternoon, looking north
Ebony 45SU, 360mm, Fuji Velvia 50
Caught by the sun at the right angle Beinn Eighe's quartzite summits can appear covered in snow. Very unusually for me this was made with a telephoto lens that helped frame the mountain within the arc of the trees.

Page 103. Allt Coire Mhic Fhearchair, Beinn Dearg (Red Mountain), Baosbheinn (Wizard's Peak) and Beinn an Eòin (Peak of the Bird)
June, late afternoon, looking west
Ebony 45SU, 90mm, Fuji Provia 100F
The cloud was forming an umbrella over the mountains, giving foreground shade, distant light. The contrast was severe, but the minimal palette of backlit colours compelled me to try this version. When I returned at sunset, the softer lighting lacked this energy.

Page 104. An Teallach (The Forge), Loch Toll an Lochain
June, dawn sunlight, looking west
Ebony 45SU, 72mm, Fuji Velvia 50
I had originally planned to photograph the dawn light on An Teallach reflected in the still waters of the corrie loch. As it became clear the huge shadow would dominate such a composition I relocated further back, using this modest pond for reflections, and the perched boulder as a focus against this dark backdrop.

Page 105. Strath Lungard and Beinn Àirigh Chàrr
April, sunset light, looking north
Ebony 45SU, 90mm, Fuji Velvia 50
Flat-topped Beinn a'Chearcaill is an extraordinary location; surrounded by slightly higher mountains it makes a great viewing balcony, and its summit plateau a fascinating foreground. Not being a Munro it is rarely climbed. I saw absolutely no-one all day in spite of perfect walking and weather conditions.

148

Page 106. Beinn a' Chlaidheimh (Peak of the Sword) from Carn a' Bhreabadair October, late afternoon, looking south
Ebony 45SU, 90mm, Fuji Velvia 50
I set out on this afternoon with little expectation, but hopes of finding a viewpoint from which to shoot An Teallach at dawn. I found a viewpoint, and this angle too. The following dawn I returned, but the light did not, and I left empty-handed

Page 107. Slioch, Loch Maree
October, late afternoon, looking northeast
Ebony 45SU, 90mm, Fuji Velvia 50
I will always associate northwest Scotland with an abundance of weather. In the months I have spent there, sunlight has been in short supply. However, good conditions don't always encourage my most creative work. I am probably too busy gratefully recording the light.

Page 108. Grudie Bridge, Caledonian pines
April, afternoon, drizzle
Ebony 45SU, 150mm, Fuji Velvia 50
Without doubt, being a photographer has taught me to appreciate rain. Colours are often far more alive, and textures too, softly sculpted by the cool, damp light.

Page 109. Liathach (Greyish One), Beinn Eighe and Loch Clair
October, early morning, looking west
Ebony 45SU, 90mm, Fuji Provia 100F
The colours in October and November are wonderful, but it is frequently wet and windy, and an image like this clearly requires the benefit of calm conditions. Precise camera positioning and control of focus help clarify what can appear as chaotic subject matter.

Page 110. An Teallach from Bidein a' Ghlas Thuill (Peak of the Grey-green Hollow) June, late evening, looking south
Ebony 45SU, 90mm, Fuji Velvia 50
This is not a mountain you can pop up at a whim, and this picture is from my only time on its summit to date. The light was far from ideal, but nevertheless a residue of very late sunlight boosted the rhythms and texture of the foreground. One day I will return.

Page 111. Baosbheinn and Beinn an Eòin from Coire Mhic Fhearchair
June, afternoon, looking west
Ebony 45SU, 90mm, Fuji Velvia
The chaotic nature of wild places can sometimes be overwhelming. One of the creative challenges a photographer faces is revealing the subject matter, which inevitably means 'organising' a composition, without losing its wild soul.

Page 112. Beinn Damh (Stag Mountain) from Bealach na Gaoithe
October, late afternoon, looking southeast
Ebony 45SU, 90mm, Fuji Velvia 50
West of Beinn Alligin the road climbs over Bealach na Gaoithe, giving

easy access to wonderful elevated viewpoints. Leading workshops gives me the opportunity to share such wonders with others; this was one such occasion.

Page 113. Loch Coulin, Beinn Eighe
October, afternoon, looking north
Ebony 45SU, 210mm, Fuji Velvia 50
A long lens gives a calm, stand-off perspective, and the stately skyline of Beinn Eighe frames the composition. The bucolic atmosphere evokes Romantic painting; it lacks only some wading cattle, and a cowherd watching from the trees to complete it.

Page 114. Sàil Mhòr and Liathach from Beinn a' Chearcaill
April, late afternoon, looking south
Ebony 45SU, 90mm, Fuji Velvia 50
This flat-topped summit gives an unusual grandstand view of much better-known mountains. Their shaded north-facing slopes and corries typically retain remnants of winter snow into the spring and early summer.

Page 115. Torridonian sandstone, Loch Maree
April, afternoon, bright sunlight
Ebony 45SU, 210mm, Fuji Provia 100F
I love the fact that rock, which is pretty static in human terms, can appear to ripple and flow in the right light. I am interested in finding a dynamic interpretation of it, for that says more than words can about the inspiration geology holds for me.

Page 116. An Teallach, Gruinard Bay
June, late afternoon, looking east
Ebony 45SU, 90mm, Fuji Velvia 50
Perhaps this is a curious place from which to photograph a mountain, but the seashore is so much a part of Scotland's mountainous landscape I wanted to include it. This picture was made in relief after three days of unceasing rain and low cloud.

Page 117. Slioch from Beinn a' Chearcaill
April, evening sunlight, looking north
Ebony 45SU, 300mm, Fuji Velvia 50
My view camera is especially well adapted to a task such as this one, where the foreground detail and the distant mountain are of equal significance. Its focus control enables me to render sharp detail throughout the picture space.

Page 125. Coigach, stream near Culnacraig
January, afternoon, overcast.
Ebony 45SU, 110mm, Fuji Velvia 50
In the absence of overshading leaves and distracting colours, trees still express their innate vitality in winter. This composition was prompted by the two opposing 'flows': water from right to left, branches from left to right.

149

Page 126. Loch Beinn a' Mheadhoin, Glen Affric
November, late afternoon, looking east
Ebony 45SU, 90mm, Fuji Velvia 50
Earlier in the afternoon this photograph was taken I nearly lost all my camera gear when my pack overturned beside a river swollen by rain. I lost a lens, some accessories and a few sheets of film. Wounded by the experience, I determined to 'get back in the saddle', and make a photograph before the light disappeared. This is my redemption. Although a bit far south for The Far North chapter, Glen Affric has all the characteristics of Scotland's remote northern regions.

Page 127. Suilven (Pillar), Loch Sionascaig
November, sunrise, looking northeast
Ebony 45SU, 90mm, Fuji Velvia 50
Anyone who had never seen it might be forgiven for believing Suilven to be an easy photographic subject. But after years of 'hunting down' viewpoints I have found very few that begin to do it justice. It is an elusive mountain, often half hidden from the roadsides. And then there is the weather…

Page 128. Lael Forest, autumn on the slopes of Beinn Dearg
November, midday, looking north
Ebony 45SU, 210mm, Fuji Velvia 50
Modern, densely planted spruce plantations, cash crops, are a blight in Scotland's mountains. But where the planting is older, and usually done for environmental variety, such as here, the mix of native and non-native trees can be strikingly beautiful, especially in autumn.

Page 129. Stac Pollaidh (Precipice at the Pool), summit sandstone, mist November, midday, looking southwest
Ebony 45SU, 90mm, Fuji Provia 100F
As far as I know, no other Scottish mountain has such a geologically dramatic top as Stac Pollaidh. On a day when visibility never extended more than sixty or seventy metres once the cloud descended, this dramatic geology at least gave me subject matter to explore.

Page 130. Sgùrr an Fhidhleir (Peak of the Fiddler), summit view looking north January, midday, looking north
Ebony 45SU, 90mm, Fuji Velvia 50
From Ben Mor Coigach, wonderful prospects open to the north, but it is only from here (the 'Fiddler') that Suilven is framed, uninterrupted. Accurate use of a map and a ruler beforehand had prompted me to seek out this position.

Page 131. Stac Pollaidh from Druim Bad a' Ghail
January, early afternoon, looking east
Ebony 45SU, 90mm, Fuji Velvia 50
All mountains show different shapes and aspects as we move around them; this is my favourite view of Stac Pollaidh, a mountain that looks great from every angle. But from here it really has the poise and presence of some mythic volcano.

Page 132. Morven (Big Mountain), ruinous sheep enclosure
June, afternoon, looking southwest
Ebony 45SU, 90mm, Fuji Velvia 50
Morven, Scaraben and Maiden Pap are secluded hills, far from the madding crowd, and well worth exploring. This lonely landscape on the eastern side of northern Scotland offers a different beauty to the more spectacular west coast.

Page 133. Loch Druim Suardalain, deer skull
November, afternoon, cloudy bright
Ebony 45SU, 150mm, Fuji Provia 100F
Skulls have long held a fascination for me and interpreting them is simply an artistic preoccupation, as for many artists throughout the centuries. I do admit thinking that this particular example resembled the head of a Hollywood space alien!

Page 134. Stac Pollaidh from Sgùrr an Fhidhleir
November, afternoon looking north
Ebony 45SU, 90mm, Fuji Velvia 50
Ben Mor Coigach is a remarkable mountain, but being plateau-like and sprawling it is difficult to photograph in its own right. Fortunately it is fairly easy to walk up and, as well as great views, has a wealth of good geological detail for foregrounds.

Page 135. Maiden Pap and Morven
June, sunrise, looking southwest
Ebony 45SU, 300mm, Fuji Velvia 50
Maiden Pap in the foreground is probably the shortest 'mountain' in this book at 484 metres, while Morven beyond it is somewhat higher at 706 metres. This picture was made shortly after sunrise in June, around 3.30am (BST). I was back in my sleeping bag by 5am, giving me another three hours kip before breakfast.

Page 136. Foinaven (Windfell) and Arkle (Ark Mountain) from Cnoc Bad na h-Achlaise June, evening sunlight, looking northeast
Ebony 45SU, 210mm, Fuji Velvia 50
This scene looks serene enough, but the wind was gusting strongly this summer evening; the viewpoint just happened to be in a fairly sheltered spot. Sometimes it is necessity and practicality that drives the creative process, not what is 'ideal' or 'perfect'. Photography is very much the art of what is possible.

Page 137. Ben Loyal (Law Mountain or Beautiful Hill) from Lochan Hakel June, early morning, looking southeast
Ebony 45SU, 90mm, Fuji Velvia 50
This picture was taken during my first of four sessions at Ben Loyal. Literally it is my 'first encounter', the first time I saw the mountain with its wonderful broken ridge line in daylight – at 4.00 a.m on a summer dawn. I have subsequently climbed Ben Loyal twice, but frustratingly, come away – photographically speaking – with nothing. But what a mountain!

Page 138. Inverpolly from Suilven
June, late afternoon, looking south
Ebony 45SU, 150mm, Fuji Velvia 50
Topographically-speaking, this summer prospect does a decent job of describing the area. Photographically and emotionally, I am convinced it would be much more exciting in autumn or winter, with at least a dusting of snow on the distant mountains. One day, one day…

Page 139. Assynt hills, from Druim Bad a' Ghail
November, afternoon, looking east
Ebony 45SU, 90mm, Fuji Velvia 50
I hope this low angle connects with the wild atmosphere, the subtle yet rich colours of Scotland's mountains. What may not be obvious is the bitter, near gale-force winds that obliged me to locate the camera really close to the ground so the wind could be deflected around it…!

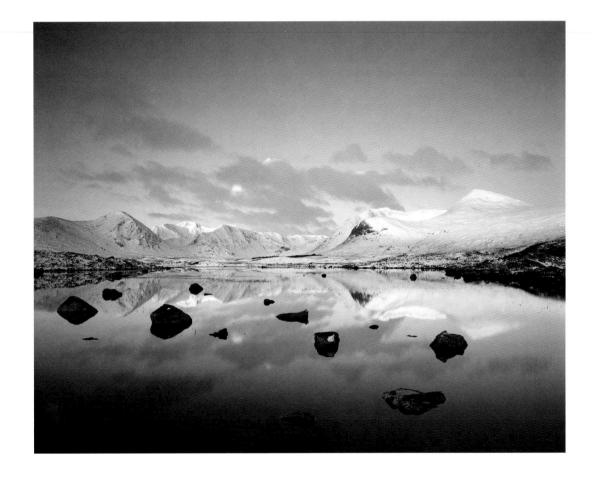

LOCHAN NA STAINGE
Stob Gabhar (Goat Peak) and Meall a' Bhùiridh (Hill of the Roaring)

FIELDWORK

CLIMBING SCOTTISH MOUNTAINS is hardly hardcore mountaineering. These heights are so modest by global standards that the highest of them, Ben Nevis, is the site of an annual footrace. The record time, running from bottom to top of the Ben and down again currently stands at 1 hour 25 minutes. With the one exception of isolated tops on the Cuillin ridge of Skye, every mountain in Scotland has an easy route to the summit in climbing terms.

One might conclude from this 'easy-ness' that these Scottish hills barely deserve the description 'mountain' at all. Yet even veteran Himalayan climbers admire and extol the appeal of Scotland's Mountains. When Alan Hinkes returned from completing the earth's 8000-metre peaks (the first Briton to do so) he was asked by journalists what he would be climbing next. A true Yorkshireman, his laconic reply was 'Stac Pollaidh'. He tells me he had never climbed this diminutive 612-metre mountain in Assynt, and had long wished to do so. The day job had got in the way...

For mere mortals, they offer us a first step, a taste of what it feels like to be high on the world. While the super fit may be able to run to the tops, for most a summit of 900 metres or more will take a number of hours to climb, and perhaps two thirds of that time to descend. From the glens or coast where we set out the landscape may be agricultural, with sheep or cattle pasture, or possibly woodland. The transition to moorland is sharp. Above a certain height the regularity and violence of the wind combined with the hunger of foraging deer eliminates trees, although where that height is depends on many localised factors including slope steepness, aspect and fertility, underlying geology, proximity of seawater, prevalence of wind direction and so on.

By 900 metres or so, the vegetation has become dwarf, and for long periods of the year will be covered in snow and ice. The highest and most exposed summits are a shattered quarry of wind and ice cleaved rock, and only lichens appear to inhabit many of the exposed surfaces. In a short time we have progressed from the familiar lowland world into somewhere brutal, harsh, unforgiving, hostile and awe-inspiring. It is this unexpectedly rapid transition, and the (relative) ease with which we can climb from the familiar to the extraordinary, that makes Scotland's mountains almost unique.

Scotland's mountains may be small but it is perhaps inevitable that climbing them, especially in winter, encourages dreams of mountaineering generally. My few forays above what might be termed the vegetation 'life line' (this is quite different to the Himalayan over-26000 feet 'Death Zone') have not inspired me to venture further, however. The high mountains are realms of gravelly rock, permanent snow, ice, blinding sunlight and crucifying blizzards. They are places of dehydration,

the pulmonary oedema, altitude-induced exhaustion, hypothermia, frostbite.

With so many of the world's major peaks now climbed, in the case of Everest by thousands, and so with no explorer's incentive to 'be the first', why do people pursue such challenges and voluntarily subject themselves to such suffering (and frankly, expense)?

Robert Macfarlane's book *Mountains of the Mind* addresses this enigma, describing and explaining the madness of mountaineering. In a world now softened by safety legislation, closed circuit television and a culture of conformism, his thesis presents mountaineering as an expression of the deep desire for death or glory.

Fortunately, death is not an especially common occurrence on the mountains of Scotland, for the altitude 'deficit' means less extreme cold and wind speed, and no altitude-induced misjudgements (caused by oxygen depletion) to contend with. Nevertheless, as I was once told, 'a fall of 40 feet or 4000 makes little difference, you hit your head you are just as dead'. A cliff is a cliff, whether on the Sgurr of Eigg or the North Face of the Eiger. As I write this, news of three climbers killed by an avalanche on the slopes of Buachaille Etive Mòr cast a shadow on last weekend's papers.

In *Mountains of the Mind*, Robert Macfarlane brilliantly distils the contradiction that lies at the heart of our perception of mountains; and in particular, our experiences when climbing them. "These are matters of hard, steep, sharp rock and freezing snow; of extreme cold; of a vertigo so physical it can cramp your stomach and loosen your bowels; of hypertension, nausea and frostbite; and of unspeakable beauty."

Reading most of this sentence one would surely question why any sane individual would subject themselves voluntarily to the mad pursuit of mountaineering. However, the final phrase banishes the preceding horrors and in one fell stroke beauty justifies any amount of suffering. Beauty may very well be in the eye of the beholder, yet all lovers of mountains will understand its meaning here; that fusion of space, colour, form, light and atmosphere that are the visual sensations of the mountain, refined and filtered by exhaustion and suffering into the heroic realm of our imagination. Memories of connection, of achievement, and of self-knowledge remain crystallised by beauty, long after the pain and fatigue have faded away.

It seems an obvious paradox that while human instinct drives us to take the easy option, and simple solutions, it is only through accomplishing complex and demanding challenges that we find true satisfaction and fulfilment. It could be said that only through navigating the rocky shores and mountainous obstacles of life that we truly find out who we really are. Mountains offer us, both literally and metaphorically, a path of self-discovery.

I HAVE ALWAYS 'FELT THE COLD', so spending a lot of time in cool, windy, damp places might seem somewhat masochistic! However, as I think Ruskin said, 'there is no such thing as bad weather, only bad clothing', and I have had great outdoor clothing from Páramo while working on this book. The Analogy fabric that their outerwear is made from gives excellent protection from wind, rain and snow, as well as being more comfortable, and durable, than laminated fabrics. Insulation is also vital in winter walking especially, and Páramo's Torres garment approaches goose down for warmth, while offering much

better wet weather performance. Waterproof leggings are also a must. Wicking fabrics next to the skin are essential in ensuring the effective performance of the weatherproof outer garments.

Boots are obviously a personal choice but I prefer to be slightly overshod rather than find I have wet feet. For pottering about around streams and lochs at low level I wear good quality rubber wellingtons, but for any climbing or walking on the hills, and especially in winter, proper boots are essential. For snow I have a pair of La Sportiva professional mountaineering boots, which are expensive but have been totally effective at keeping my feet and ankles warm, dry and secure.

Safety is as essential in mountain walking as it is in great range mountaineering. As a photographer I do have to take greater risks than would normally seem wise, or else never make photographs from high ridges and summits at dawn and dusk when the light is at its most magical and evocative. I therefore plan as carefully as I possibly can, with the first rule being never to climb mountains when the weather forecast predicts deteriorating conditions. The Mountain Weather Information Service, www.mwis.org.uk, has proved a reliable source of information on the state of the weather, with an emphasis on conditions above 900 metres. The details it provides are also useful for planning photographic expeditions at low levels.

I have camped out on Lochnagar, Ben Macdui and An Teallach, bivouacked on Ben Cruachan, and slept in bothies beside Loch Muick and in the Lairig Ghru. In every case I have had companions in whom I had total confidence and trust. Having friends and companions must surely be the best way to ensure a great experience on the hill.

Safety usually involves a chain of events and consequences. The higher we raise the stakes, the more important it is to have everything covered. In general it is wise to never go onto the hill alone. However, I have also done that many times. Whether alone or not we should always inform someone where we are going, be it hotel, guest house or campsite manager, with details of a proposed route and an estimated time of return. If unsure of the area and the conditions, contacting the local mountain rescue service, or enquiring at the local outdoor shop, will usually yield much useful advice.

Most big mountains in Scotland have well-established routes onto the summits, but these are rarely engineered trails, and on less well-known hills can be very faint or non-existent. It goes without saying that map-reading skills, and preferably a compass or GPS instrument should all help ensure safe navigation of the mountain should visibility deteriorate.

Finally, a word of warning to photographers who aspire to photograph from high up at dawn or dusk. Don't! Or if you must, be sure you have the skills, equipment and the support to see you have a comfortable night on the hill, or the strength, stamina and agility to navigate safely off in approaching darkness. It is not an undertaking for the faint-hearted.

WHEN YOUNGER I read many mountaineering books, including some of the classics, Joe Tasker, Pete Boardman, Chris Bonington, and of course Joe Simpson. After a trip to Alaska with Raleigh International in 1991 I developed a strong interest in wilderness and subsequently started climbing mountains with my Alaska comrades. But when my close friend Vincent Diamond died on Mount

Ushba in the Caucasus in 2000, my mountaineering ambitions faded. Much of what I had learned about mountaincraft was from him, and with his death much of my enthusiasm for mountaineering died too.

I continued to read, occasionally, books on mountaineering. I remained enthralled by the insanity and heroism of the participants, but reminded myself I was not the insane or heroic type. Besides which I was past 40 and surely getting too old for such skylarking.

In 2003 I went to the Caucasus on a pilgrimage of sorts to see the mountain where my friend's body lay, buried somewhere deep beneath the ice and snow. High in the mountains, above the wildflower-rich meadows of the valleys I realised that this realm of mountaineers, of ice, snow and glacially bulldozed rock was not for me. Too harsh, too brutal, too unyielding, too hard to photograph, too hard to breathe. Too hard to bear.

But in the north of Britain, Scotland's mountains remained within reach. And perhaps a dream remained unfulfilled. When asked to do this book I jumped at the opportunity. It felt like a last chance, a final challenge for my still fit but ageing legs, heart and lungs.

To begin with the mountains conspired against me, calling me north like sirens, only to disappear into vapour and rain as I approached. I dreamed of the ideal mountainscape, in all its transient, radiant glory; I imagined the sun shining through a strategically positioned gap in the cloud to illuminate a fairytale land. I yearned for a communion of weather and landscape, a convergence of photographic perfection. But it never happened. Ultimately, my impotence to control events became utterly clear and I relaxed into a form of acceptance. Of course I could never control the weather, and normal life

made timing my visits with the 'best' weather impossible. I came to realise that this was a task to see what was real. It would be what it would be.

There is no doubt it would have been easier to take only the view from below for this assignment. Or when making summit forays, to have carried just a lightweight digital camera. But in the interests of consistency I decided that my 'full strength' view camera system should come onto the summits too. And while I may not have visited every mountain, or even every range, I have sought every angle. From below, from the midslopes, and from the top. With the exception of aerial photography, as far as is possible, I have tried to make this a balanced view.

Carrying so much gear up the mountain has been more than a bit of a struggle. In the winter it was a bitter struggle. Yet the endeavour has taught me much about myself, about my physical and mental abilities and limitations. Having once thought 40 was too old to be climbing mountains, I now realise at 50 plus I still have unfinished business there. In the realms of mountaineering lore my efforts on the Scottish hills have been puny; but in the mountains of my mind, this book has been my personal Everest.

THANKS

A special word for Colin Prior, in age my direct contemporary, but who has always been there before me. Colin's seminal books on the Scottish landscape established him as the leading photographer of mountains in Britain. I have always respected and enjoyed his outstanding photography, and admired his dedication. Now, having had to pursue a similar path, carrying back-breaking loads long distances and on big ascents and descents I really understand in a deeper way just how great his commitment and craft are. His panoramas remain a unique and compelling vision of Scotland, much copied but never equalled. *Scotland: The Wild Places,* especially, with its lucidly worded explanation of the challenges and inspiration of mountain photography is also a great read for anyone seeking enlightenment on the subject.

To all my companions on the hill: Ken Jaquiery, Richard Childs, Stuart Parker, Nicky Kime, Richard Holroyd, Ted Leeming, Paul Mackie, Clive Minnit, Kyriakos Kalorkoti, Roger Soep; and to Fred Davie for his driving skills. For your effort, patience, support, encouragement, humour, kindness and friendship: thank-you.

To Robert Macfarlane, whose magnificent book, *Mountains of the Mind* helped me understand the cultural context of our appreciation of mountains. The quotations he kindly let me use in these pages perfectly sum up many of my own ideas and feelings about mountains far more eloquently than I could express them myself.

To Les Maclean, whose printing and Photoshop skills informed my preparation of the photographs for reproduction.

To Eddie Ephraums for his design, inspiration, incalculable support and encouragement.

To Piers Burnett for his confidence and faith in me, and to Stuart Cooper for his fastidious and insightful copy-editing.

To Rob Cook and Michael Howard at Paramo for supporting my clothing requirements for Scottish mountaineering. No other outerwear I have used comes close to working as well in the characteristic wet and windy weather of Scotland's mountains.

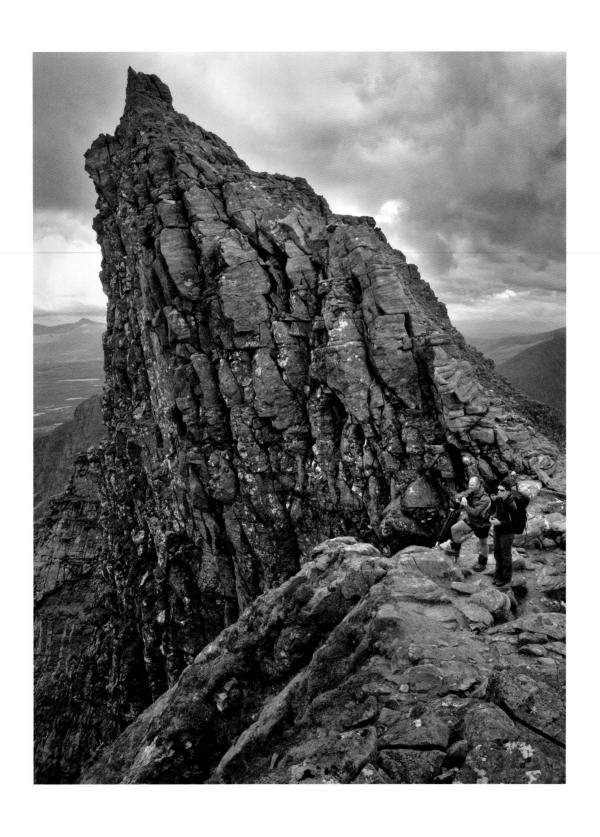

LORD BERKLEY'S SEAT, AN TEALLACH

Ken Jaquiery and Nicky Kime

First published in Great Britain 2009
by Aurum Press Ltd
7 Greenland Street, London NW1 0ND
www.aurumpress.co.uk

A catalogue record for this book is available from the British Library.

ISBN 978 1 84513 346 7

Designed by Eddie Ephraums

Printed in China

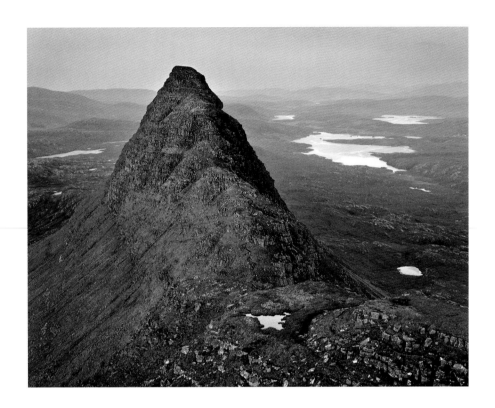

MEALL MHEADONACH
Suilven's eastern summit

Dedication

For Jenny, Chloe and Sam, whose patience, understanding, and enthusiasm for my
mountain photographs made it possible for me to complete this book.

And for the Scottish Mountain Rescue teams, whose skill and
dedication I now admire even more.

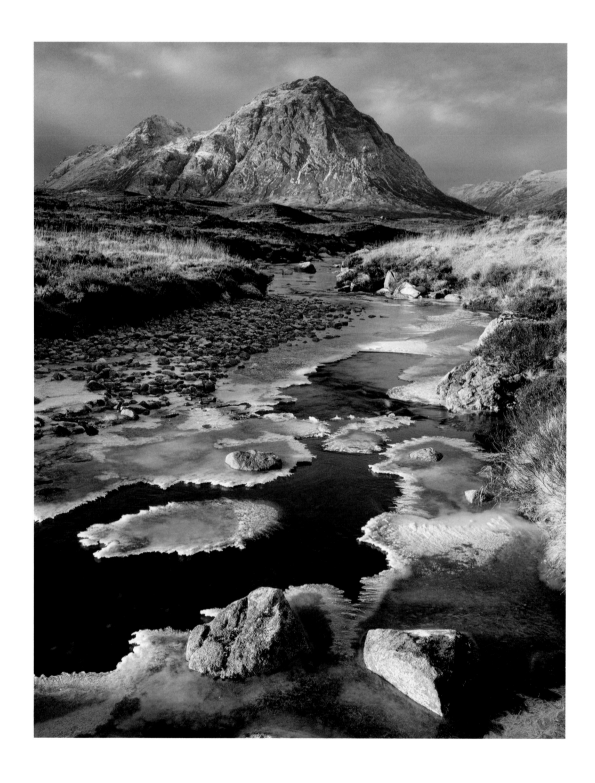

BUACHAILLE ETIVE MÒR

This photograph was made in in 1998, with my first Ebony camera.
It is, perhaps, my first authentic image of Scotland's Mountains.